American Poster Renaissance

"... the great periods of art were those in which it
allied itself most intimately with the daily life
of the people, and in this craze for posters, 'the
poor man's picture gallery,' as they are called, is
seen almost the first sign of a renaissance in
which the spirit of the century, which is so
largely a commercial one, will find an utterance
in beauty instead of ugliness."

Claude Fayette Bragdon
Quoted in *Poster Lore*, 1896

"The kiss of Fame and art for art's sake were his goal
When Chromer, painter, with the world first went to cope;
But now he barely pays for bread and board and coal
By making lurid posters for Van Apple's soap."

Anonymous

American Poster Renaissance

BY VICTOR MARGOLIN

WATSON-GUPTILL PUBLICATIONS / NEW YORK

First published 1975 in the United States and Canada by Watson-Guptill Publications,
a division of Billboard Publications, Inc.,
One Astor Plaza, New York, N.Y. 10036

Library of Congress Cataloging in Publication Data
Margolin, Victor, 1941–
 American poster renaissance.
 Bibliography: p.
 Includes index.
1. Posters, American. 2. Decoration and ornament—
Art nouveau. I. Title.
NC1807.U5M37 1975 769'.5 75-4813
ISBN 0-8230-0214-4

Manufactured in U.S.A.

First Printing, 1975

Edited by Sarah Bodine
Designed by Jim Craig and Bob Fillie
Set in 11 point Caledonia by Publisher's Graphics, Inc.
Printed by Parish Press, Inc., New York
Bound by A. Horowitz and Son, New York

*For my parents
and for Sylvia*

Color Plates

Mass Magazines

Little Magazines

Books

Newspapers, Commerce, and Exhibitions

Contents

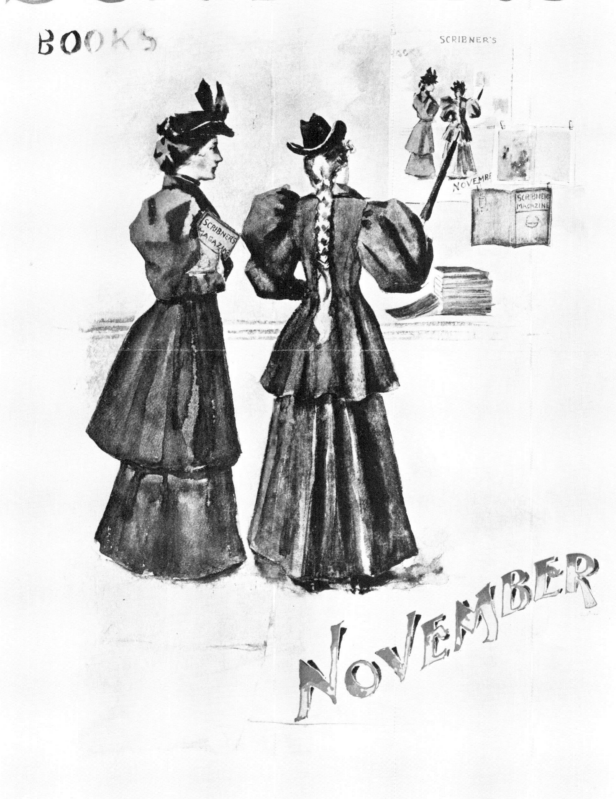

Posters advertising books and magazines were displayed by booksellers and newsdealers. Francis Day used a repetitive image on this placard. Two women are looking at a poster of themselves looking at a poster of themselves.

Introduction

During the 1890s, the poster in America came into its own as a medium of artistic expression. Although it had long been the handmaiden of commerce, the poster was considered merely a means of advertising until the late 1880s and was not thought to have any intrinsic artistic value.

But the popularity of the new artistic posters by Chéret, Grasset, Toulouse-Lautrec, and others in Paris convinced several American publishers that an appealing placard, prominently displayed in booksellers' windows, on walls, and on hoardings, might increase the sales of their magazines. When the artistic posters proved as popular in America as in Europe, other publishers commissioned them to promote their books, newspapers, and periodicals.

The American poster renaissance flourished for a few brief years in the 1890s. The leading patrons were the publishers, but manufacturers, impressed by the commercial success of the new posters, soon climbed on the bandwagon. Before the decade ended, posters by leading American artists and designers had been used to tout bicycles, patent medicine, and even dynamite.

It is doubtful that the poster movement would have thrived without the bursting energy and momentous changes that characterized the 1890s. Thomas Beers called that period the "mauve decade." When Beers' book of the same name appeared in 1926, Henry Seidel Canby stated in a review that "the purple of our heroic period was diluted into mauve in the materialistic scramble that followed the Civil War. . . . But it was an electric mauve."

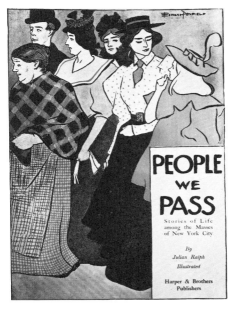

Edward Penfield's poster for a book of stories about the masses of New York City, 1896.

Business was expanding in all directions and great cities rose to become the centers of financial power. Thousands of migrants from rural areas as well as millions of aspiring immigrants from Europe flocked to the cities to find more stimulating and remunerative employment. For the first time, women in large numbers joined the working force. They were pioneers in the social work movement and became doctors, lawyers, and artists. Among the better poster designers of the decade were Ethel Reed, Alice Glenny, and Blanche McManus.

Intellectuals and artists came to the cities seeking outlets for their work among the magazines, newspapers, book publishers, and theaters that were springing up to inform and divert the urban population. Though many poster designers of the 1890s had fine arts backgrounds, most were making their living as commercial artists in the large urban centers—New York, Boston, Philadelphia, Chicago, and San Francisco.

The decade had opened on a note of prosperity, but financial speculators, flooding the country with false securities, precipitated the Panic of 1893. Banks, corporations, and mortgage companies failed and unemployment spread. By 1897 the Panic had waned, but not before new organizations were formed to protect the interests of the workers: the Populist Party, the Socialist Labor Party, and the American Federation of Labor.

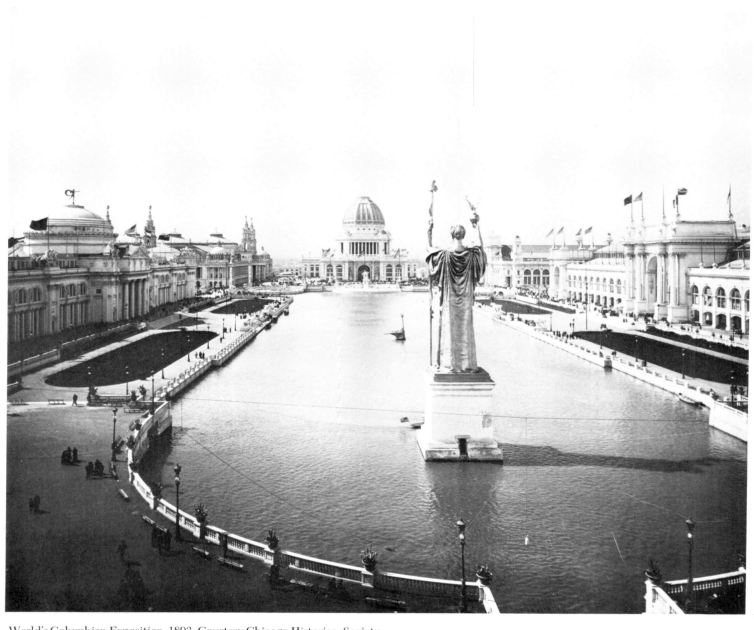

World's Columbian Exposition, 1893. Courtesy Chicago Historica Society.

Undaunted by the nation's economic difficulties, the World's Columbian Exposition opened in Chicago in May 1893. Young Maxfield Parrish, who was soon to become a prominent illustrator and poster designer, had journeyed all the way from Philadelphia to see the Fair. He wrote to his mother: "These stupendous architectural groupings could scarcely be surpassed in fairy tales without becoming absurd." In spite of the Fair's dedication to progress, the paintings in the Palace of Fine Arts and the monumental sculpture which confronted the visitor at every turn gave little hint of the new art movements flourishing abroad. Mrs. John Pierpont Morgan remarked that the French paintings must have been picked by a committee of chambermaids.

Nevertheless, the Columbian Exposition symbolized a spirit of change and helped create a fitting climate for the almost simultaneous emergence of the artistic poster in America.

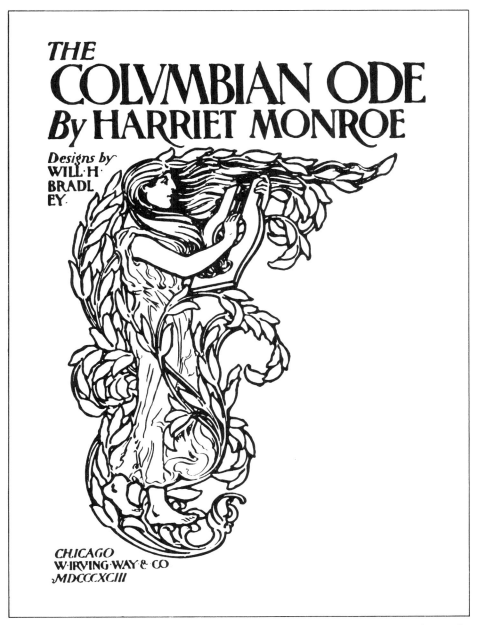

The cover of poet Harriet Monroe's ode to the World's Columbian Exposition was designed by Will Bradley, 1893.

Jules Chéret's posters exuded the *joie de vivre* of Belle Epoque Paris.

European Origins

The roots of the artistic poster stretch back to early 19th century France. In Paris, a new type of popular book was responsible for the poster revival that occurred in the 1830s and 1840s. Booksellers, who were often also publishers, displayed small posters in their shop windows and on the boulevards to advertise the illustrated books they sold in installments. The posters were usually enlarged book illustrations, printed as monochrome lithographs, with text added. Their creators were the best-known book illustrators of the day: J.J. Grandville, Gavarni, Tony Johannot, Gustave Doré, Raffet, Nanteuil, and Edouard de Beaumont. Balzac attested to the interest of "those maniacs called collectors" when he wrote in *Illusions perdues* that the placards were "a poem for the eye and often enough an unpleasant surprise for the purse of their admirers." By 1850 the book poster had declined. Edouard Manet's illustrative black and white placard for Champfleury's *Les Chats* in 1869 is a rare example after that date.

Also in 1869, Jules Chéret printed the first color poster in France. Chéret, known as the "father of modern lithography," established the poster as an art form. Before him, posters were either lithographed illustrations or scenes resembling genre paintings transferred to stone by anonymous craftsmen. Chéret was the first to understand that the poster was meant for the street and not the gallery. To attract attention it had to be bold and simple.

Most lithographers of Chéret's day were skilled technicians who specialized in reproducing the paintings and drawings of others. But Chéret eliminated these middlemen and made his own drawings directly on the stone. By experimenting with new techniques, he created the subtle shadings and textures that characterized his style.

Chéret was a self-taught artist who began as a printer. In 1856, as a young man of 20, he went to England to study the more advanced technique of chromolithography. Ten years later he returned to Paris and opened his own firm. His first poster, a monochrome, publicized *La Biche au bois*, a play starring a 22-year-old actress named Sarah Bernhardt. From 1869 to 1888 Chéret worked in three colors, but after that he never used less than four or five. Though theaters, museums, and newspapers all commanded his talents, he is most closely identified with the music halls and cabarets that blossomed in Montmartre during the 1880s and 1890s. Chéret's frothy figures, who seem to defy gravity as they float joyously in space, are the quintessence of Belle Epoque exuberance. The artist was awarded a Légion d'Honneur in 1889 for creating a new branch of art by applying artistic techniques to commercial and industrial printing. By 1891, Chéret had created over 1,000 posters. As standards of poster production declined toward the end of the century, he abandoned lithography for pastel and oils.

Although Chéret was a technological innovator, he was also a classicist who found his inspiration in the painting of earlier periods, particularly the French rococo. Eugène Grasset, a contemporary of Chéret, looked even far-

A French book poster done in 1895 by Tony Johannot. This is one of 800 illustrations he created for Cervantes' novel.

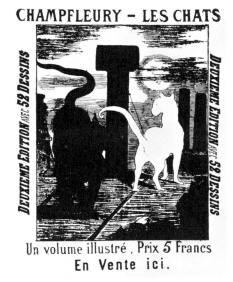

Edouard Manet's placard for Champfleury's *Les Chats*.

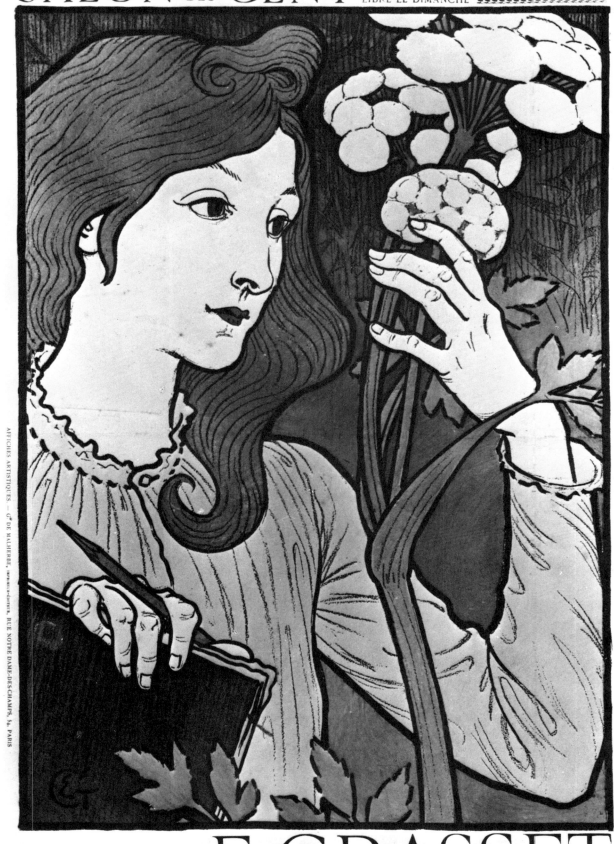

Eugène Grasset's poster for his 1894 one-man exhibition at the Salon des Cent.

ther back to the tranquil art of the Middle Ages. Grasset was more interested in the decorative arts than in painting. He had been influenced by the English Arts and Crafts Movement, whose guiding spirit, William Morris, was also an ardent medievalist. Grasset displayed his fondness for the medieval period in designs for furniture, jewelry, textiles, books, and stained glass. His first poster was designed in 1886 and he subsequently received many commissions from both sides of the Atlantic. Although Grasset preferred to cling to tradition and vowed that there could never be a "new art," the curving lines, flat two-dimensional modeling, and subjective colors of his posters nevertheless made them the forerunners of Art Nouveau.

The term Art Nouveau is usually used to connote the decorative style that developed in France in the late 19th century and then spread to other countries. In graphic art, its predominant elements are a swirling line, an attention to ornamental detail, and an emphasis on the flat surface rather than modeling in depth. The artist who most reflected the Art Nouveau style in England was Aubrey Beardsley; in America it was Will Bradley.

Bonnard, Toulouse-Lautrec, and Steinlen, who were less intrigued by Art Nouveau, shared a common interest in the contemporary life of Paris, particularly the bustling activity of Montmartre. Toulouse-Lautrec's posters chronicled the gaiety of the cafés and music halls. Steinlen's usually depicted the two subjects dearest to him, his little daughter and his cats. And his many lithographs, which didn't have to please a patron, portrayed deep interest in the poor workers of his *quartier*. The notable artistic quality of the French poster in the 1890s was due to the revival of interest in color lithography by these artists and their predecessors among the Impressionists. It is interesting to note that the first color lithographs of Bonnard and Toulouse-Lautrec were posters.

Ernest Maindron's *Les Affiches illustrées* (1886), an erudite history of the poster in France, stimulated public interest in collecting and confirmed the poster as a respectable art form. The journal *La Plume*, founded in 1889, published an occasional article on the poster and held regular exhibitions at its gallery, the Salon des Cent. Collectors found their mecca at the shop of Edmond Sagot, whose catalog, published in 1891, listed more than 2,200 different posters for sale. By the end of 1891, posters were being bought and sold in Brussels, London, and New York.

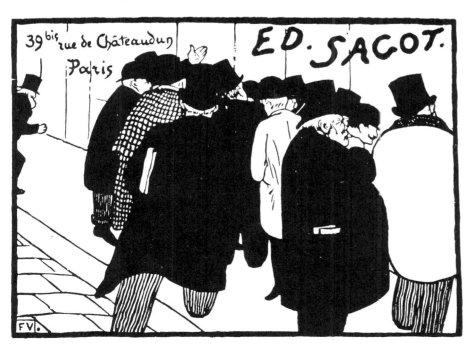

Félix Vallotton designed this woodcut placard for Edmond Sagot, the Paris poster dealer.

Early holiday posters for *Harper's* and other mass magazines were visually undistinguished.

Posters in America

Early 19th century American posters, which often used one or two colors, were printed from woodblocks. They were simple and somewhat crude. Small ones with text and no illustrations appeared in bookshop windows, as they did in France, while larger ones were posted on walls. Jules Chéret may have been inspired by the color woodcut posters that announced the performances of an American circus at the Paris Exhibition of 1867.

Woodcut posters were used well into the 1880s even though lithographic firms had begun to take over the poster business 20 years earlier. The Strobridge Lithographic Co. of Cincinnati, The Forbes Co. of Boston and New York, and The Courier Lithographic Co. of Buffalo were prominent firms of the period. Many of their clients were manufacturers of soaps, patent medicines, and other products although they were especially known for the posters advertising the plays, circuses, wild west shows, and minstrel troupes that toured the country. These posters could reach an enormous size and were sometimes composed of as many as 28 separate sheets.

The lithographers, mostly first and second generation German-Americans, considered themselves craftsmen whose role it was to reproduce an image with photographic fidelity. Their technique consisted of making highly finished crayon drawings on stone which resulted in a stippling effect. H.C. Bunner referred to the "perverse conservatism" of these craftsmen who were uninterested in graphic experimentation. They neither signed the posters themselves nor did they like the artists to do so. Matt Morgan, an Englishman who joined The Strobridge Co. in 1878, was the first artist to sign his posters regularly. But Morgan was essentially a skillful copyist whose illustrative characterizations of actors and actresses had little more interest than a photograph. Brander Matthews thought that Morgan had difficulty escaping the British physiognomy and that "his Irishmen and negroes, do what he might, were always Englishmen made up for the character."

Theater owners paid little attention to the posters they commissioned from the lithographic firms. Charles Cochran, an English impresario who visited America in 1891, described these theater bills in a British poster magazine: "The figures were tailor's dummies without life or movement, and the backgrounds were the old stereotyped German photographic reproductions of scenes from the play advertised."

A few artists tried to liven up the theater poster. George Frederick Scotson-Clark, who had come over from London with Cochran, was one of the rare poster artists to challenge the lithographers' obsession with anonymity. His theater bills for "The Red Girl," "In Gay Coney Island," and other plays brightened the hoardings in the early 1890s. But they were exceptions, as were Frank Nankivell's Marie Hatton poster for Koster & Bial and several theater posters by another Englishman, Archie Gunn. Will Bradley, best known for his small posters in the Art Nouveau and Arts and Crafts styles,

GRAND OPERA HOUSE. ONE NIGHT ONLY, FRIDAY, JAN. 3.

JOHN T. RAYMOND AS THE INSURANCE AGENT IN BARTLEY CAMPBELL'S COMEDY. RISKS.

A lithographed theater poster by Matt Morgan.

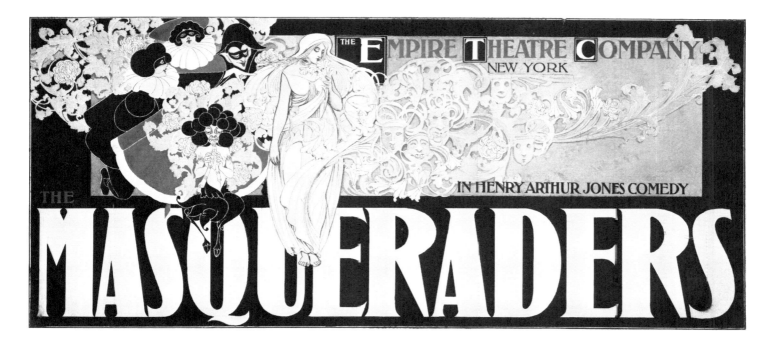

Will Bradley's sketch for a billboard-sized theatrical poster. The gigantic lettering, which was designed so that it could be changed for later productions, was intended to capture the public's attention. Courtesy the Metropolitan Museum of Art. Gift of Mrs. Fern Bradley Dufner, 1952.

made a rare foray into the theater world with his design for a huge Beardsleyesque billboard poster to advertise Henry Arthur Jones' "The Masqueraders." Despite these few examples the theater placard remained unaffected by the new artistic tendencies that characterized the poster movement of the 1890s.

But the public could not have been expected to demand better quality in its theater posters when it hardly paid attention to the fine artists of the day. Wealthy industrial barons like J.P. Morgan were too busy scouring Europe for the art of the past to notice the excellent paintings being done at home. The best of the American painters—John Singer Sargent, James McNeill Whistler, and Mary Cassatt—found it more congenial to live in Europe where their work was appreciated. An American purchaser could not even be found for Whistler's masterpiece, "Portrait of the Artist's Mother," which the French government snapped up in 1891 for an absurdly low price.

After 1830, and possibly before, magazine publishers began to use colored posters, with illustrations appropriate for the season, to advertise the holiday issues of their publications. This custom continued throughout the 1890s. Sometimes the design was an enlarged version of the cover, but often it was created especially for the poster format.

Eugène Grasset's first design commission in America was a special cover for the Thanksgiving Day Issue of *Frank Leslie's Illustrated Newspaper* in 1882. The cover, which appeared during the campaign to raise funds for the Statue of Liberty, featured an allegorical figure of the United States draped in an American flag. Grasset's symbolism, derived from his studies of medieval art, was a radical departure from the standard representational fare to which the public had been accustomed. Apart from this cover, little happened during the 1880s to increase the public's awareness of the artistic styles that Cheret, Grasset, and other French artists were creating in Paris.

But the popularity of the French posters did not go unnoticed by American publishers. In 1889, Harper & Bros. commissioned Grasset to do a cover for *Harper's Bazar* and two holiday posters for *Harper's Magazine.* The selection of Grasset, though commendable on artistic grounds, was a calculated concession to Puritan morality since his curly-locked cherubs, in contrast to the gay revelers of Chéret, were certain not to offend a prim public. The same year, Louis Rhead, an English artist who had been in America since

1886, was asked to do holiday posters for the magazines, *The Century* and *St. Nicholas*.

In November 1890, enthusiasts saw a large selection of French posters at the first poster exhibition in America, sponsored by the Grolier Club. They were impressed by the colorful placards of Chéret and Grasset which outshone the few realistic posters by American lithographers, particularly Matt Morgan. The new artistic tendencies which the Grolier show publicized were brought to the attention of a wider audience in an article written by Brander Matthews for *The Century* in 1892. Matthews called Chéret "an impressionist who has a masterly command of line and an absolute control of color." Yet, anticipating the moral reaction of the public, he still found it necessary to defend Chéret's nymphs against possible charges of sensuality or lewdness. In spite of Matthews' praise of Chéret, later articles sometimes warned of the dangers to a young man's character if he decorated his room with posters by the French artist.

The Poster Craze

Encouraged by the enthusiastic reception of their holiday posters, Harper & Bros. made the momentous decision in the early months of 1893 to publicize *Harper's Magazine* with a monthly placard. The assignment fell to Edward Penfield, a young illustrator and art director for the company. Critics usually date the beginning of the American poster movement from the appearance of Penfield's *Harper's* posters beginning in March 1893.

Other magazines soon began to commission posters on a regular basis, although *Harper's* was the only magazine with posters by a single designer until late 1894, when *Lippincott's* hired Will Carqueville. Penfield's posters, and those commissioned by other magazine and book publishers, were small in size since they were designed for bookshop windows and newsstands rather than the hoardings.

Direct copying was not common but it did occur. A design by a European or American artist might appear on the opposite side of the Atlantic in a slightly veiled form. A particularly amusing example was the adoption of Maxfield Parrish's androgynous youth from his 1896 *Century* poster for a Spanish placard advertising sausages. Occasionally an artist sold a slightly different version of a design to another client, as did Will Bradley when he gave a modified drawing for a Victor bicycle poster to a London firm that manufactured typewriters.

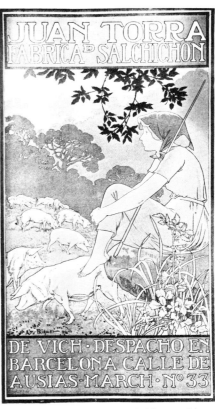

The young woman on Maxfield Parrish's 1896 *Century* poster (top) appeared two years later on a Spanish placard advertising sausages (above).

The poster contest was a way of discovering new talent as well as drumming up publicity for the sponsor. The winning artists earned substantial prizes and a good deal of acclaim. The losers benefited little since their designs were usually kept by the sponsoring firm and sometimes used for promotional exhibitions. One irate artist who received an announcement from a dried-fruit firm for a poster contest in which only one prize would be awarded and all the entries would become the property of the firm, sent the following reply: "Gentlemen—I am offering a prize of fifty cents for the best specimen of dried fruit and should be glad to have you take part in the competition. Twelve dozen boxes of each fruit should be sent for examination, and all fruit that is not adjudged worthy of the prize will remain the property of the undersigned."

Maxfield Parrish was a frequent winner of poster competitions. In 1896 the Pope Manufacturing Co. sponsored a contest for a poster to advertise the Columbia bicycle. Parrish's poster was considered the best of 525 entries and

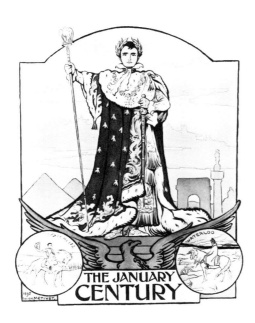

Judges in the 1895 *Century* poster contest preferred Lucien Métivet's portrayal of Napoleon as a regal emperor (top) to Toulouse-Lautrec's more realistic interpretation of him as a military leader (above).

earned him the first prize of 8250. That same year Parrish received second prize in *The Century*'s contest for a midsummer holiday poster. He might have had the first prize, which went to J.C. Leyendecker, but entries had been restricted to three colors and Parrish, an avid experimenter with the new halftone process, employed five.

The Century Co. had sponsored another contest the previous year for a poster to advertise Professor Sloane's *Life of Napoleon*, which had been serialized in *The Century* and was now appearing in book form. The publisher's conservative taste led them to hold the contest in France with three artists of the Academy, Gérome, Detaille, and Vibert, as judges. The prize was awarded to Lucien Métivet for his pompous portrait of Napoleon at his coronation. Toulouse-Lautrec, who had also entered the contest and was disappointed by the outcome, had 100 copies of his rejected poster printed and gave them as presents to his friends.

A few American connoisseurs were already buying French posters as early as 1890, but the collecting mania didn't begin until 1893 when the mass-circulation magazines started to issue their monthly placards. Publishers soon realized the popularity of the posters and began printing extra copies for sale to collectors. Free posters were also offered to attract new subscribers.

Although many magazines were sold by subscription, there was still a brisk newsstand sale that was boosted significantly by the new posters sent to the dealers. When the newsdealers discovered that the artistic posters were of such interest to collectors, they began selling them instead of displaying them as the publishers had intended. Booksellers followed the same practice, eventually discouraging many publishers from issuing further posters. In Paris, avid collectors obtained posters of Chéret and other artists by bribing the billstickers or else removing the posters from the walls during the night with damp sponges.

It is tempting to view the "poster craze" as a revolution in decorative taste, yet there seems often to have been more interest in the completeness of a collection than in the discerning selection of the best designs. Leading collectors like Charles Bolton, Ned Arden Flood, and H.L. Sparks owned as many as 1,000 different posters. In 1894 an article in *The Chap-Book* reiterated the emphasis on completeness: "In America . . . everyone has a chance to have a complete collection of posters. One need only begin a year back, for nothing before that is worth collecting."

By 1895 the poster fad was widespread. *The Chap-Book* was advertising back posters at 25 to 50 cents each when the magazine itself was selling for only 5 cents. American artists had already been recognized abroad. In London, *The Studio* published an article on Will Bradley in 1894 and Parisians saw posters by Bradley and Edward Penfield in S. Bing's first Salon de l'Art Nouveau exhibition in December 1895. That same year, Charles Scribner's Sons published the first American book on the poster movement, entitled *The Modern Poster*. To appeal to collectors, it was published in a limited edition of 1,000 copies with a signed and numbered poster by Will Bradley for each purchaser.

Important poster exhibitions were held at the Union League Club and Pratt Institute in New York, and shows followed in Boston, Chicago, San Francisco, as well as other cities across the country. Dealers sprang up in the big cities. Brentano's, the New York bookseller, opened a poster department that specialized in imports from France. Other New York poster dealers were C.S. Pratt, Meyer Bros., and Gustave P. Fressel.

Two magazines devoted exclusively to the placard, *The Poster* and *Poster Lore*, were started in 1896, when the fad reached its peak, but neither lasted through the year. Percival Pollard, a Chicago journalist, was one of the foremost proponents of the artistic poster. As editor of *The Echo*, a biweekly magazine, he commissioned posters from Will Bradley, John Sloan, and Frank Nankivell. His column in *The Inland Printer* contained all the latest information about new posters in America and Europe. The author and journalist Ambrose Bierce, skeptical of Pollard's cultist attitude, wrote in a *San Francisco Examiner* column: "I dare say that in the secret soul of him my friend Pollard cherishes for the purple blondes and yellow brunettes of his collection a sentiment that ought to land him in the divorce court. . . . As for me, I feel as yet no call to go forward to the anxious seat, but with a wicked and stiff-necked perversity propose to continue in my state of sin, regarding the poster with contumelious irreverence."

Despite Bierce's impiety, the poster business was booming. *Poster Lore* announced an estimated 6,000 collectors in America and another 1,000 in Canada. Twenty printing firms producing only posters represented investments of nearly three million dollars. By 1896 most designs were being transferred photomechanically onto lightweight, manageable zinc or aluminum plates, which replaced the cumbersome lithographic stones. Zinc plates had long antedated aluminum and may have been in use as early as the 1860s. In general, posters printed from metal plates were difficult to distinguish from those pulled from stones. Halftone printing, the photographic reproduction of a painting or drawing, was also used to reproduce poster designs and became increasingly popular after the turn of the century. The continual improvement of printing technology during the 1890s facilitated the use of more colors. The first artistic posters of Bradley and Penfield had a limited range of two or three colors, but later designs by Parrish and others employed as many as four or five.

E.B. Bird's placard for a poster exhibition in Boston, 1895.

Poster prices continued to rise and French posters were fetching between one and ten dollars. A curious byproduct of the fad was the poster party. Women guests were invited to come dressed as figures from particular newspaper or magazine posters. During the party each woman was asked to pose and the other guests had to guess which poster she represented. Posters also influenced women's fashions, particularly in the stronger colors of their dresses.

In spite of the widespread enthusiasm for the artistic poster, opinion as to its merits was divided. Some critics were offended by its departure from the realistic style that dominated American painting and lithography at the time. Their exception to the flat planes and expressive colors of the new posters was indicated in a poem published by *Harper's* in February 1895:

You must draw a dame with awful angularity
In a landscape of geometry run mad;
Give her frock a sweep with long particularity,
And a pattern that no raiment ever had.

Oh, the sky it must be green, and the tree it must be blue!
And the lake must look a claret-colored bubble;
And a foreground must be found
That can be a far background
But a fashionable poster's worth the trouble!

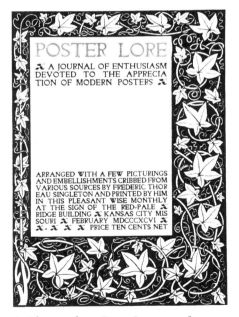

A title page from *Poster Lore*, one of two magazines started in 1896 to cover the poster movement.

However, the main opposition to the artistic poster was on moral, rather than aesthetic, grounds. Buttressed by a staunch Puritan heritage allied with

Victorian conservatism, critics equated effervescence with licentiousness and frowned on the Gallic gaiety of Chéret. Louis Rhead, who lectured with missionary zeal on "The Moral Influence of the Artistic Poster," found Chéret commonplace and often lewd. Though the blue trees and yellow skies of Rhead's posters offended art critics, the placidity of his modest maidens nevertheless pacified the moralists.

The Archfiend in this morality play was the English artist, Aubrey Beardsley, whose brilliant innovations in the use of sweeping line and flat black and white masses were obscured by the wicked and decadent figures he portrayed. Beardsley was a serious artist whose drawings were based on established antecedents—the early Renaissance, the Pre-Raphaelites, and Art Nouveau. He was also a young *fin-de-siècle* poseur who toyed with the grotesque and the depraved. This didn't daunt progressive English publishers like John Lane and Fisher Unwin from commissioning Beardsley posters to publicize their books. Nor did it prohibit their American counterparts, Stone & Kimball and Copeland & Day, from publishing Beardsley's drawings or distributing *The Yellow Book*, for which he was the art director. Will Bradley and John Sloan, among other artists, were indebted to Beardsley's style though they preferred less bizarre subjects. H.C. Bunner probably spoke for many critics when, ignoring the innovative quality of Beardsley's drawings, he deplored the "hopelessly vulgar" English middle class which could accept Beardsley "in all his offensiveness."

A poster, using an Aubrey Beardsley illustration, to promote *The Yellow Book* which Copeland & Day distributed in America.

Claude Bragdon's parody of Beardsley's style entitled "A Wilde Night" (right).

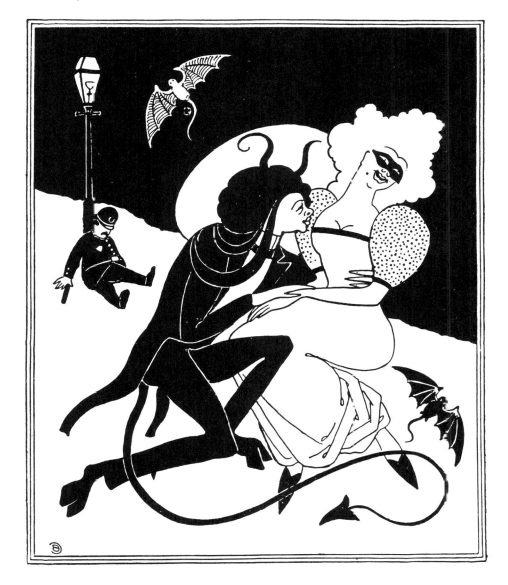

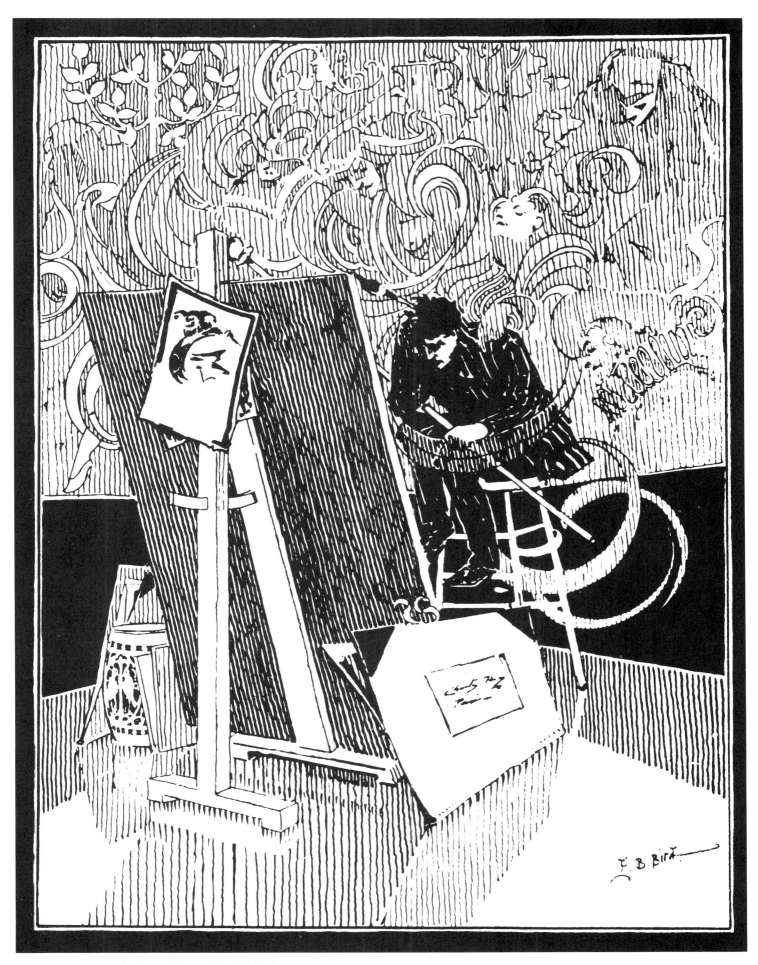

"An Acute Attack of Beardsleyism" by E.B. Bird.

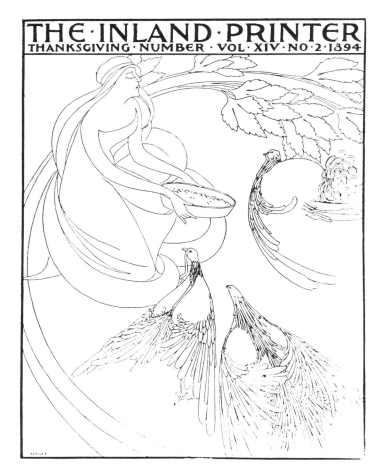

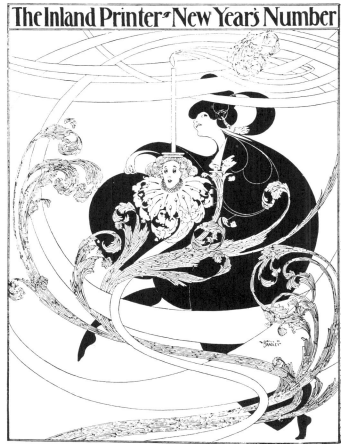

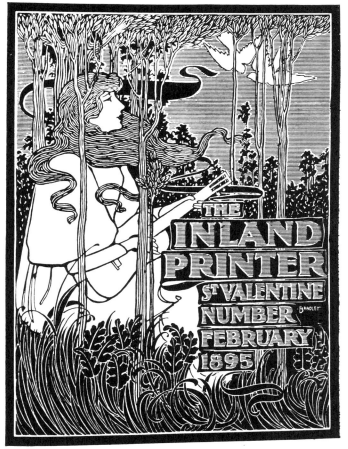

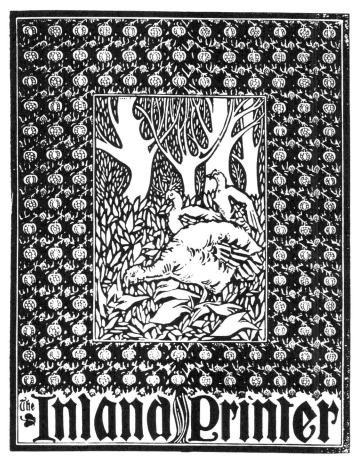

Four *Inland Printer* covers designed by Bradley. The influences of Aubrey Beardsley and William Morris are evident in the use of the swirling line and ornate border.

Styles and Artists

Two stylistic innovations—one derived from the decorative arts, the other from the graphic arts—prepared the way for the American poster renaissance. The Arts and Crafts aesthetic, which originated in England, opposed the machine production of the Industrial Revolution in favor of the personal workmanship of the Middle Ages. William Morris, the prime advocate of the Arts and Crafts philosophy, was a prodigious worker who applied his love of careful craftsmanship and ornate decoration to a multitude of endeavors, the design of chairs, wallpaper, and books among them. In France, Eugène Grasset combined the Arts and Crafts philosophy with his interest in the Japanese prints popular at the time. The style he evolved for his illustrations and posters employed flat color areas and heavily outlined two-dimensional figures. Beardsley, too, preferred the decorative quality of line and ignored conventional modeling in favor of the juxtaposition of positive and negative masses. The term "decorative style" could be loosely applied to the work of these artists. With its roots in romanticism and its overtones of symbolism, it recognized the artist as free to interpret or ignore reality in any way he liked.

Bonnard, Toulouse-Lautrec, and Steinlen—to whose art the term "descriptive style" might be applied—also had little interest in academic notions of pictorial composition. Like Grasset, they admired the strong colors and flat spaces of the Japanese prints. From Chéret they discovered the potential of lithography for creating textured surfaces. Although interested in graphic experimentation, they also preferred to depict the reality of daily life. The subjects of their paintings, lithographs, and posters were likely to be their own friends and families rather than the nymphs, dwarfs, and angels preferred by the decorative artists.

The decorative and descriptive styles were the sources of two distinct schools of American poster design. Foremost among the decorative artists were Will Bradley, Louis Rhead, and, to some extent, Ethel Reed. The leading designer in the descriptive style was Edward Penfield. A third tendency, the "illustrative style," was represented by Maxfield Parrish. The work of the illustrative artists was not necessarily less imaginative than that of other designers but it did not reflect, or did so to a lesser degree, the new graphic movements which had developed in Europe the previous two decades.

Will Bradley.

Will Bradley

Will Bradley, whom *The Saturday Evening Post* called the "Dean of American Designers," was a self-taught artist whose early training was in the printing profession. He was born in Boston in 1868, the son of a cartoonist for a Lynn, Massachusetts, newspaper, *The Daily Item*. At the age of 12, he obtained his first job as a printer's devil with *The Iron Agitator* in Ishpeming, Michigan, where he had moved with his mother after his father's death. There he quickly learned to set type, deal with advertising display, and make

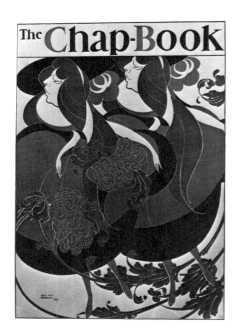

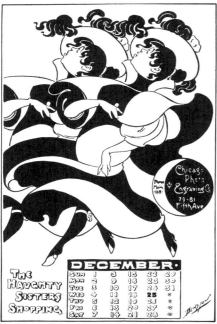

Bradley's Art Nouveau poster "The Twins" (top) and a parody of it by Will Denslow for a "Fin-de-Siècle" calendar (above).

up the paper. Bradley set out for Chicago when he was 16 and found a position with Rand McNally as an apprentice in the design department. But he was dissatisfied with the job and returned to Michigan. The next year Bradley went back to Chicago and became a full-fledged designer with Knight & Leonard, the city's leading printer. He took a keen interest in all forms of printing and design and seemed well aware of his contemporaries' work: the book covers of J.C. Leyendecker, the labels of Frank Getty—"a glorious departure from the conventional truck of the label lithographers"—and the illustrations of Abbey, Frost, and Pennell in *Harper's Weekly*.

After two years with Knight & Leonard, Bradley, whose expanding talents could hardly be contained by a single firm, became a freelance designer. In 1893, the year of the World's Columbian Exposition, he received a commission from the publisher W.I. Way & Co. to design a cover and decorations for poet Harriet Monroe's paean to the Exposition, *The Columbian Ode*. Bradley's first important commission came in 1894 when *The Inland Printer*, a Chicago journal of the printing trade, asked Bradley to design a permanent cover. He did so but then persuaded the publisher to change the cover each month. This resulted in a commission for 18 *Inland Printer* covers between 1894 and 1896.

These covers, some of which were used on posters to advertise the magazine, reflect Bradley's interest in the heavily ornamented Arts and Crafts books of William Morris and the sinuous drawings of Aubrey Beardsley which were just reaching America via *The Yellow Book*. Though Bradley was called the "American Beardsley" by many critics, the appellation is unjust. There is no doubt that Bradley was influenced by the swirling lines and juxtaposed black and white masses of the English artist, but he used Beardsley's discoveries for his own purposes and within a few years had ceased to work in the Art Nouveau style. A.H. McQuilkin, the editor of *The Inland Printer* who first asked Bradley to design a permanent cover for the magazine, said about him: "He has never been imitative. His ideas, so exquisitely worked out, are his own ideas, and not the reworked fruit of another brain." McQuilkin praised Bradley's thoroughness and said that he was "painfully and unnecessarily scrupulous about his work—that it should approximate closely his sense of what it should be. The combined strength and daintiness of his designs made his services to be sought for." However, the editor added that "his ideas of business are singularly vague." McQuilkin also expressed a mild distaste for the influence of Beardsley and the Arts and Crafts Movement on Bradley's work: "Withal one wishes that the demand for the grotesque black and white massed designs would cease—the novelty has palled upon the fancy, and the undoubted artistic and decorative excellences are merely tantalizingly suggestive of what the best efforts of Mr. Bradley may be."

Bradley's first poster design was probably "The Twins," which he created for Stone & Kimball's literary magazine *The Chap-Book* in the summer or fall of 1894. It was considered the first Art Nouveau poster in America and added to the wave of interest in poster collecting started by Edward Penfield's *Harper's* placards. But Bradley's decorative style was not as easy to accept as Penfield's more straightforward portrayals of the *haute bourgeoisie*. A critic writing in *The American Printer* said of "The Twins" that ". . . the funniest thing out is the 'Chap-Book' poster. No mortal man can possibly tell without deliberately investigating, what it means or what it represents. Ten feet away one would be willing to make an oath that it was a very, very red turkey gobbler very poorly represented. On closer inspection it seems to have been intended for two human beings, one at least being in a red gown very short at both ends."

During 1894 and 1895 Bradley did seven posters for *The Chap-Book*, all of which were extremely popular. His first book assignment also came from Stone & Kimball in late 1894: a commission for a cover, title page, page decorations, and a poster for a book of verse by Tom Hall, *When Hearts Are Trumps*. The poster was another example of the strong influence the Art Nouveau style had on Bradley at the time.

Because of his early training as a printer, Bradley's posters are distinguished by their good taste in typography which is an integral part of the design. The typography of most 1890s posters left much to be desired. Bradley's placards were notable exceptions, as were those of other typographers such as Bruce Rogers and Bertram Grosvenor Goodhue. Bradley admired the dense ornamentation of William Morris' book pages but did not share the Englishman's love for the heavy Gothic type face that was almost impossible to read. Though he occasionally used variations of the Gothic, Bradley preferred simpler types such as the early English face, Caslon. Sometimes he designed his own lettering. The American Type Founders purchased the rights to his letters for the *Inland Printer* cover of December 1894 and cast them as a type they christened "Bradley."

Late in 1894 Bradley left Chicago for Springfield, Massachusetts, where he continued to work as a freelance designer, accepting further commissions from Chicago. He also began to do more commercial work for manufacturers of bicycles, paper, and patent medicine. After a year of freelancing, he established The Wayside Press. As its device he chose the dandelion leaf "because the dandelion is a wayside growth." Bradley had always intended to be an artist and considered printing only a wayside to achieving that end.

For a year he published his own literary and art journal, *Bradley: His Book*, one of the most elegant "little magazines" of the 1890s. Bradley was the publisher, editor, designer, illustrator, and sometimes the writer. But McQuilkin's observation proved to be true. He was no businessman. In 1898 The Wayside Press was merged with the University Press of Cambridge, Massachusetts, and Bradley opened a design and art service in New York.

While in Massachusetts he had been an informal spokesman for the Arts and Crafts philosophy, which he applied in his heavily decorated and ornamented poster and book designs of that period. After moving to New York he simplified his style, which became better suited to the needs of mass publishing and commerce. Many years later Bradley had some second thoughts about the decorative phase of his career. In a brief autobiography written when he was in his 80s, Bradley referred to the 1890s as "a period of over-ornamentation and bad taste." Nevertheless he thought those years were ones of "leisurely contacts, kindly advice, and an appreciative pat on the back by an employer, and certainly a friendly bohemianism seldom known in the rush and drive of today."

After the turn of the century, Bradley was active as a designer, art director, writer, and even film-maker. He died in 1962 at the ripe old age of 94.

Louis Rhead

Louis Rhead was an Englishman who gained his reputation as a poster artist in the United States. Like Bradley, he worked in the decorative style, but he lacked the former's originality. Whereas Bradley had been able to forge many influences into a strong individual style, Rhead never transcended the influence of Eugène Grasset, the French artist he so admired. Rhead was a competent but unimaginative illustrator who seldom varied his subject matter. The long-plaited, blank-faced women he drew to the point of tedium

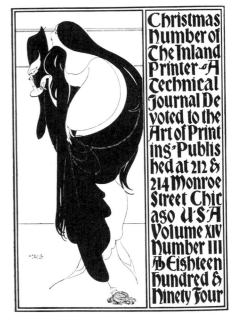

Will Bradley's *Inland Printer* cover for December, 1894, showing the type face called "Bradley."

An advertisement for The Wayside Studio which Bradley established, along with The Wayside Press, in Springfield, Massachusetts.

Louis Rhead.

seemed equally at home with a box of Pearline Washing Compound or a copy of *The New York Journal*. In 1896 a critic for *The Artist* wrote: "Mr. Rhead is an admirable artist but not a genius. We admire his work, and go away without the bitterness of having an irresistable longing to possess it." Rhead's greatest virtue was his feeling for color, and his more striking posters, such as those for *The New York Sun* and the *Journal*, derive their effect mainly from the intense combinations of tones he employed so adeptly.

Rhead was born in 1857 in Etruria, Staffordshire, where his father was an artist at the Wedgewood pottery factory. His two brothers were also artists. When only 13 years old, Rhead was sent to Paris to study painting. Later he attended an art school in South Kensington. Before he came to New York in 1883 to work as an illustrator for D. Appleton & Co., Rhead had already exhibited his paintings at important galleries in England and France. Between 1889 and 1891 he did a series of covers and posters for *Harper's*, *The Century*, and *St. Nicholas*. His placards of that period were among the first artistic posters to appear in America. At the time Rhead's work was more illustrative than decorative since he had not yet come under Grasset's influence. From 1891 to late 1894 he was working and studying in Europe. During this time he saw an exhibition of Grasset's posters in Paris at the Salon des Cent, where he met the artist. Rhead was often quoted as saying how much he profited from the influence of Grasset.

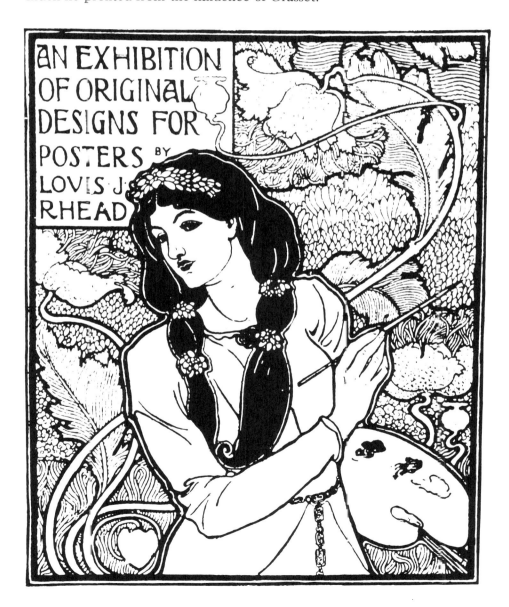

Catalog drawing for Louis Rhead's one-man exhibition at New York's Wunderlich Gallery in January, 1895 (right).

His one-man show at New York's Wunderlich Gallery in early 1895 established his American reputation. This was further enhanced by the gold medal he won at the International Poster Exhibition held shortly thereafter in Boston. In 1897 Rhead was given a poster show of his own at the Salon des Cent. A French critic wrote a glowing review for *La Plume*: "These designs modestly cataloged as advertising posters, are really magnificent frescos constituting the most charming mural decoration possible."

Ethel Reed

Ethel Reed, the youngest of any of the designers, was the best known of the women poster artists of the 1890s. She was born in Newburyport, Massachusetts, in 1876 and studied with the noted miniature painter, Laura Hill. By the time she was 18 she was already known for her book illustrations. Lamson, Wolffe & Co. and Copeland & Day, the two leading literary publishers of Boston, provided most of her poster commissions, but she also did newspaper, book, and magazine placards for other firms. Elements of her most successful posters, particularly the lush flowers and the dark and light color areas, recall Japanese prints. The preciocity of her coy young women and arch little girls does pall a bit, however. In the late 1890s Ethel Reed took a long rest and vacation in Ireland. Nothing was heard from her after the turn of the century.

Ethel Reed.

Edward Penfield

Edward Penfield, a young art director for Harper & Bros., exemplified the descriptive style in American poster design. Although Penfield had studied fine arts at the Art Students League in New York and was influenced by Toulouse-Lautrec and Steinlen, he clearly understood the aesthetic limitations of the poster form. His own simple designs, which rarely incorporated more than one or two figures, testified to his belief that "A design that needs study is not a poster, no matter how well it is executed."

For six years, with only one or two exceptions, Penfield drew the monthly placards for *Harper's*. During this period he evolved from rather lackluster designs drawn with a pen to bolder graphic statements, often created with brushstrokes and stippling on the zinc printing plates. Will Bradley admired Penfield's textural effects and emulated his techniques in some of his own posters. He paid tribute to Penfield with the statement that "in methods of reproduction, that difficult point to which so few give even a passing thought, he is a past master."

Edward Penfield, a self-portrait.

Throughout his career at *Harper's*, Penfield rarely departed from his portrayals of the rather bored and aloof members of the genteel class. Perhaps this was a stipulation of his publishers, who may have wanted posters to reflect the self-image of the monied readers they sought to attract. Penfield's placards appeared during the depression of the mid-90s when few but the wealthy could afford the magazine's price of 35 cents. His concentration on a single social milieu and his static figures without animation or emotion led one French writer to refer to his work as "a good bourgeois cuisine which offers a profusion of substantial dishes."

Despite the aloofness of Penfield's subjects, there is an element of warmth in many of his posters, derived from his love of animals, particularly cats, and his quiet and subtle whimsy. For the March 1894 *Harper's* poster Penfield drew a lion reading a copy of *Harper's* and a lamb waiting in the background in reference to the old saying that March comes in like a lion and

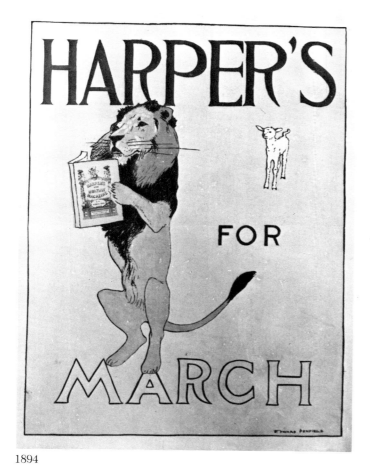

1894

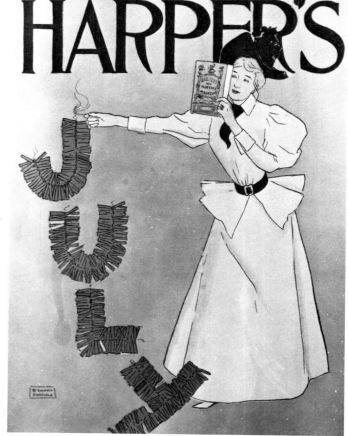

1894

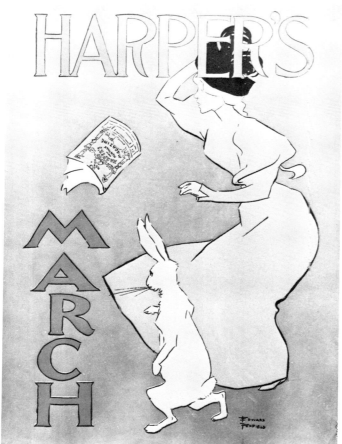

1895

1895

Harper's posters which exemplify Penfield's whimsical humor.

goes out like a lamb. Penfield's poster for the July 1894 issue employs the typography as part of the picture space. The word "July" is formed out of firecrackers and a distracted reader is shown putting a match to them. A classic bit of Penfield humor is the March 1895 poster which depicts a woman and a March hare watching a copy of *Harper's* being blown away by a gust of wind.

Initially Penfield portrayed on every *Harper's* poster someone reading or carrying a copy of the magazine. Sometimes he handled this in a tongue-in-cheek manner, as with the October 1895 placard which shows a hunter engrossed in a copy of *Harper's* while two smiling hares perch right under his nose. The practice of displaying a copy of the magazine on each poster was picked up by other publications, including *Lippincott's*, *Scribner's*, and *St. Nicholas*. After several years Penfield ceased to follow this practice regularly.

Penfield worked almost exclusively for Harper & Bros. throughout the 1890s, doing both magazine and book posters. After 1900 he was active as a book and magazine illustrator for various companies.

Maxfield Parrish

Although Maxfield Parrish was a regular winner of poster competitions in the 1890s, his best-known designs have the quality of enlarged illustrations. They are much more detailed than the posters of Bradley or Penfield and their subtle color relationships and complexities of line and modeling, which recall early German and Flemish etchings, require careful study.

Percival Pollard, who referred to Parrish's style as "modern archaic," declared that he didn't care for "designs in advertising that are but pretty pictures." There were exceptions, particularly Parrish's placard for a Philadelphia poster show in which the figures were constructed from a few simple, flat shapes.

Parrish was the son of the painter and etcher, Stephen Parrish. Born in Philadelphia in 1870, he studied at the Pennsylvania Academy of Fine Arts and briefly with Howard Pyle, the noted illustrator. Pyle's love of faraway lands and earlier historical periods seems to have influenced Parrish, whose own illustrations were usually located in an imaginary time and place. It must have been the romantic and escapist elements of his prints that made them so popular in households across the country after the turn of the century.

Maxfield Parrish.

By the mid-90s Parrish had begun to achieve success as a magazine cover artist. Most of the Harper & Bros. publications as well as *Scribner's*, *St. Nicholas*, and others used his designs. His first book illustrations were done in 1897 for *Mother Goose in Prose*, the first book written by L. Frank Baum, author of *The Wizard of Oz*. Shortly thereafter he drew the covers for two novels, *Bolanyo* and *Free to Serve*. Both drawings were later used as posters, a testament to Parrish's dictum that "A book cover should certainly have a poster quality." Conversely, a drawing very similar to his prizewinning Columbia bicycle poster of 1896 was equally appropriate as a cover for *Harper's Weekly*.

Although technically accomplished, Parrish was a conservative draftsman whose posters recall the past, both in theme and style. Nevertheless, they must have been popular because anyone strolling around New York in 1896 could see "high up on the hoardings another prizewinner in the shape of a hearty and jolly little boy who has found contentment in a big bowl of oatmeal."

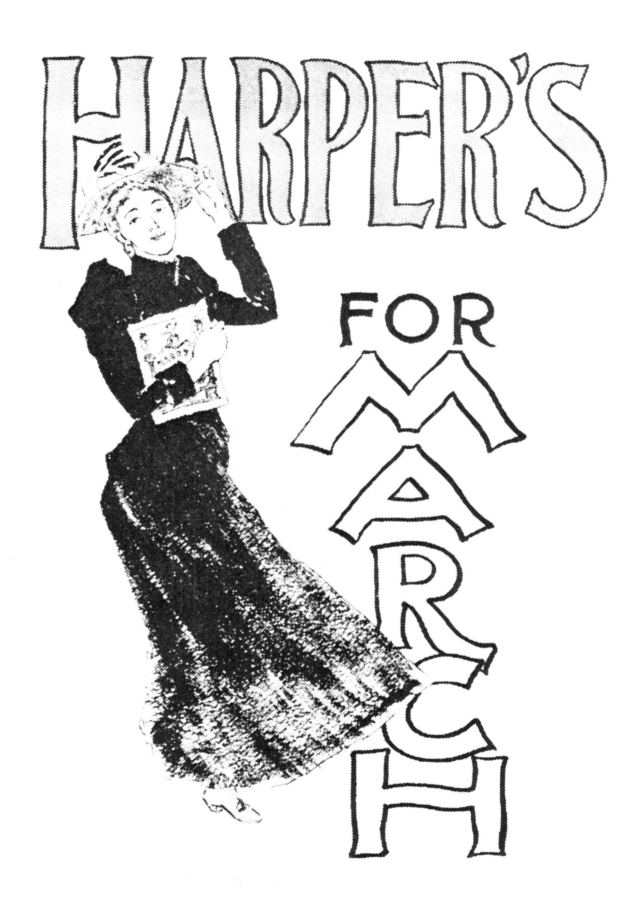

Edward Penfield's first *Harper's* poster, March, 1893.

The Patrons

During the 1890s artistic posters were commissioned and developed in the United States to attract the attention of the buying public. The range of patrons included book, magazine, and newspaper publishers as well as commercial concerns and exhibitions.

Mass Magazines

The leading magazines at the beginning of the mauve decade were the "genteel aristocrats," *Harper's*, *The Century*, *Scribner's*, and *Atlantic*. Leisurely and literary, they tended to avoid the controversies of the day. Their readership was derived from the monied and well-educated classes who could afford the monthly price of 35 cents—25 cents in the case of *Scribner's*—for their dignified and proper doses of culture and self-improvement.

The first artistic posters to advertise mass magazines were done in 1889 by Eugène Grasset and Louis Rhead for *Harper's* and *The Century*. When *Harper's* began its series of monthly placards in March 1893, it was the only magazine committed to a regular designer, Edward Penfield. *Lippincott's* followed in late 1894 by hiring Will Carqueville and later J.J. Gould.

Scribner's, *The Century*, and other magazines used posters by many artists, among whom were Charles Dana Gibson, Louis Rhead, Maxfield Parrish, and J.C. Leyendecker. While Penfield's *Harper's* posters reflected an increasing tendency toward graphic exploration, particularly of colors and textures, the placards done by his counterparts for *Scribner's* and *The Century* were more conservative and rarely departed from the illustrative style. There were notable exceptions, such as J.C. Leyendecker's prize-winning poster for *The Century* in August 1896, but the majority of the artists who did posters for these magazines were either academic painters, like George Wharton Edwards, or book and magazine illustrators, such as Charles Dana Gibson or Hy Mayer.

Atlantic Monthly was slow to adopt the placard, particularly since it was the only magazine of its class without illustrations. Bruce Rogers designed an elegant typographic poster for the Fortieth Anniversary Issue in 1897, and illustrated posters were occasionally commissioned from artists such as R.L. Emerson, James Montgomery Flagg, or George Hallowell.

Other magazines frequently used posters for advertising. *The Bookman*, edited in New York by Harry Thurston Peck, commissioned placards from Louis Rhead, Scotson-Clark, and Howard Chandler Christy. *Outing*, a magazine of recreation, used a series of posters by Hy Watson and a group of lesser-known artists: Jean Carré, Higby, and O.C. Malcom. *Truth*, another New York magazine, drew on the talents of Hy Mayer and Ernest Haskell. The latter artist had some original ideas but was mainly a facile imitator of his contemporaries—Chéret, Mucha, Bradley, Parrish, and others.

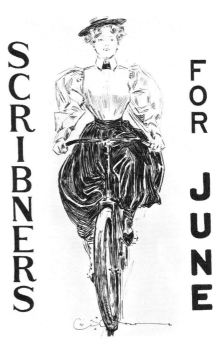

Charles Dana Gibson's *Scribner's* poster was simply an enlarged illustration with text added, 1896.

A poster for *The Bookman* by Howard Chandler Christy, 1899.

Harper's was the oldest of the genteel monthlies. Started in 1850 by the firm of Harper & Bros., the magazine was edited by Henry Mills Alden and built its reputation on the fiction of English authors for whose work the publishers could afford to pay huge advances. Wilkie Collins' *The Moonstone*, George Eliot's *Middlemarch*, and Dickens' *The Mystery of Edwin Drood* were all serialized in *Harper's*, which appealed to a wide audience on a cultural level slightly lower than that of its competitors. Other magazines published by Harper & Bros. included *Harper's Weekly*, *Harper's Bazar*, *Harper's Round Table* and *Harper's Young People*.

In 1870, J.C. Holland and Roswell Smith, a wealthy Western lawyer, started *Scribner's Monthly*, which was published by Charles Scribner's Sons. The magazine ceased publication when, ten years later, Smith bought out the publisher's interest and, with Holland, formed a company to publish a new magazine, *The Century*. It first appeared in 1881 with Richard Watson Gilder, poet and reformer, as the editor. The magazine was strong in serialized biographies and short fiction. Gilder also serialized a number of outstanding novels, among them William Dean Howells' *The Rise of Silas Lapham*, and Mark Twain's *Huckleberry Finn* and *Pudd'nhead Wilson*.

Like *Scribner's Monthly* before it, *The Century* was beautifully illustrated and printed by Theodore De Vinne, the finest printer of the day. The magazine boosted its circulation in the 1880s with its famous series of Civil War memoirs, followed less successfully by Nicolay and Hay's ponderous life of Lincoln.

The Century's serialized biography of Napoleon by Professor Sloane had an enormous following. Napoleon was much admired by the middle class, which strove so hard for self-improvement and success. Two posters by Grasset in 1894 and 1895 publicized the biography. The first, known as "The Wooly Horse," was so popular that Tiffany made a stained glass window from it. A trade journal noted somewhat jealously that "The overpraised Napoleon poster, by Grasset, has been talked of as something unattainable by American genius, yet the composition contains many obvious faults which few American designers of Grasset's class would care to father."

When Charles Scribner's Sons sold its interest in *Scribner's Monthly* to Roswell Smith, it agreed not to bring out another publication using the Scribner name for five years. At the end of the lustrum following *The Century's* publication, the firm launched *Scribner's Magazine* in 1886. A special selling point was its lower price of 25 cents. Editor Edward L. Burlingame, who gave less attention to public affairs and social causes than *The Century*, continued the Scribner policy of publishing American fiction but printed the work of many British authors as well. Robert Louis Stevenson contributed to the magazine as did Teddy Roosevelt.

Atlantic Monthly occupied a place by itself. Started in Boston in 1857

with James Russell Lowell as it first editor, it eschewed political and social controversy and continued to publish the writing of New England's literary Brahmins.

The best of the second-rung monthlies was *Lippincott's*, a Philadelphia-based magazine, started in 1868. It maintained a high literary level throughout its existence and was fairly widely circulated. In the late 1880s the editors decided to publish a complete novel in each issue. Among the books they selected were Rudyard Kipling's first novel, *The Light That Failed*, and Oscar Wilde's controversial *Picture of Dorian Gray*.

Although most of the important magazines of the 1890s emanated from the East Coast metropolises, there was also some publishing activity in the West. In 1868 the *Overland Monthly* first appeared in San Francisco under the editorship of Bret Harte, whose story "The Luck of Roaring Camp" brought fame to both author and magazine. After Harte left the *Overland Monthly*, publication was suspended for several years, but it became the most important magazine on the Pacific Coast after its reappearance in 1882. Posters for the publication were created by the Western artist, Lafayette Maynard Dixon.

The economic slump of the early 1890s put the more expensive magazines beyond the reach of thousands of subscribers, a factor which helped precipitate the revolution of the cheap monthlies such as *McClure's*, *Munsey's*, and *Cosmopolitan*. An important factor in this revolution was the advent of the halftone illustration, which was one-tenth the price of the fineline wood engravings used previously by the genteel monthlies. The cheap magazines depended on halftones entirely and even *The Century*, which built its reputation on the exquisite wood engravings of Timothy Cole and other artists, used them. Illustrated periodicals had a strong appeal for the public and both the halftone and the photograph helped increase the popularity of the cheaper magazines.

McClure's, the first of these lower-priced publications, was started in June 1893 by S.S. McClure, who already headed a successful newspaper syndicate. Initially the price was 15 cents, but when *Munsey's* and *Cosmopolitan* lowered their price to 10 cents an issue, *McClure's* quickly followed. The magazine relied on the poster for promotion but did not commission new ones as often as its more expensive competitors. Henry McCarter designed a placard which was used extensively. Posters were occasionally commissioned from other artists including Ethel Reed and J.C. Leyendecker.

The publishers of the cheaper monthlies had discovered a stratum of readers, less widely read, less intellectually ambitious, which the older magazines, with their lengthy biographies and elegant discourses on the fine arts, had not been able to reach. This new public, along with the thousands of would-be *Harper's* or *Century* readers who felt keenly the difference between 10 cents and 35 cents in a time of great financial stringency, made up the enormous audience for the cheap monthlies which enabled them to quickly surpass the circulations of their higher-priced predecessors.

Although the depression slowed the rate of increase for new publications considerably, *The Nation* nonetheless reported in the mid-90s that periodicals were being born "in numbers to make Malthus stare and gape."

The leading children's magazine of the 1890s was *St. Nicholas*, inaugurated by Charles Scribner's Sons in 1873. The magazine moved with Roswell Smith to the newly formed Century Company in 1880, but its format remained unchanged. Posters for *St. Nicholas* were often as delightful as its contents.

The magazine was amply illustrated, and flourished under the able edi-

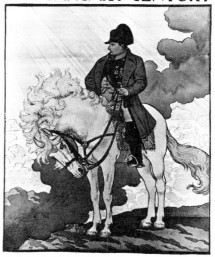

Eugène Grasset's popular "Wooly Horse" poster for the serialized *Century* biography of Napoleon, 1894.

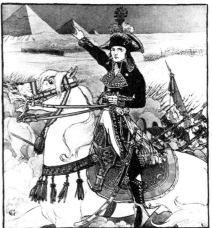

A second poster by Grasset for *The Century* biography of Napoleon, 1895.

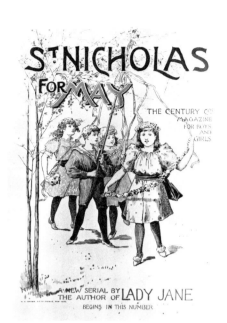

A *St. Nicholas* poster by Louis Rhead, c. 1891.

The cover of *The Chap-Book* was characterized by a simple type face and an uncluttered table of contents.

torship of Mary Mapes Dodge, who published the best juvenile fiction of the day. She once heard Rudyard Kipling telling a story of life in the Indian jungle and urged him to write it for publication. Though Kipling had never written for children, the result was *The Jungle Book*. *St. Nicholas* readers were delighted by the brownie drawings of Palmer Cox whose miniature society with its brownie policemen and brownie wheelmen was an amusing mirror of the adult world. Grown-ups as well as children enjoyed these tiny creatures, who also turned up in newspapers, advertisements, and books.

Puck, Judge, and *Life* were the great comic weeklies of the period. Some of the illustrators and cartoonists who worked for these magazines were also known for their book, magazine, and newspaper posters. Among the *Puck* artists who designed placards were Frank Nankivell and Hy Mayer, who was also *Puck's* editor at one time. There were also posters by *Life* illustrators Charles Dana Gibson, Oliver Herford, and E.W. Kemble, whose "Blackville" drawings portrayed the black man with benign condescension.

Puck, founded in 1877, was the oldest of the comic magazines. Its brilliant editor for many years was H.C. Bunner, a short-story writer and essayist whose important article on American posters first appeared in *Scribner's* in 1895 and then in the Scribner book, *The Modern Poster*.

Judge, which started publication in 1881, was modeled on *Puck* but lacked its vigor, even though the editors wooed some of the *Puck* artists away from their rival. For many years *Judge* had the strong backing of the Republican Party. The satirical drawings in both magazines were in the tradition of the German *Fliegende Blätter* and inspired the editorial cartoons that began to appear in the newspapers a few years later.

Life, founded and edited by J.A. Mitchell, appeared in 1883. Mitchell was a man of strong social concerns with Democratic leanings. His magazine, which began by caricaturing the manners and morals of the day, ended the century as the expression of the liberal social conscience, particularly in its opposition to the Spanish-American War. After 1889 Charles Dana Gibson's pen and ink satires of upper-class society appeared in *Life's* pages as did the "Gibson girl" and "Gibson man," those models of propriety who influenced the dress and behavior of thousands of middle-class men and women.

Little Magazines

A unique feature of magazine publishing in the 1890s was the appearance of the "little magazines." They surfaced for a few brief years and had mostly disappeared before the turn of the century. Attuned to the more offbeat literary trends in America and Europe, they appealed to a limited readership whose more individual tastes could not be satisfied by the mass publications. Whether the voice of a generation of writers, as was Stone & Kimball's *The Chap-Book*, or of a single individual, as was Elbert Hubbard's *The Philistine*, these pocket periodicals were the apotheosis of the personal style that became the hallmark of magazine journalism in the mauve decade.

The "little magazines" were described by Claude Fayette Bragdon as being "devouringly egocentric and self-assertive and either good-naturedly or bitterly critical of one another." Even their picturesque names—*The Fly Leaf, The Buzz Saw, The Lotus, The Red Letter*, and *The Wet Dog*—emphasized their distinctiveness.

If the "dinkey books," as they were called, did not pose a threat to the new monthlies such as *McClure's* and *Munsey's*, they were certainly little understood by these publications. *Munsey's*, in the summer of 1896, called

them "freak periodicals" and declared that "each new representative of the species is, if possible, more preposterous than the last." The Chap-Book, being the first of these journals, was the one that inspired many of the others. F.W. Faxon, who compiled a bibliography of "ephemeral bibelots" in 1905, listed 228 publications that he thought owed their origin to The Chap-Book's success. Some, like The Clack Book and The Chop Book were outright burlesques. Most, however, were serious journals whose editors seemed less concerned with making money than with merely keeping them alive.

The Chap-Book was started by two Harvard seniors, Herbert Stone and Ingalls Kimball, in May 1894. It appeared twice a month and was a bargain at 5 cents an issue. At first it was published in Cambridge but moved with the firm to Chicago in August 1894. The young publishers had initially intended The Chap-Book to be a promotional organ for the books of their publishing house, but the originality of its contents and the distinction of its format made it immediately popular among the cognoscenti. The editors soon broadened its scope to make it a vehicle for all the new literary and artistic movements of the day: the "symbolists" in France, the "decadents" and the Arts and Crafts Movement in England, and the new American writers like Stephen Crane, Hamlin Garland, and Bliss Carman. Stone solicited contributions not only from literators but also from newspapermen, several of whom—Eugene Field and George Ade—wrote for The Chicago Record, edited by his father.

The artistic standards of The Chap-Book were as high as the literary. Line drawings and woodcuts by John Sloan, E.B. Bird, Frank Hazenplug, Will Bradley, Claude Fayette Bragdon, and Félix Vallotton graced its pages. Caricatures by Max Beerbohm were also a feature.

Following the lead of the mass magazines, The Chap-Book's publishers began to use monthly posters to promote the new issues. They were more adventurous than their commercial counterparts and gave Will Bradley, then a young Chicago designer, a chance to experiment with a range of styles. The public was startled by the bold designs of the Chap-Book posters and competed in keen bidding for them. Other artists who did placards for the magazine included Frank Hazenplug, the staff artist for Stone & Kimball, Claude Fayette Bragdon, E.B. Bird, and J.C. Leyendecker. In 1896 Stone & Kimball commissioned a Chap-Book poster from Toulouse-Lautrec who gladly responded with a color lithograph, the "Irish-American Bar." There is no record that the poster was displayed in America, but it may have been used to promote the sale of The Chap-Book in Paris.

Just as The Chap-Book's small and simple format inspired numerous imitators, so were its promotion methods eagerly adopted by its rivals. Percival Pollard's The Echo used placards by Will Bradley, Frank Nankivell, John Sloan, and others. Sloan's talents were also enlisted by a small Philadelphia literary journal, Moods. E.B. Bird designed placards for The Red Letter and The Black Cat, while posters by Arthur Dow and Bruce Rogers publicized Modern Art, a journal dedicated to the Arts and Crafts ideals. Will Bradley did all the posters for his own short-lived publication, Bradley: His Book.

The most delightful "little magazine" of the 1890s was The Lark, published in San Francisco. Everything about it was fresh and unpretentious. The editors—Gelett Burgess, Bruce Porter, Ernest Peixotto, and Willis Polk—who used to meet at the Bohemian Club, cared little for the literary aspirations of The Chap-Book and its imitators. In May 1895 they published their first issue "just for a lark" and were surprised by the enthusiastic response of their readers. William Doxey, the bookseller, took over the publishing chores and kept the magazine going for two years. The Lark was dominated by the

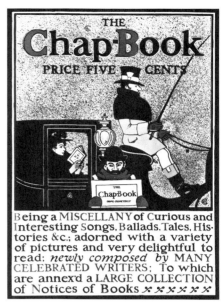

A poster for The Chap-Book by Claude Fayette Bragdon, 1896.

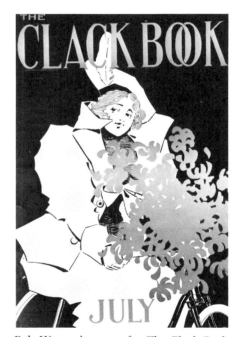

Rob Wagner's poster for The Clack Book, a burlesque of the little magazines of the 1890s.

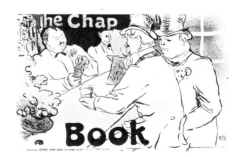

Toulouse-Lautrec's Chap-Book poster, designed in 1896, depicted the "Irish-American" bar in Paris.

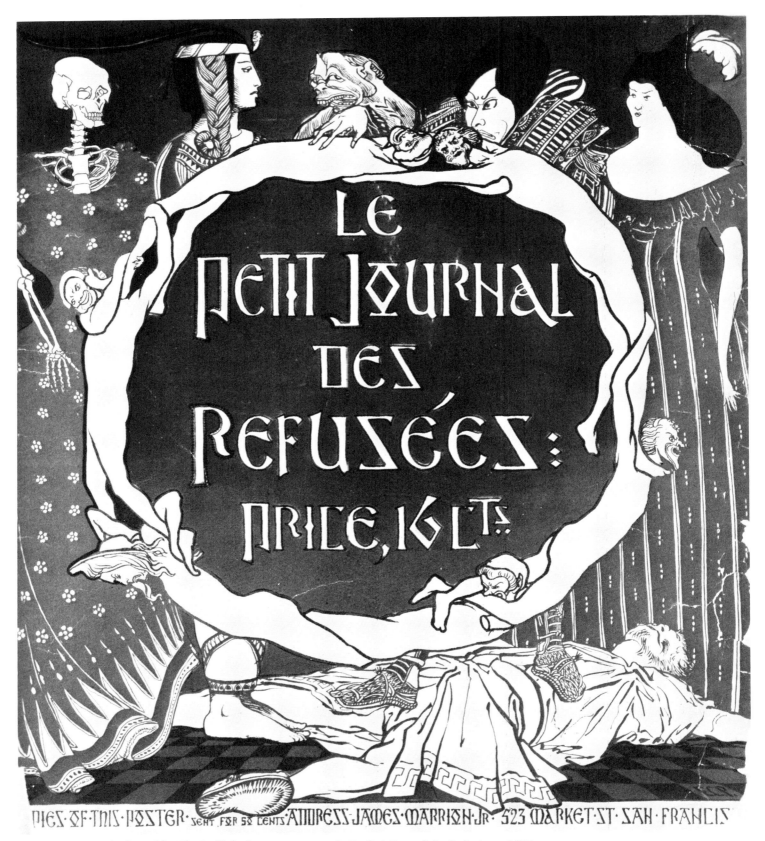

Ernest Peixotto's placard for *The Lark*'s little magazine parody, *Le Petit Journal des Refusées*, c. 1897.

whimsical drawings and doggerel of Gelett Burgess, whose famous "Purple Cow" ditty appeared in the first issue. The magazine's joycus spirit was epitomized by the charming woodcut posters of Florence Lundborg and Bruce Porter.

Before *The Lark* ceased publication, the editors issued an amusing parody of the "little magazines" entitled *Le Petit Journal des Refusées*, the name being a take-off on the French Salon des Refusés. The announcement proclaimed that it would be "the smallest and most extraordinary magazine in existence" and that it would be printed on black paper with yellow ink, a satire of the *Yellow Book* cover which was printed on yellow paper with black ink. Ernest Peixotto's poster for *Le Petit Journal des Refusées* was a biting parody of Beardsley's style.

In June 1895, just a month after *The Lark* appeared, Elbert Hubbard, a former soap salesman, began to publish *The Philistine* in East Aurora, New York. Hubbard was a frustrated novelist and essayist who had left a successful business career to pursue a life of letters. He used his magazine to tilt at his foes: the editors and publishers who had turned down his books, the critics, the colleges, and doctors, lawyers, and preachers.

Will Denslow, who had begun his career as a poster designer in Chicago and later created the original illustrations for *The Wizard of Oz*, was hired in 1896. For *The Philistine* he created a series of posters illustrating the publisher's simplistic slogans.

Hubbard's diatribes were laced with vitriolic personal attacks such as the following:

"The dear American public has gagged at last on the blood-boltered gospel of Ruddy Kipling. After much raw meat it is expiating its gluttony by a horrible attack of indigestion. . ."

Stone & Kimball thought that Hubbard's style had "a delicacy of touch as of a hippopotamus on a tightrope." Hubbard retorted by advertising back issues of *The Chap-Book* at two for a penny.

Yet it seemed that Hubbard's blustering prose spoke for many Americans. *The Philistine* had the longest life of any "little magazine" and, before its demise in 1915, was reaching almost a quarter of a million readers.

Books

The large commercial book publishers used posters more extensively in the 1890s. Some placards, which featured enlarged illustrations from the books they advertised, differed little from the French book posters of the 1830s and 1840s. Others were specially commissioned, often from the same artists whose magazine and newspaper posters could already be seen in shop windows and on hoardings. Publishers like Harper & Bros., Scribner's Sons, and The Century Co. had begun using artistic posters to advertise their magazines and continued the same practice to promote their books. Among the artists who designed book placards for the commercial publishers were Edward Penfield, A.B. Lincoln, Robert Chambers, E.B. Wells, Blanche McManus, and H.M. Lawrence.

The major publishing event of the 1890s was the passing of the 1891 International Copyright Act. This legislation was a decided stimulus to American authors. Since publishers could no longer reprint British fiction without paying a decent royalty, prices for American manuscripts now competed favorably with those from abroad. New fiction titles increased every year. In 1895 Harry Thurston Peck, the editor of *The Bookman*, first conceived the

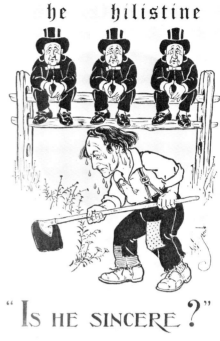

Will Denslow's posters for *The Philistine* illustrated Elbert Hubbard's homilies.

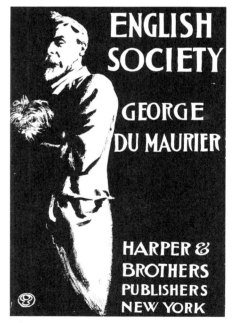

Edward Penfield's book placard for George du Maurier's *English Society*, 1897.

idea of a "best-seller" list, based on periodic reports from representative bookstores around the country.

The most popular novels of the day whisked readers away to exotic locales where they could enjoy the thrills of romance and adventure. Anthony Hope Hawkins' *The Prisoner of Zenda* (1894) was a cloak-and-sword account of a handsome Englishman caught up in an intrigue against the King of Ruritania. Henryk Sienkiewicz's *Quo Vadis* was a best-seller in 1896. Readers were moved to tears by the suffering of the early Christians in Rome and pleasantly titillated by the decadent society of Nero's reign. Charles Major's novel *When Knighthood Was in Flower* (1899) went back to the reign of Henry VIII, using the tempestuous Mary Tudor as its heroine.

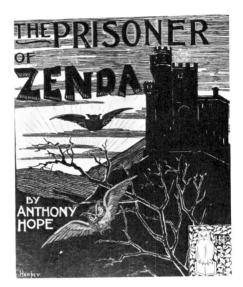

Will Hooper's poster for *The Prisoner of Zenda*, an 1894 best-seller that intrigued readers with its sense of mystery and adventure.

Not all authors were attracted by the comforting glow of the sentimental novel. The realists wanted to portray life as it was. Henry James and William Dean Howells were intrigued by the manners and morals of the New England social Brahmins. The hardships of rural life were depicted by Hamlin Garland in *Main-Traveled Roads* (1891), while young Stephen Crane drew a grim picture of slum degeneracy in *Maggie, A Girl of the Streets* (1892) and described the stark reality of the Civil War in *The Red Badge of Courage* (1895).

According to the contradictions of Victorian morality, truthfulness in fiction was often considered to be of questionable moral value. Realistic novelists like Zola were taken seriously in Paris but in America a "French book" was synonymous with decadence. When multimillionaire John Crerar bequeathed two and a half million dollars for the founding of a free public library in Chicago, he explicitly stated that "dirty French novels" be excluded from the collection. Victorian moralists were also disturbed by Oscar Wilde, whose *Picture of Dorian Gray* reached thousands of readers through *Lippincott's*. The President of Princeton University told undergraduates that Wilde was the vilest sinner since Nero.

An interest in fine printing and the passing of the International Copyright Act, which also acted to protect the American publisher of foreign books, prompted a number of enterprising young men to start publishing firms in the 1890s. These men were dedicated to producing books of high literary quality in a tasteful format. Chicago and Boston were the centers of "literary" publishing and the leading firms were Stone & Kimball and Copeland & Day.

A decorated page by Bertram Goodhue from Daniel Berkeley Updike's *Altar Book*, a volume which exemplified the Kelmscott style in America.

The interest of these publishers in producing books of quality was shared by a small group of designers, printers, and typographers who were inspired by the Arts and Crafts Movement, particularly the ideas of William Morris.

The Kelmscott Press was founded in England by Morris in 1891 to revive the art of fine printing he admired in the books of earlier centuries. Comments in the American press brought wide attention to the Kelmscott books and encouraged men like Will Bradley, Bertram Goodhue, Daniel Berkeley Updike, Theodore De Vinne, Bruce Rogers, and Frederick Goudy to follow Morris' example.

However, there was more interest in his dedication to craftsmanship than in the heavy medieval appearance of his books. With some exceptions, American designers preferred simpler types, wide margins, and little ornamentation, although decorative borders were sometimes used to surround uncluttered pages of type.

The Kelmscott style reached a large audience through a series of small books published by Thomas Bird Mosher, "a poor man's William Morris," and also through the publications of Elbert Hubbard, printed at his Roycroft

Shop in East Aurora, New York, and distributed through far-reaching mail-order channels.

It is no coincidence that the literary publishers, with their interest in fine printing, were also important patrons of the poster renaissance. Lamson, Wolffe & Co. and Copeland & Day gave Ethel Reed most of her poster commissions. Other artists who did posters for these firms were Louis Rhead, John Sloan, E.B. Bird, Blanche McManus, Maxfield Parrish, and Thomas Meteyard.

Stone & Kimball gave Will Bradley his first commissions for book and magazine posters. Other placards for Stone & Kimball books were designed by Frank Hazenplug, Henry McCarter, and John Twachtman, the Impressionist painter who created the poster for the firm's sole best-seller, *The Damnation of Theron Ware*.

Stone & Kimball was founded in 1893 while Herbert Stone and Ingalls Kimball were still Harvard undergraduates. Both were from prominent families and could draw on sufficient money and connections to begin their venture. In May 1894 *The Chap-Book* appeared, and in August of that year the company moved to Chicago.

During the next two years Stone & Kimball published books by the leading writers of America and Europe: Hamlin Garland, Eugene Field, Robert Louis Stevenson, Paul Verlaine, and William Butler Yeats. The books were rarely printed in editions of more than 500 copies. In spite of the publishers' idealism and one best-seller, difficult financial straits forced Stone & Kimball out of business in 1896. The firm left a legacy of 114 titles which were later much sought after by collectors.

Another Chicago literary publisher, Way & Williams, started in 1895. Will Bradley, whose studio was on the floor above their offices in the Caxton Building, described W. Irving Way as a man "who would barter his last shirt for a first edition, his last pair of shoes for a volume from the Kelmscott Press of William Morris." Way's partner, Chauncey Williams, put a large sum of money into the company which issued well over 50 handsome books before it ceased operation in 1898.

In Boston, Copeland & Day and Lamson, Wolffe & Co. were the important literary firms. Herbert Copeland who, with his partner Frederick Holland Day, founded Copeland & Day in 1893, was part of the literary circle of Harvard undergraduates that included Herbert Stone, Ingalls Kimball, and W.B. Wolffe. Day, somewhat older, came from a wealthy family and had the means to pursue his literary and artistic interests. At first Copeland & Day distributed the English books of Elkin Mathews and John Lane, including *The Yellow Book*, but they soon built a list of American authors. They were particularly interested in the first books of young writers and published considerable volumes of verse as well as foreign translations.

Lamson, Wolffe & Co. began in 1895 while W.B. Wolffe was still at Harvard. Between the founding date and 1899, when the firm folded, some 70 titles appeared.

The small literary publishers were all out of business by the end of the decade. Though each had at least one wealthy family behind it, their limited capital and lack of commercial drive made survival impossible. They had been willing and eager to publish unknown American writers in whose sensibilities the commercial houses were uninterested, and through their good graces many foreign authors found their way into the mainstream of American letters.

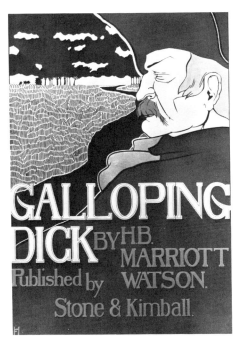

A book poster by Frank Hazenplug for Stone & Kimball, 1896.

Newspapers

The phenomenal growth of the newspaper in the late 19th century necessitated new means of promotion. As newspapers became big business, publishers were more and more concerned with increasing their circulation and profits. In the big cities, the poster became a handy vehicle for advertising the daily and Sunday editions.

George Frederick Scotson-Clark's poster for the Sunday *New York Recorder* of January 6, 1895, was said to be the first placard to advertise an American newspaper. As a rule, the newspaper posters were cheaply printed, often by the newspaper's own presses, on their own poor-quality stock. The publishers, lacking the taste of a Herbert Stone or Roswell Smith, seemed to care little about the posters' appearance. The designs were usually mediocre—a figure set above or next to a large block of text—but notable exceptions included placards by Ethel Reed and Edmund Garrett for *The Boston Sunday Herald*, Alice Glenny for *Buffalo Courier*, de Jonghe for *The New York Times*, and Claude Fayette Bragdon for *The Rochester Post Express*.

Louis Rhead created a group of handsome posters for *The New York Sun*. His striking designs complimented the good taste of editor Charles Dana, who considered journalism an art and saw no reason why the news column couldn't be as well written as a piece of literature.

But the character of the metropolitan newspaper was influenced by the rapid pace and high tension of city life. Most editors had to resort to sensationalism to capture the attention of a preoccupied public. William Randolph Hearst and Joseph Pulitzer greatly expanded the circulations of their respective papers, *The New York Journal* and *The New York World*, by outdoing each other with their lurid reporting. Hearst even lured away Pulitzer's entire Sunday staff with a promise of larger salaries. The rivalry reached its culmination in the coverage of the Spanish-American War, which their jingoistic propaganda had had a large part in creating. The public fervor for war, whipped up by bold headlines, reporting of Spanish atrocities, and fierce editorials, overcame President McKinley's unwillingness to intervene in Cuba. Never before had the press gained such a powerful influence over the policies of government.

The New York World first demonstrated the possibilities of the Sunday edition. No other paper could equal its circulation or number of pages. Those which came closest were *The Boston Herald, The Boston Globe, The Chicago Tribune, The Philadelphia Item*, and two other New York papers, the *Sun* and the *Herald*. The large size of these papers, their wide coverage, their photographs and four-color illustrations, and their voluminous advertising made them the wonders of their day. "American journalism," commented an English observer, "has reached its highest development in the Sunday newspaper. There is no parallel to it in England or any other country."

Besides the Sunday editions, other innovations changed the complexion of the newspaper in the 1890s. There had been a steady increase in pictures, mainly line cuts of drawings made from chalk plates or zincographs. With the advent of halftone printing, it was possible to use photographs, just in time for the papers to bolster their melodramatic coverage of the Spanish-American War.

Political cartoons had appeared in newspapers for many years, but they came into more widespread use in the 1890s, particularly in the Sunday editions. The effectiveness of the cartoon had already been demonstrated in the 1870s when Thomas Nast's acerbic drawings in *Harper's Weekly* helped oust Boss Tweed and cause the downfall of Tammany Hall. Homer Davenport,

Bold headlines in *The New York Journal* and other papers typified the sensational journalism of the 1890s.

Homer Davenport's cartoon for the presidential campaign of 1896 shows Mark Hanna as the power behind McKinley.

whom Hearst had hired away from the *World*, made his reputation during the presidential campaign of 1896 with his satirical characterizations of Mark Hanna as the cigar-smoking money man and McKinley as his puppet.

The first continuing use of comic characters in a newspaper was in the form of single drawings rather than panel strips. As an occasional feature in *The New York World*, Richard F. Outcault had begun a page-wide drawing called "Hogan's Alley" that caricatured the city's tenement life. For the Sunday supplement, one of the printers suggested making the long robe of the central character bright yellow. Thereafter the name of the weekly drawing was changed to "The Yellow Kid." When Hearst lured the *World*'s Sunday staff to the *Journal*, Outcault joined them and continued his drawings for Hearst's paper. The "Yellow Kid" was omnipresent in New York, particularly on the posters plastered throughout the city. His yellow garment inspired the term "yellow press," which became synonymous with the sensational journalism practiced by the *World* and the *Journal*.

The discrepancy between the morbid contents of *The New York Journal* and the blithe posters used to advertise it led one critic to question: "How there can exist in Mr. Hearst's mind the willingness to pander to such debased tastes as crave views of intoxicated monkeys and poisonous underwear, together with the recognition of the best art of such men as Eddy and Nankivell is, I admit, one of the seven wonders of Gotham."

Edward Penfield's placard for the Stearns bicycle, c. 1896.

Commerce and Exhibitions

Once the publishers had proven the commercial worth of the artistic poster, manufacturers were eager to associate designs of the best artists with their products. Long content with nondescript lithographs, they now sought posters in the new graphic styles from Bradley, Penfield, Rhead, and other artists. Percival Pollard thought that "the beautifying influence this [poster] movement has had, and continues to have, upon the art of advertising in America, is a palpable and delightful thing."

The most consistent commercial patrons of the artistic poster were the bicycle manufacturers. Cycling, or "wheeling," had been popular in America since the end of the Civil War, but not until the advent of the "safety" bicycle in the late 1890s did the sport gain widespread popularity. As a jour-

A poster by Moores for a popular book of cycling adventures, c. 1896 (left).

Will Bradley's "Narcoticure" poster was a milestone in patent medicine advertising, 1895.

nalist wrote in *Scribner's*: "There is a psychic and moral void in city life which the 'bike' goes farther toward filling than any other single institution."

For women the bicycle played an emancipating role. Mrs. Reginald de Koven wrote in *Cosmopolitan* in 1895: "To men, rich and poor, the bicycle is an unmixed blessing; but to women it is deliverance, revolution, salvation. It is well nigh impossible to overestimate . . . its influence on dress and social reform." Yet some moralists objected to women on wheels. Elbert Hubbard's *The Philistine* reported that 30 percent of the "fallen women" who came to the Women's Rescue League of Boston for help had been "bicycle riders at one time."

Books on cycling were widely read, as were the special bicycle issues of the mass magazines such as *Harper's Weekly*, *Life*, and *Godey's Magazine*. The leading journal for cyclists was *Bicycling World*; others included the *Wheelman's Gazette* and *Bearings*, which was publicized by the colorful posters of Charles Cox.

Though Edward Penfield was preoccupied with placards for Harper & Bros., he occasionally portrayed one of his expressionless figures astride a Stearns, Orient, or Northampton cycle. Will Bradley's posters for the Overman Wheel Co. to advertise the Victor and Victoria bicycles were cluttered with Kelmscott ornamentation but were, nevertheless, a tribute to the progressive taste of the company.

Other manufacturers who used advertising posters were the makers of patent medicines which were peddled by "doctors" and "medicine men" via road shows. Concoctions promised cures for everything from frigidity to the smoking habit. An assemblage of local people would gather to see the show and buy the snake oil or rubbing linament it promoted. Unsold bottles were left behind at the crossroads store or market and were advertised by posters tacked or hung in the window. Hood's Sarsaparilla was a favorite home remedy promoted by the medicine showmen. The placards they put up on their arrival would often draw the entire populace of a town to try for a prize and buy a bottle.

Will Bradley adapted his style to the more commercial needs of the patent medicine firms. His placard for "Narcoticure," which revolutionized patent medicine advertising, and one for Hood's Sarsaparilla were more illustrative than his book and magazine posters and used bolder lettering.

Through his interest in printing and the publication of *Bradley: His Book*, Bradley found a welcome reception in the printing industry for his artistic style. He created a colorful poster for the Whiting Paper Co. and a series of magazine advertisements for the Ault & Wiborg Co., makers of lithographic inks. The advertisements, some of which may have been used as posters, ran past the turn of the century and mirrored the decline of the Art Nouveau style, particularly in Bradley's case. Toulouse-Lautrec designed a poster, "Au Concert," for Ault & Wiborg, the only other poster besides his *Chap-Book* placard commissioned from the French artist by an American patron.

Other artistic posters were created by Maxfield Parrish, John Sloan, and Louis Rhead to promote a gamut of products from coal and bicycles to washing compound, perfume, and cameras.

Special placards were sometimes designed for art exhibitions, including poster shows. Posters by Alice Glenny, George Wharton Edwards, and Charles Woodbury were in the conservative tradition of the Academy, while those of Bertram Goodhue, Arthur Dow, and Maxfield Parrish reflected the influences of the Arts and Crafts Movement, the Japanese print, and Art Nouveau.

Three Ault & Wiborg advertisements which reflect Will Bradley's transition from Art Nouveau to a more illustrative style.

Epilog

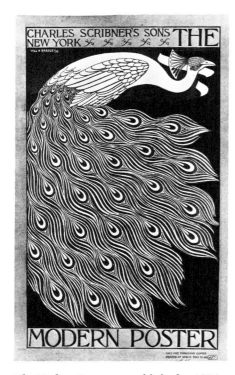

The Modern Poster was published in 1895 in a limited edition with signed and numbered posters by Will Bradley.

The innovation and experimentation that characterized the best posters of the 1890s was due in large part to the fact that many of the designers were young men and women with no commitment to the academic traditions that preceded them. The most dedicated of the young poster artists were interested in developing their own styles and had the good fortune to begin their careers at a time when so many opportunities existed for trying out new ideas and techniques. Most of the artists were still in their twenties when the poster movement reached its peak. J.C. Leyendecker was 22 when he won the *Century* poster contest in 1896 and Ethel Reed was only 19 when booksellers first began to display her placards.

By the end of the decade the interest in poster collecting had waned. The literary book and magazine publishers who had been responsible for so many elegant posters were out of business and the commercial publishers tended to favor a more realistic style. Though artists produced noteworthy posters after the turn of the century, there was no longer the sense of an artistic movement that one felt in the 1890s. Edward Penfield, Will Bradley, and Louis Rhead continued as commercial illustrators but designed few posters. Maxfield Parrish's dreamy paintings hung in homes throughout America and J.C. Leyendecker became a popular advertising illustrator and magazine cover artist. Some of the poster designers of the 1890s, particularly Ethel Reed, Frank Hazenplug, and J.J. Gould, were no longer heard from.

The American poster renaissance was brief but its effect on the visual arts was permanent. The poster in the 1890s was the chief medium through which Americans were introduced to the new European graphic styles, particularly Art Nouveau and the post-impressionist lithographic experiments. The enthusiasm for the artistic poster may also be seen as an early phase of the loosening of academic ties that culminated in the total freedom of the 1913 Armory Show.

Mass Magazines

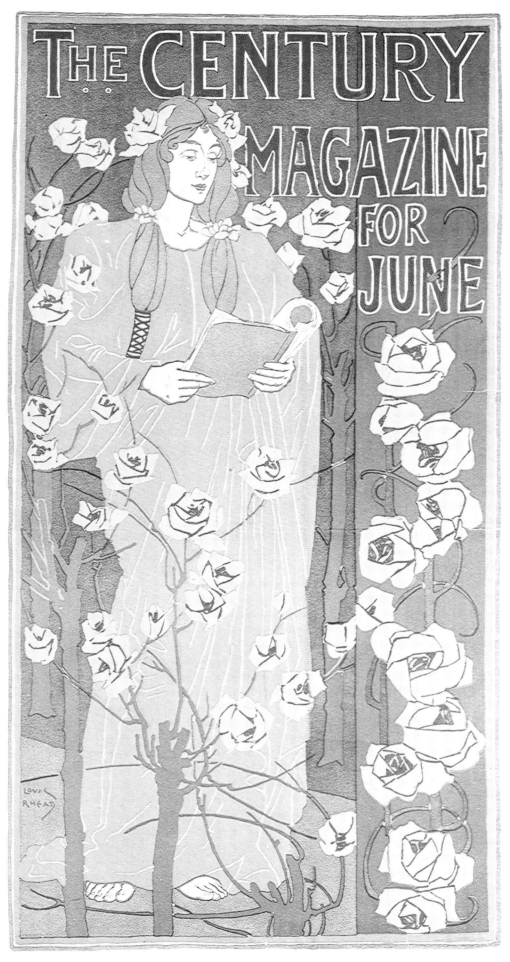

Louis Rhead, *The Century*, 1896.

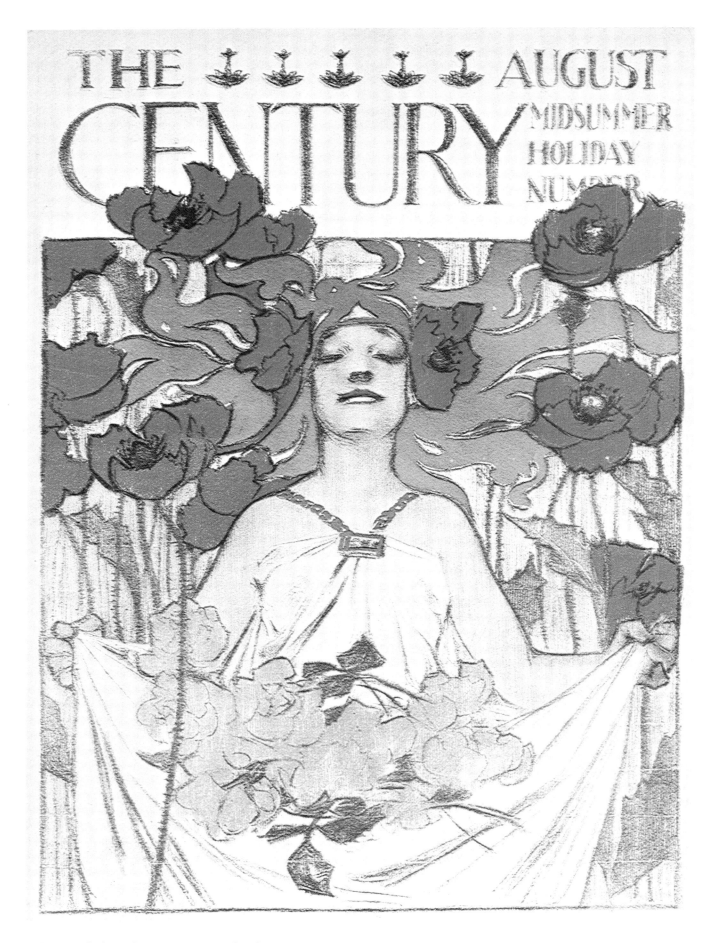

J.C. Leyendecker, *The Century*, 1896. This design won first prize in the magazine's midsummer poster contest.

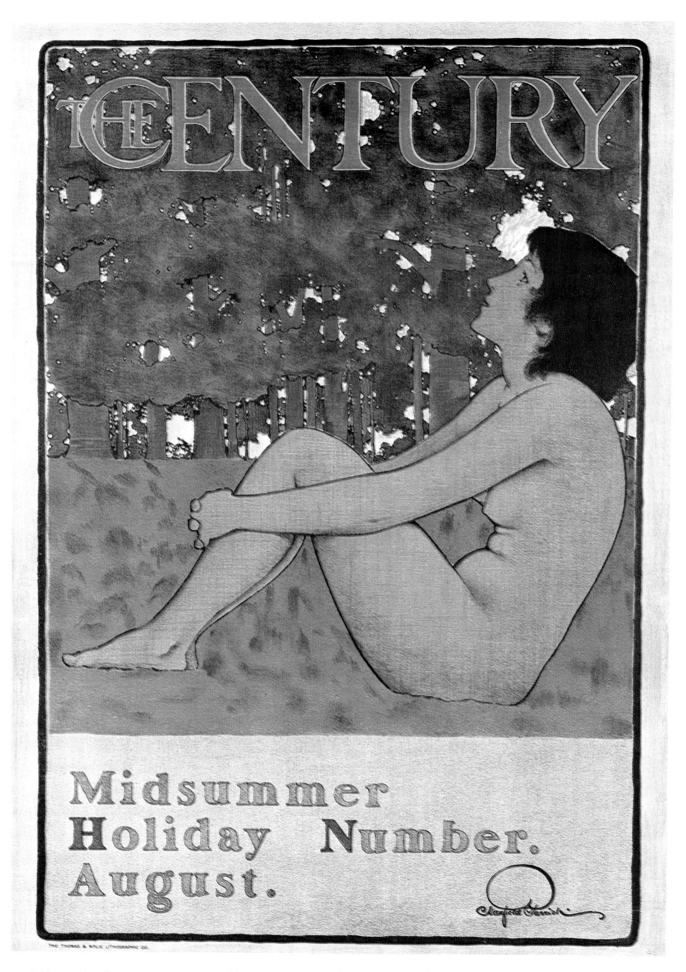

Maxfield Parrish, *The Century*, 1896. Parrish's poster won second prize in the midsummer poster contest.

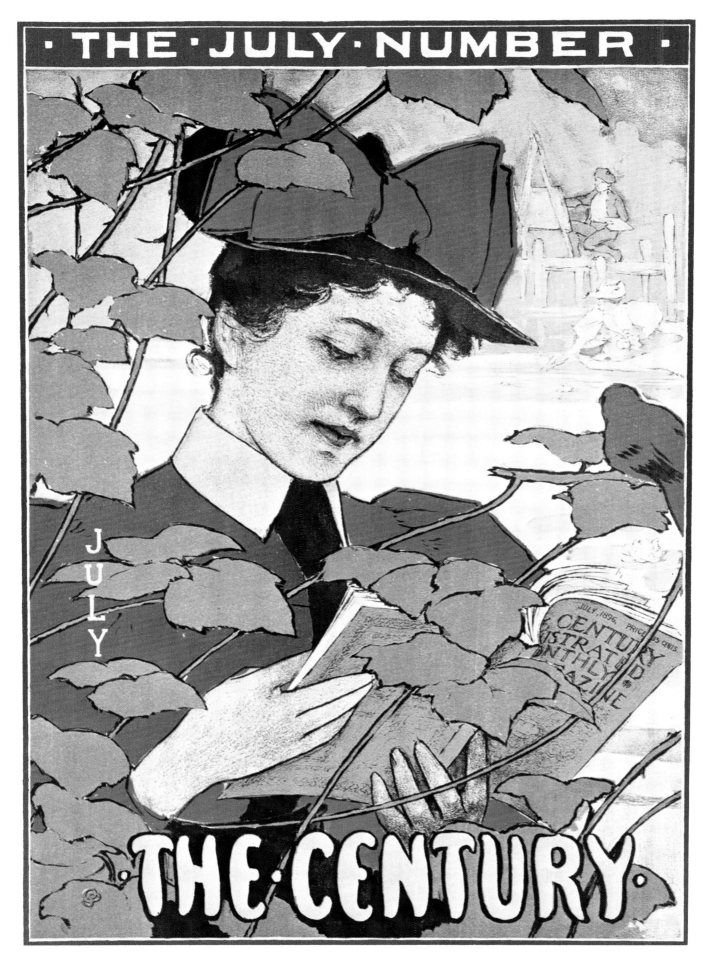

Edward Potthast, *The Century*, 1896. This poster received an honorable mention in the midsummer contest.

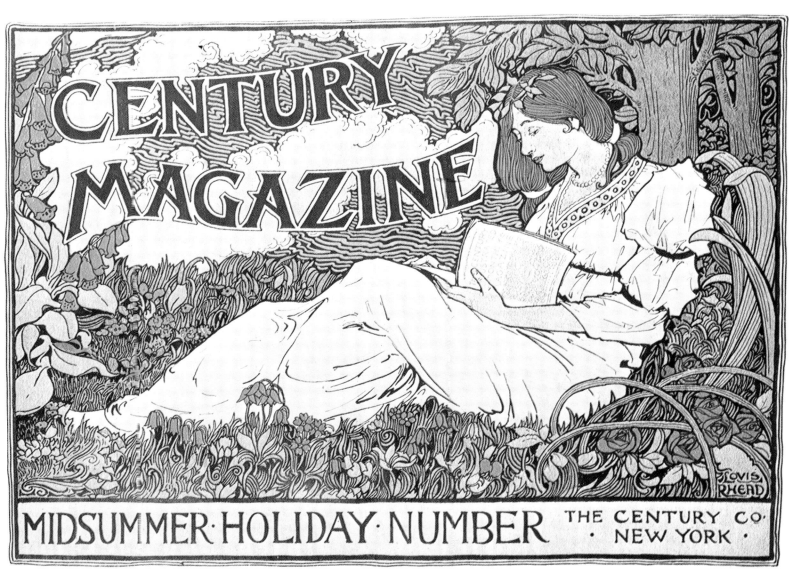

Louis Rhead, *Century Magazine*, 1894.

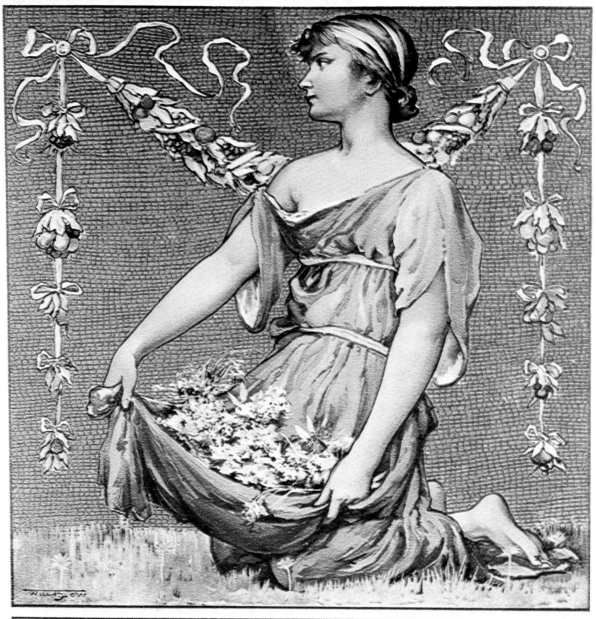

Will Low, *Scribner's*, c. 1895.

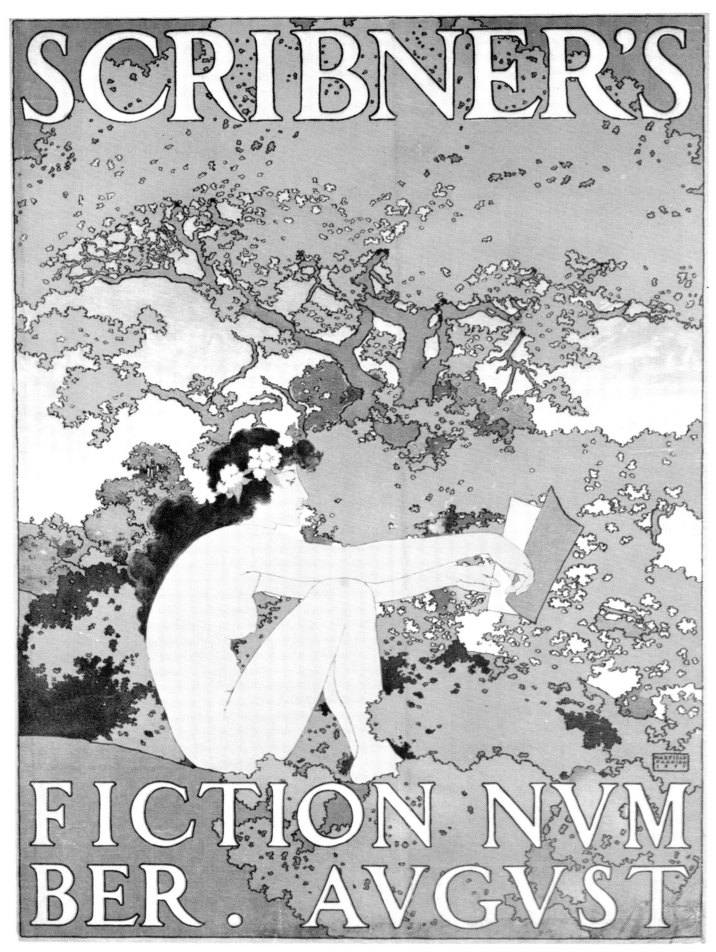

Maxfield Parrish, *Scribner's*, 1897.

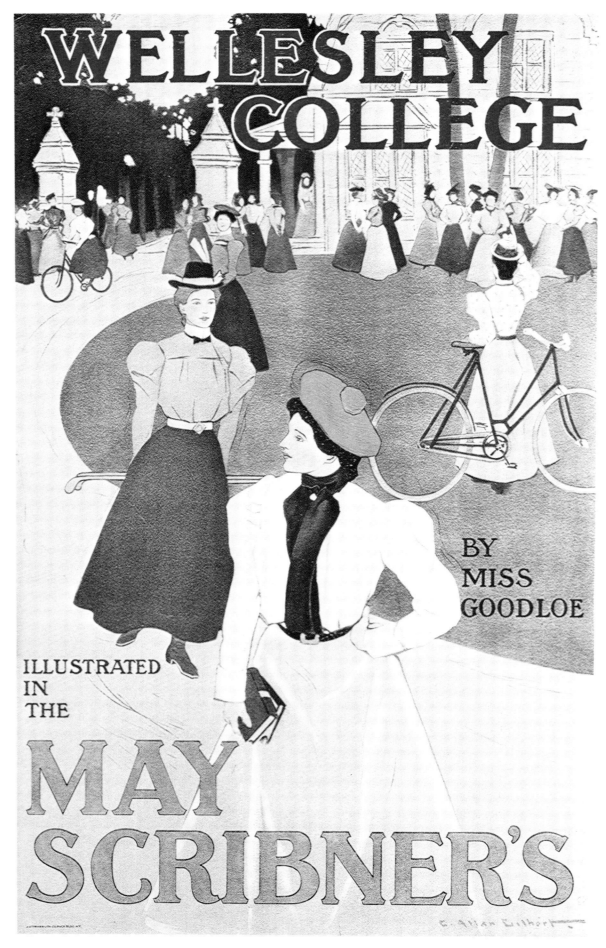

C. Allan Gilbert, *Scribner's*, 1898.

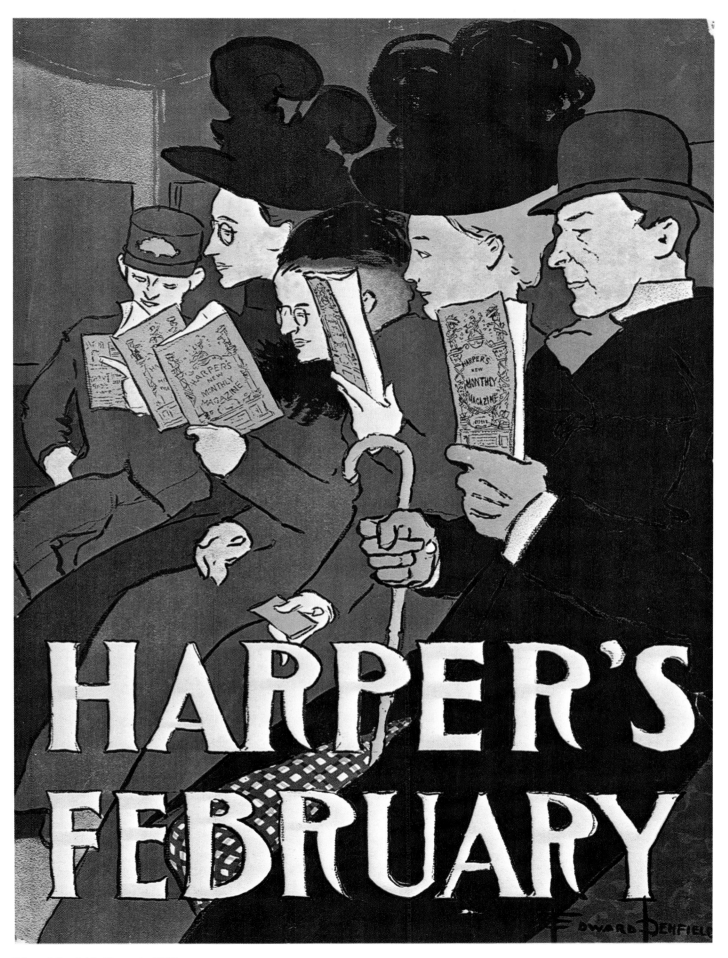

Edward Penfield, *Harper's*, 1897.

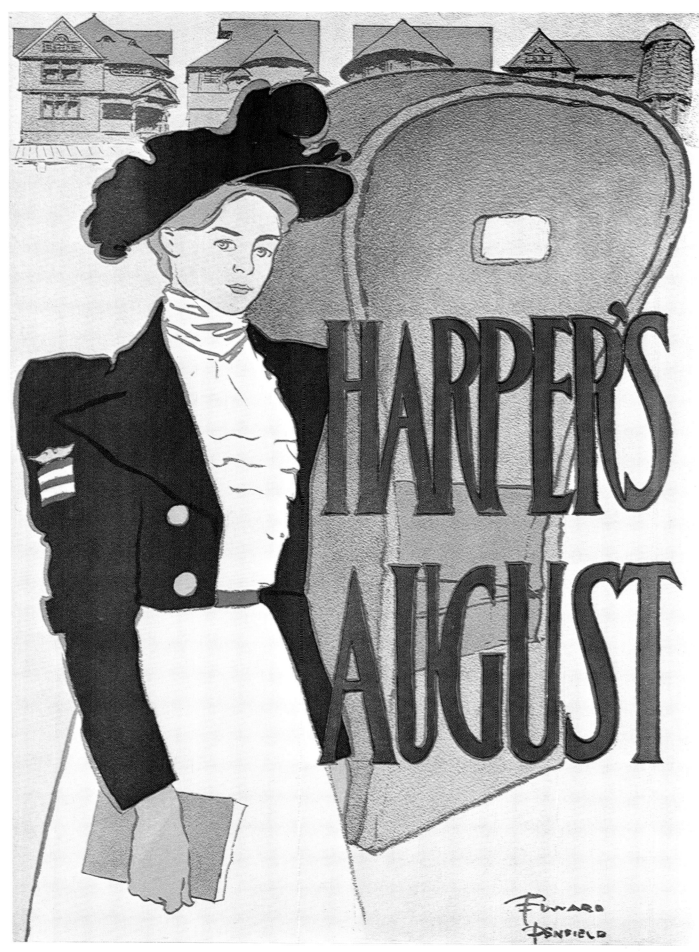

Edward Penfield, *Harper's*, 1897.

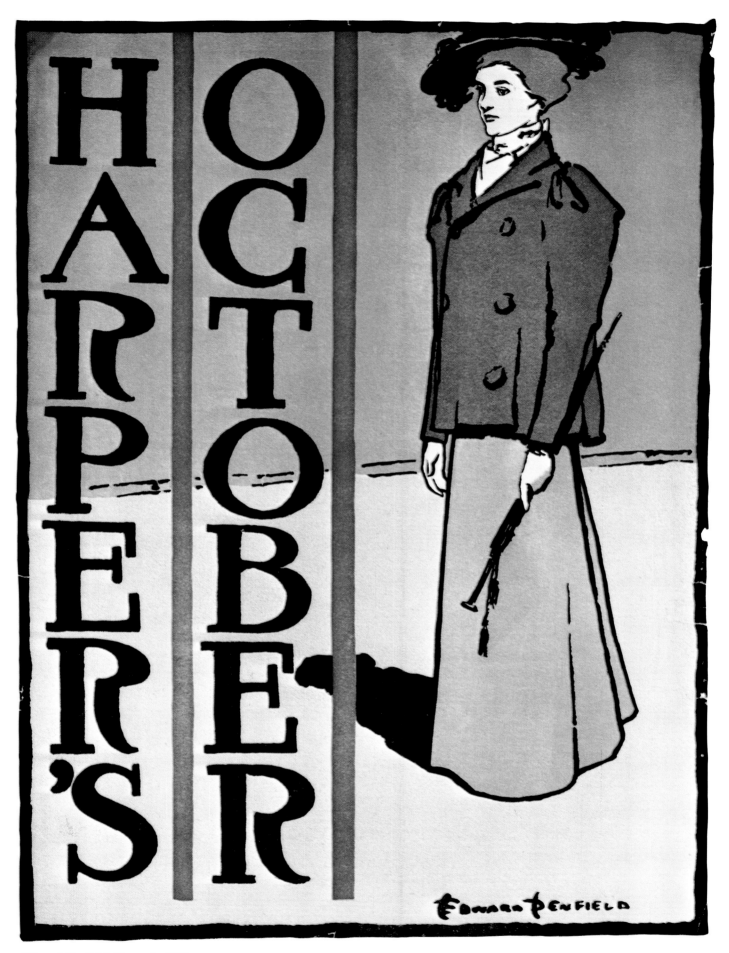

Edward Penfield, *Harper's*, 1897.

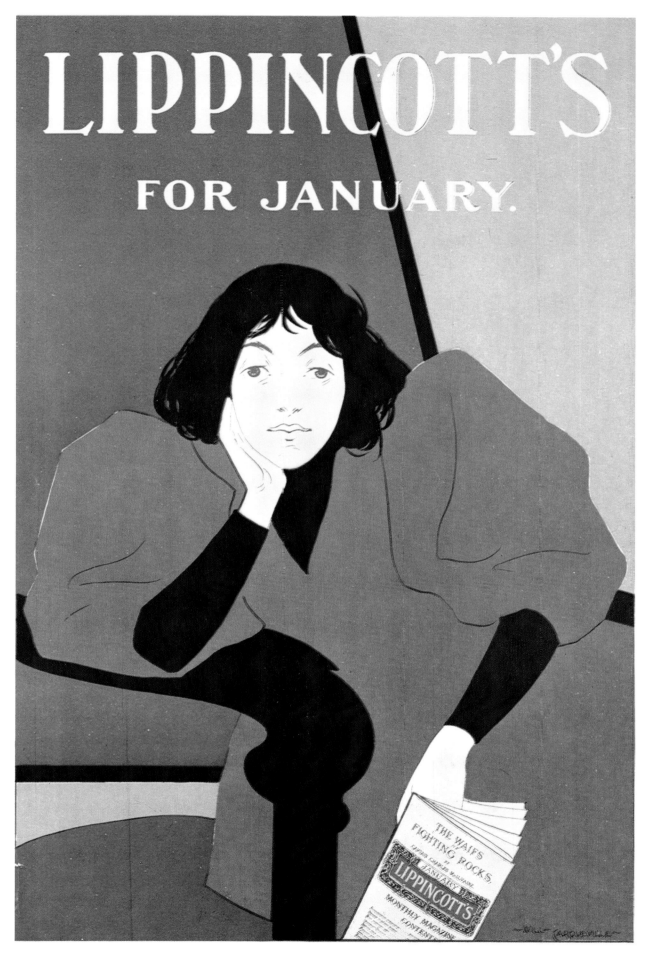

Will Carqueville, *Lippincott's*, 1895.

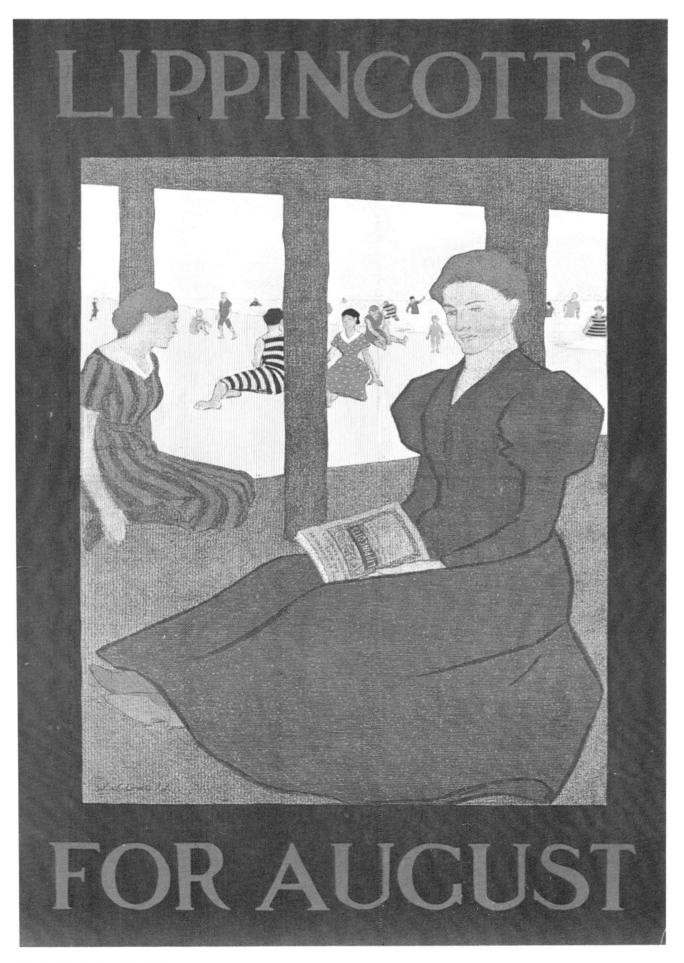

J.J. Gould. *Lippincott's*, 1897.

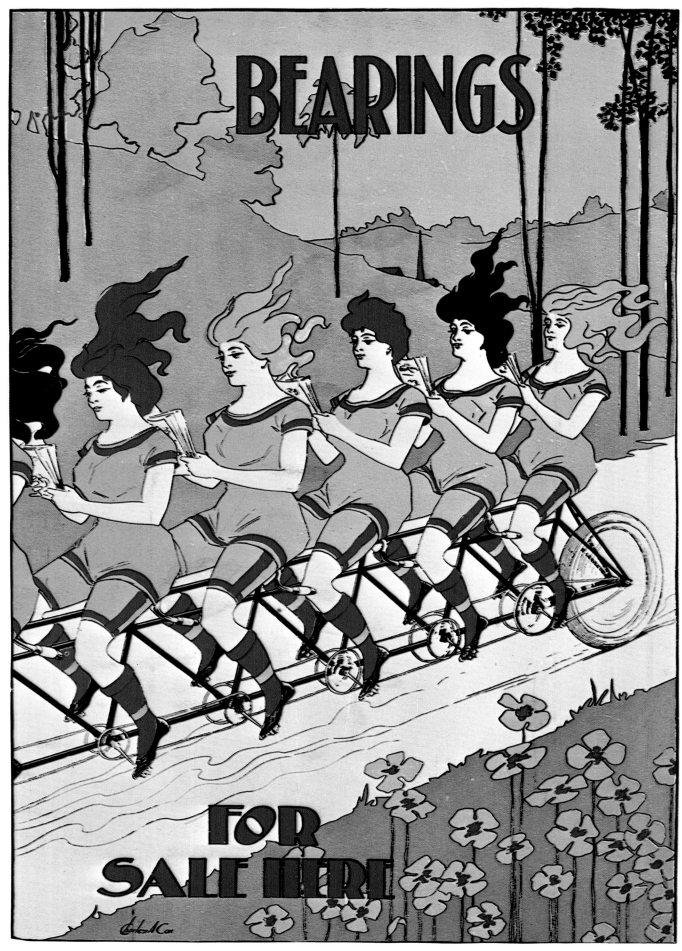

Charles Cox, *Bearings*, c. 1896.

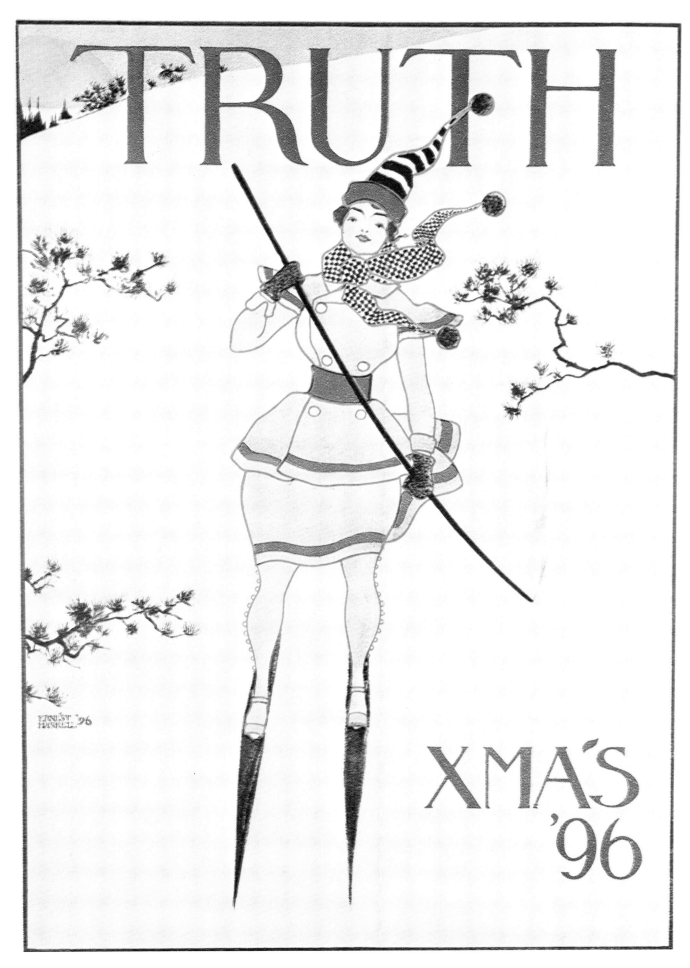

Ernest Haskell, *Truth*, 1896.

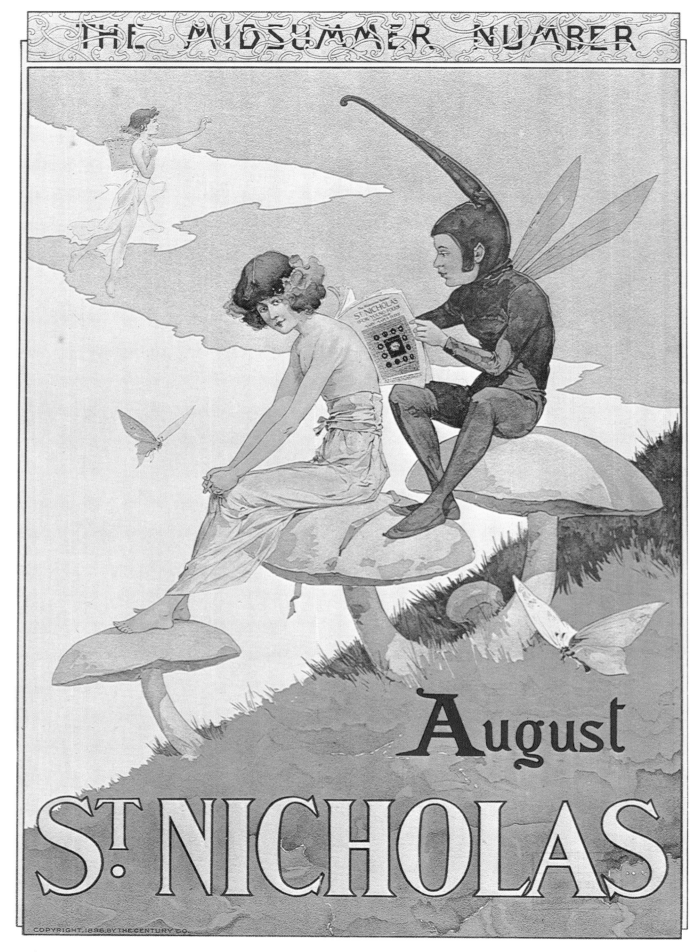

Theo Hampe, *St. Nicholas*, 1896.

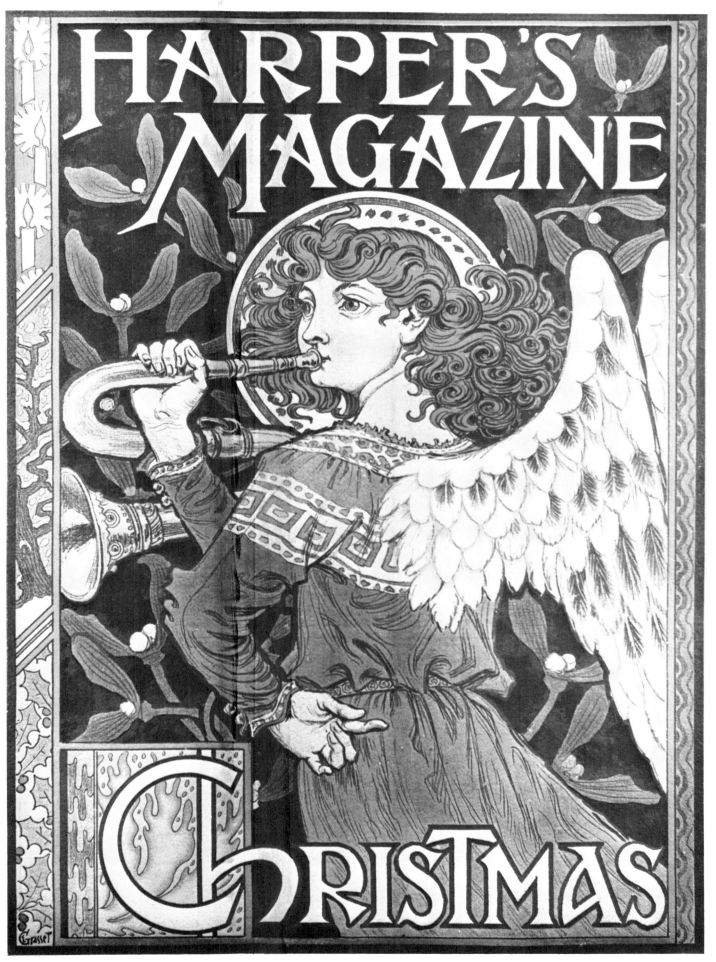

Eugène Grasset, *Harper's*, c. 1892.

Edward Penfield, *Harper's*, 1895. This poster exemplified Penfield's use of fluid brush line. The design is enigmatic: the magazine appears to be floating on a body of water and it is difficult to imagine what the rope, which the woman clutches, is connected to.

Edward Penfield, *Harper's*, 1896. Penfield and Steinlen had a love of cats in common.

Edward Penfield, *Harper's*, 1896. The stippling effects were created directly on the zinc printing plates.

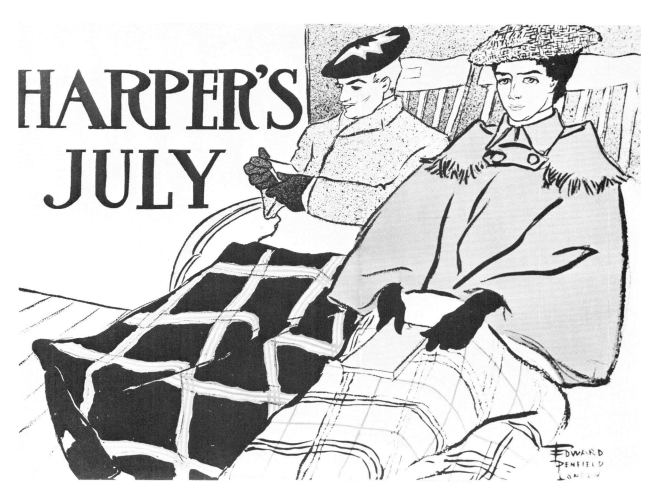

Edward Penfield, *Harper's* posters, 1897.

Harvey Ellis, *Harper's*, 1898.

W.S. Vanderbilt Allen, *Harper's Weekly*, c. 1895.

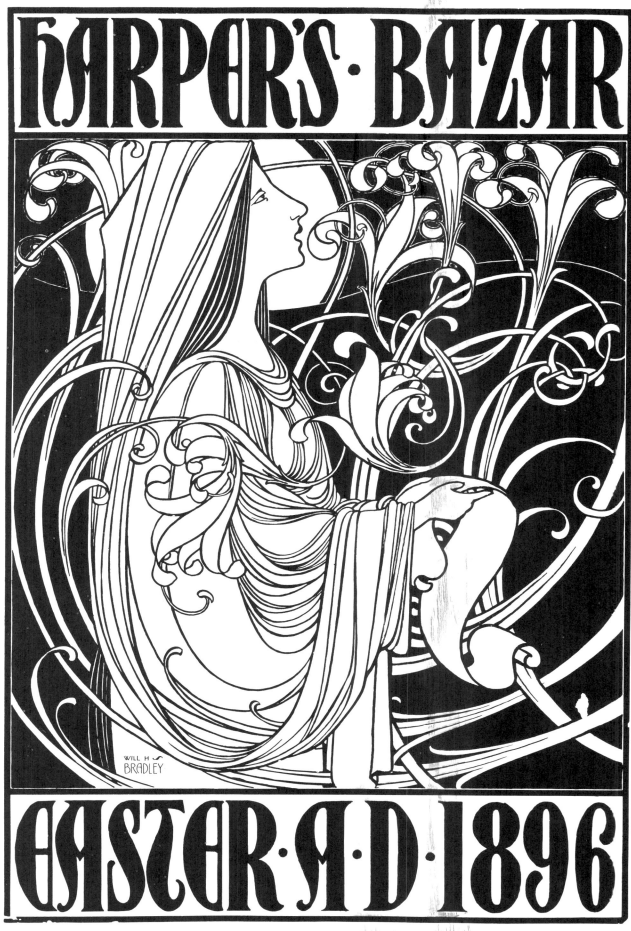

Will Bradley, *Harper's Bazar*, 1896. This design was a rare example of the Art Nouveau style on a mass magazine poster.

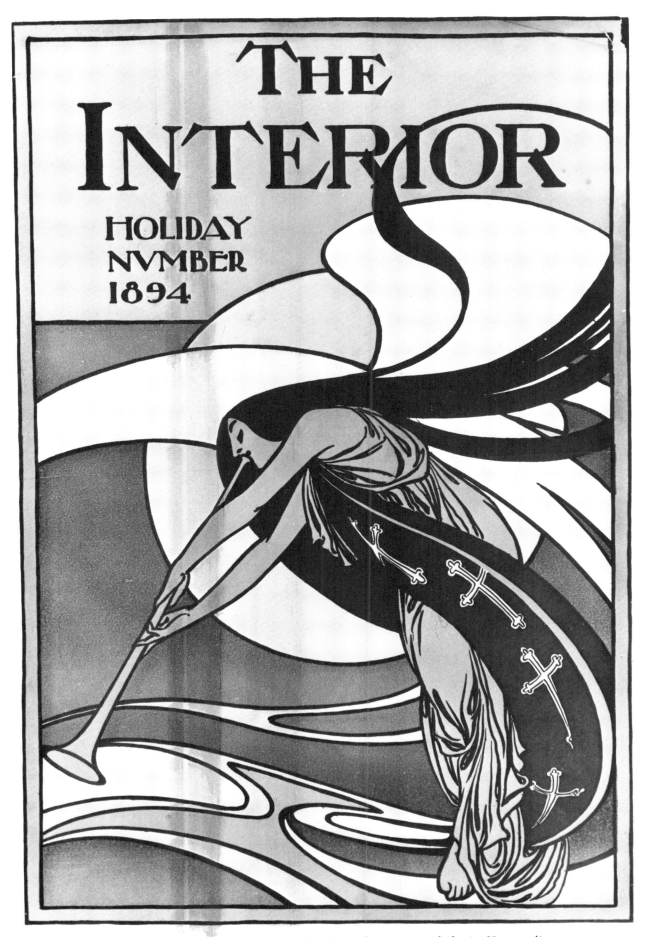

J.C. Leyendecker, *The Interior*, 1894. An early design which shows fascination with the Art Nouveau line.
This was a passing interest; later designs were less stylized and relied on modeling in depth.

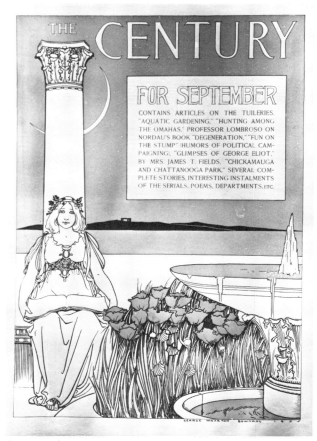

Charles Woodbury.

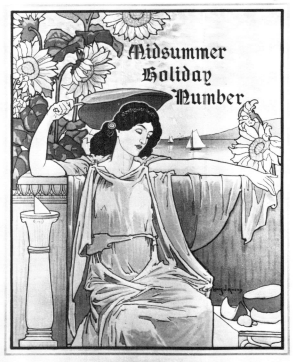

Louis Rhead.

George Wharton Edwards.

H.M. Lawrence.

Four *Century* posters from 1895. The *Century* designs tended to be conservative and done in an illustrative style.

H.M. Rosenberg, *The Century*, 1896. Rosenberg's poster won an honorable mention in *Century's* midsummer poster contest.

A *McClure's* placard by Ethel Reed, c. 1895.

THE CHRISTMAS SCRIBNER'S

Poem by Rud~
yard Kipling ✻

Six illustrated
stories by Joel
Chandler Harris
Henry van Dyke
and others ✻ ✻

Poem by James
Whitcomb Riley

The Workers by
Walter A. Wyckoff

The Art Features
include Christmas
frontispiece by A.
B. Frost ✻ 8 pages
in colors by A.B.
Wenzell ✻ 21 Re~
productions of Sir
E.J.Poynter's work

Special Christmas
Cover in 9 colors
by Maxfield Parrish

Maxfield Parrish, *Scribner's*, c. 1900.

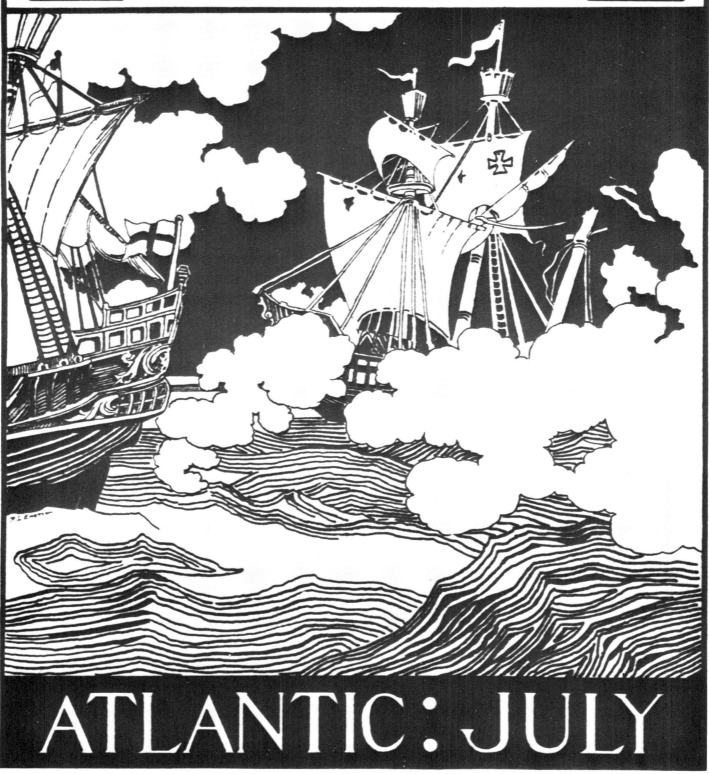

THE ELIZABETHAN
SEA KINGS
BY JOHN FISKE

ATLANTIC : JULY

R.L. Emerson, *Atlantic Monthly*, 1895.

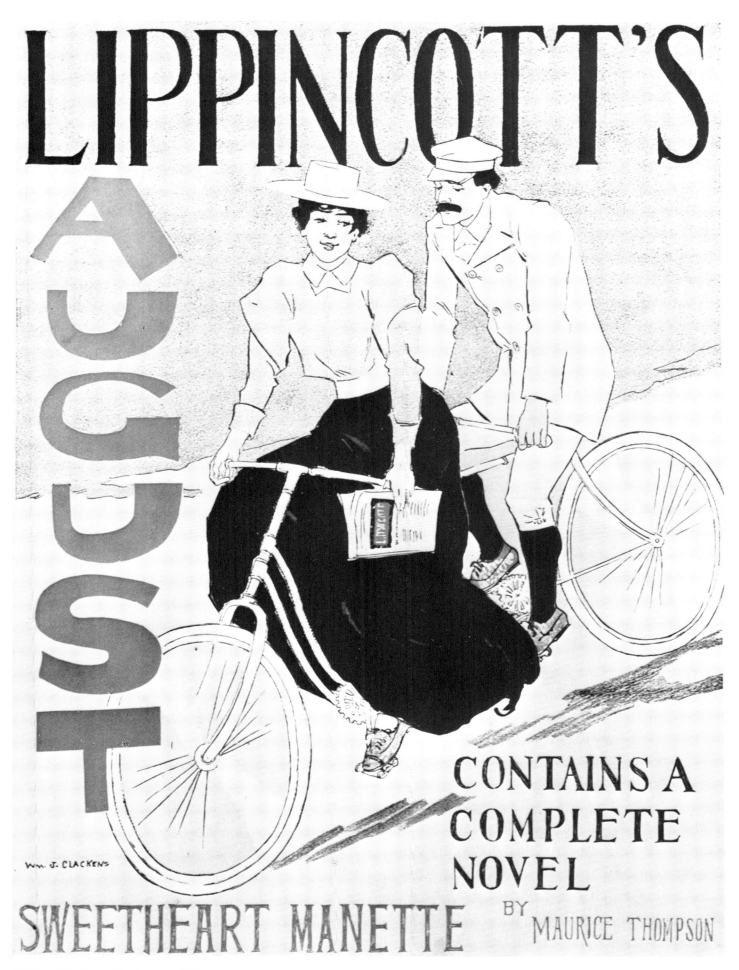

William Glackens, *Lippincott's*, 1894.

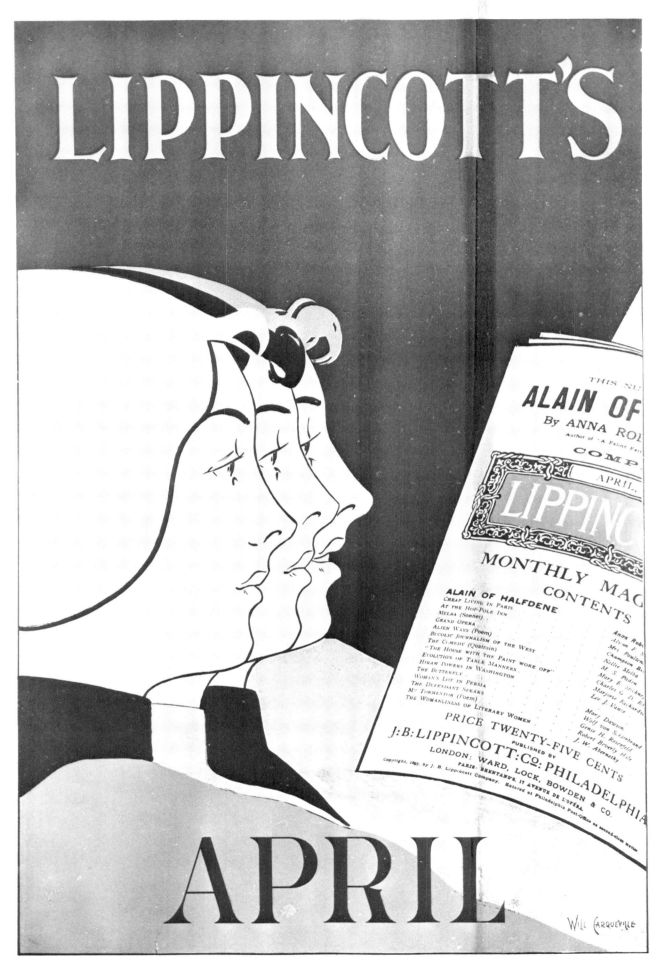

Will Carqueville, *Lippincott's*, 1895.

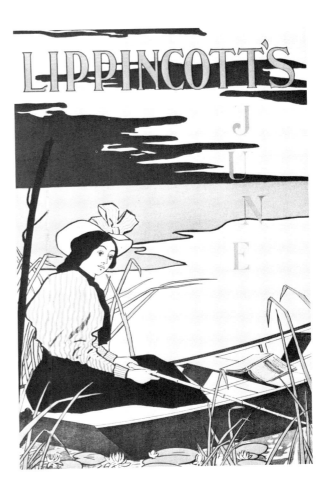

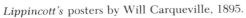
Lippincott's posters by Will Carqueville, 1895.

J.J. Gould, *Lippincott's*, 1897.

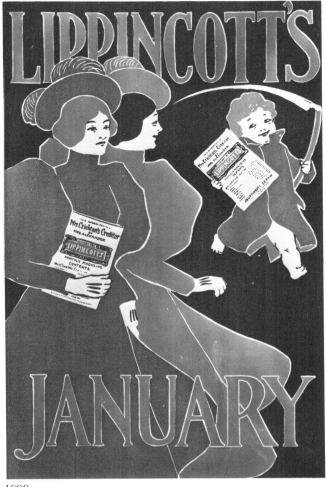

1896

1896

1896

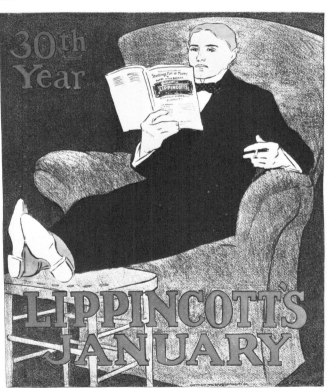

1897

Lippincott's posters by J.J. Gould.

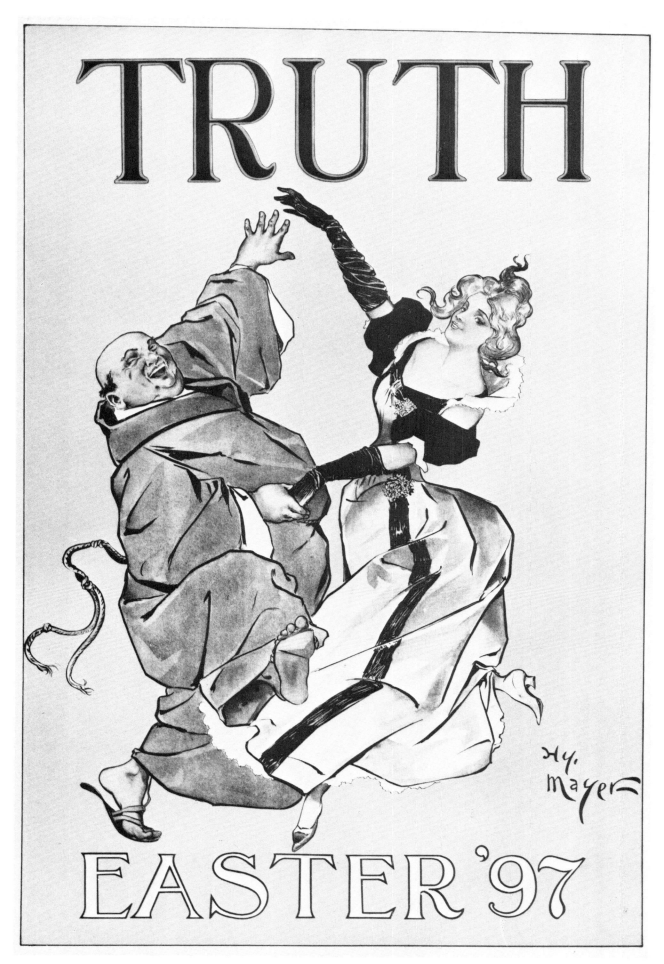

Hy Mayer, *Truth*, 1897. The buoyancy of Mayer's droll design derives directly from Chéret.

Ernest Haskell, *Truth*, 1896. Haskell was a facile imitator of contemporary styles; in this case, Chéret.

Chéret's poster for *Folies-Bergère*.

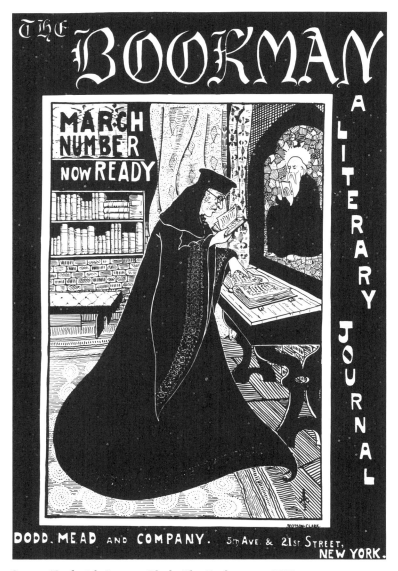

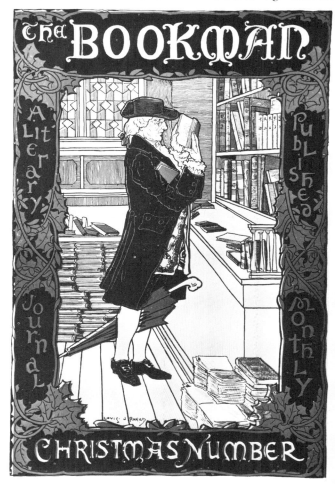

George Frederick Scotson-Clark, *The Bookman*, c. 1896.

Louis Rhead, *The Bookman*, c. 1895.

Howard Chandler Christy, *The Bookman*, 1896.

M.E. Norton, *The Bookman*, c. 1895 (above left and right).

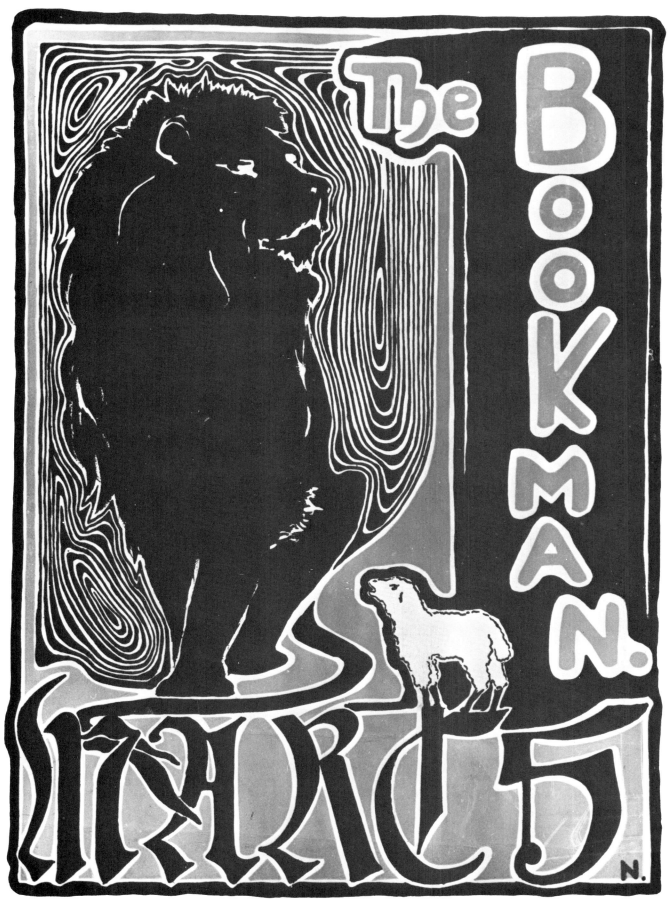

M.E. Norton, *The Bookman*, c. 1895.

Lafayette Maynard Dixon, *Overland Monthly*, c. 1894.

O.C. Malcom, *Outing*, c. 1896.

Jean Carré, *Outing* , 1896.

Higby, *Outing*, 1897.

Hy S. Watson, *Outing*, c. 1895.

Martin Justice, *Woman's Home Companion*, c. 1897.

Frederick Richardson, *International*, c. 1896.

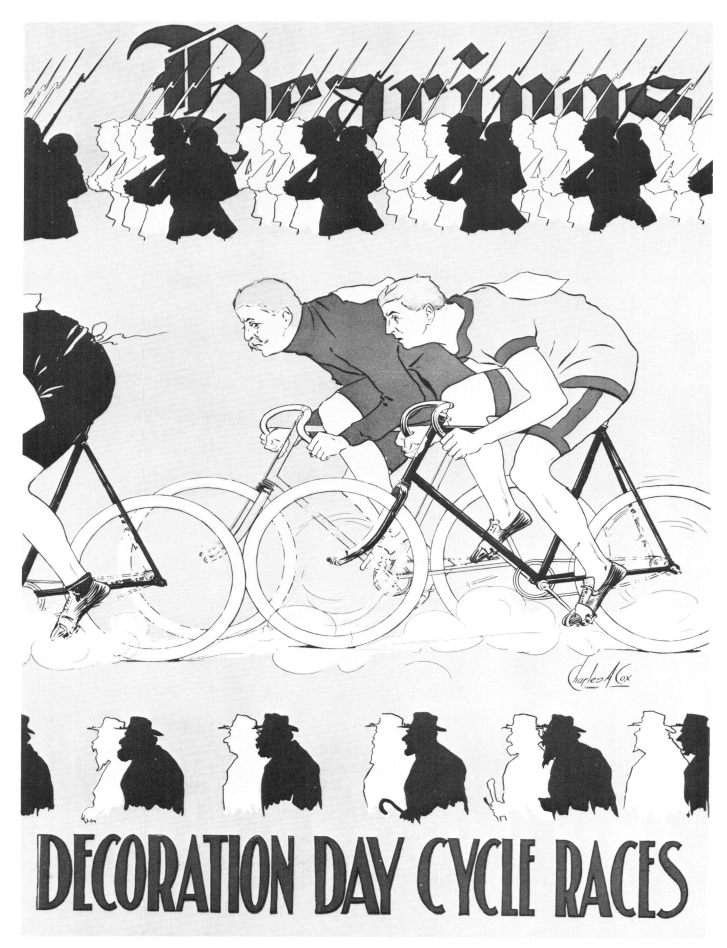

Charles Cox, *Bearings*, c. 1895.

Little Magazines

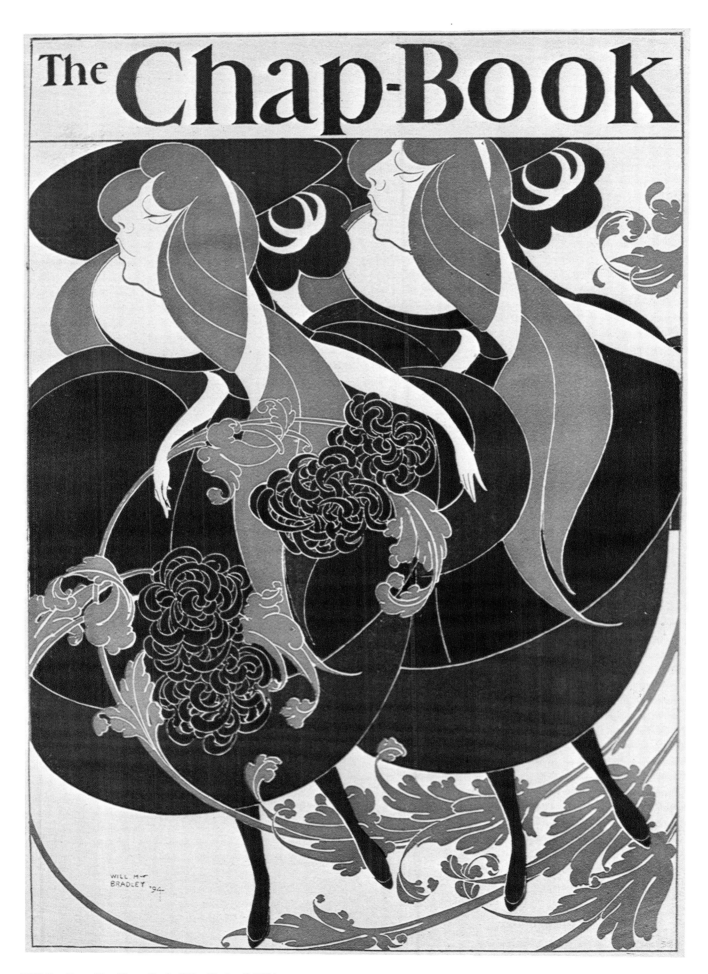

Will Bradley, *The Chap-Book*, "The Twins," 1894.

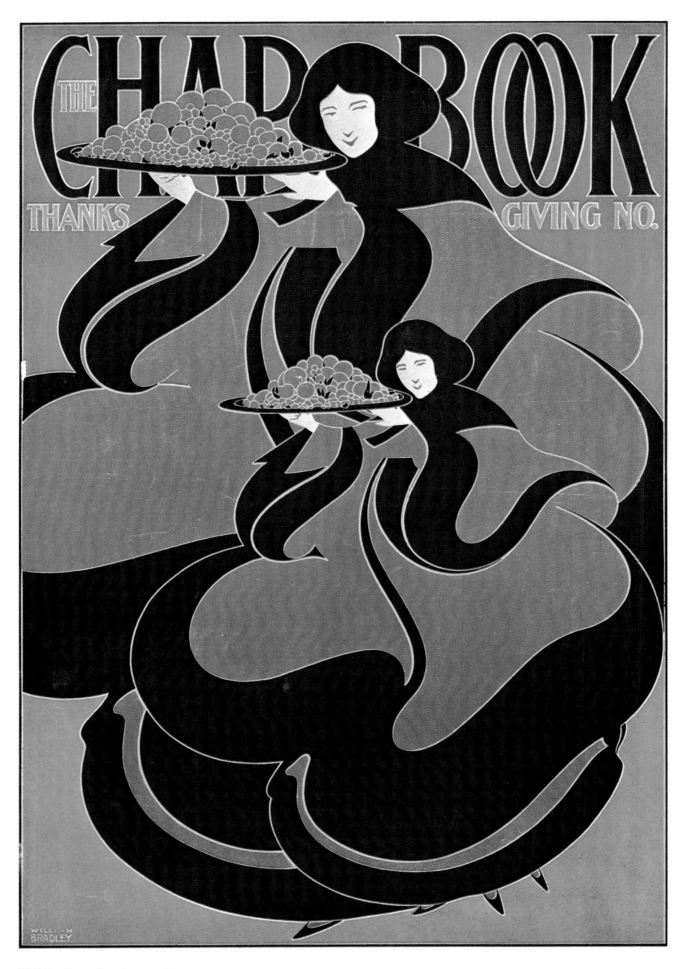

Will Bradley, *The Chap-Book*, 1895.

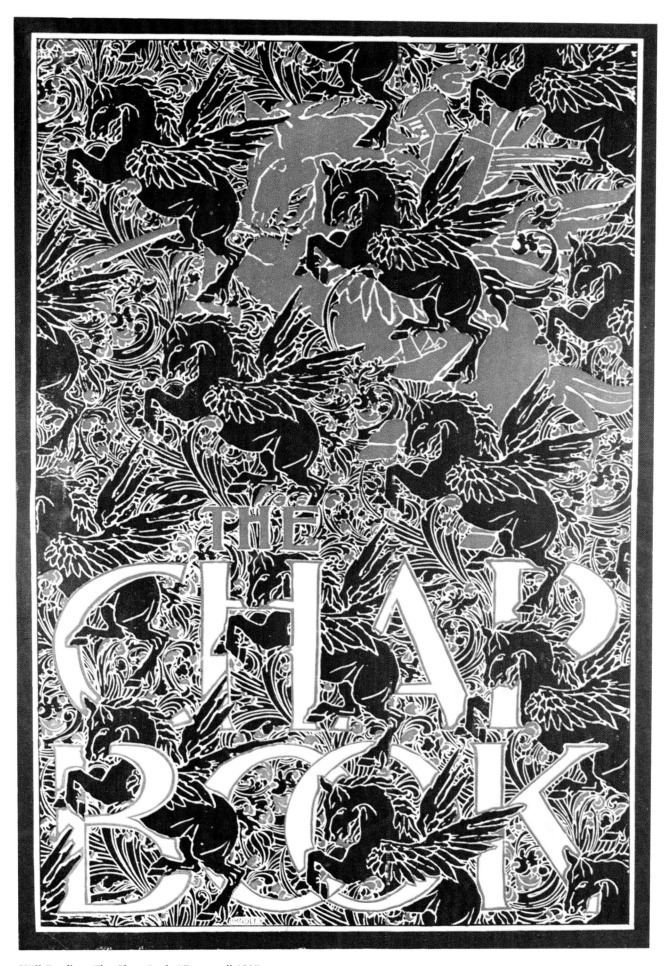

Will Bradley, *The Chap-Book*, "Pegasus," 1895.

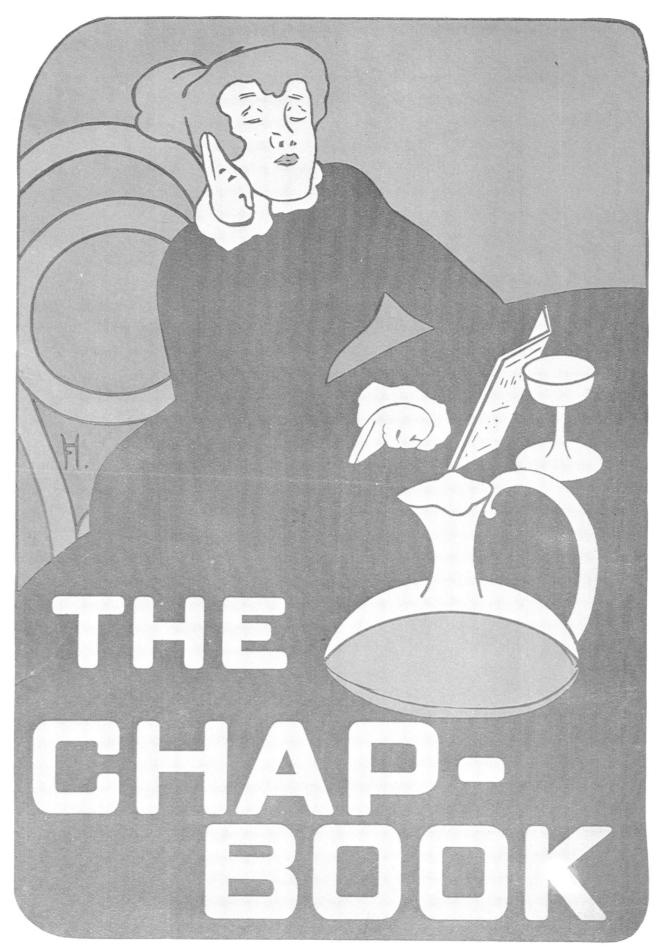

Frank Hazenplug, *The Chap-Book*, "The Green Lady," 1896.

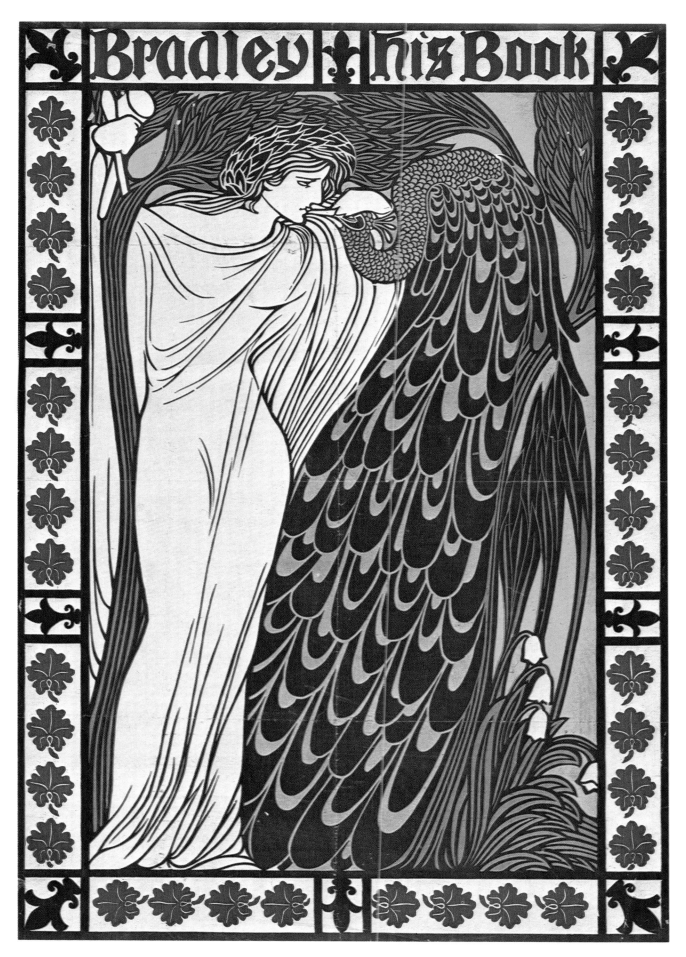

Will Bradley, *Bradley: His Book*, 1896.

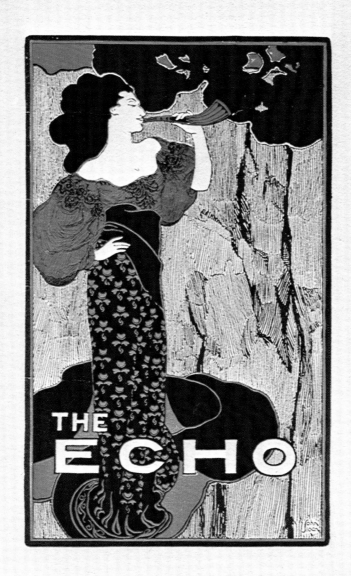

THE
ECHO

FOR SALE HERE.

John Sloan, *The Echo*, 1895. This poster reflects Sloan's interest in Japanese prints: "It was mostly from a study of Japanese prints that I found fresh ideas about design, discovered in observing everyday life."

Arthur Dow, *Modern Art*, 1895. From his study of Japanese prints, Dow learned to create a scene with flat color planes and juxtapositions of different textured areas. The scene on this poster, set against the poppies, is the Ipswich, Massachusetts countryside where Dow spent several summers.

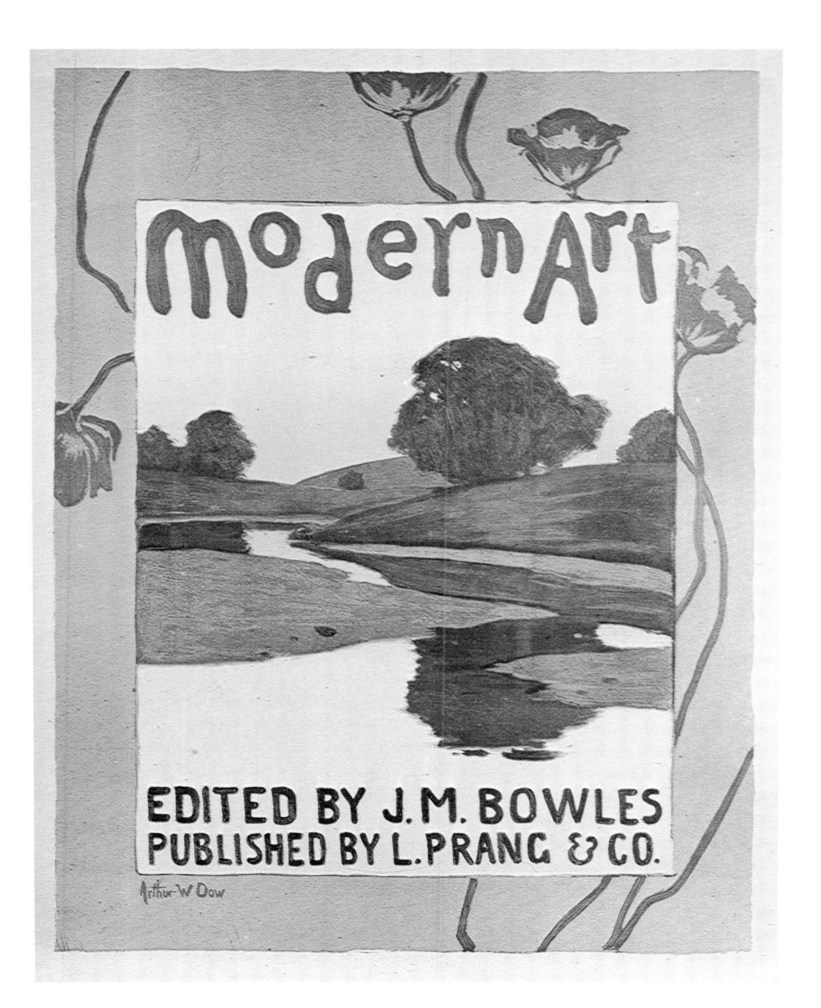

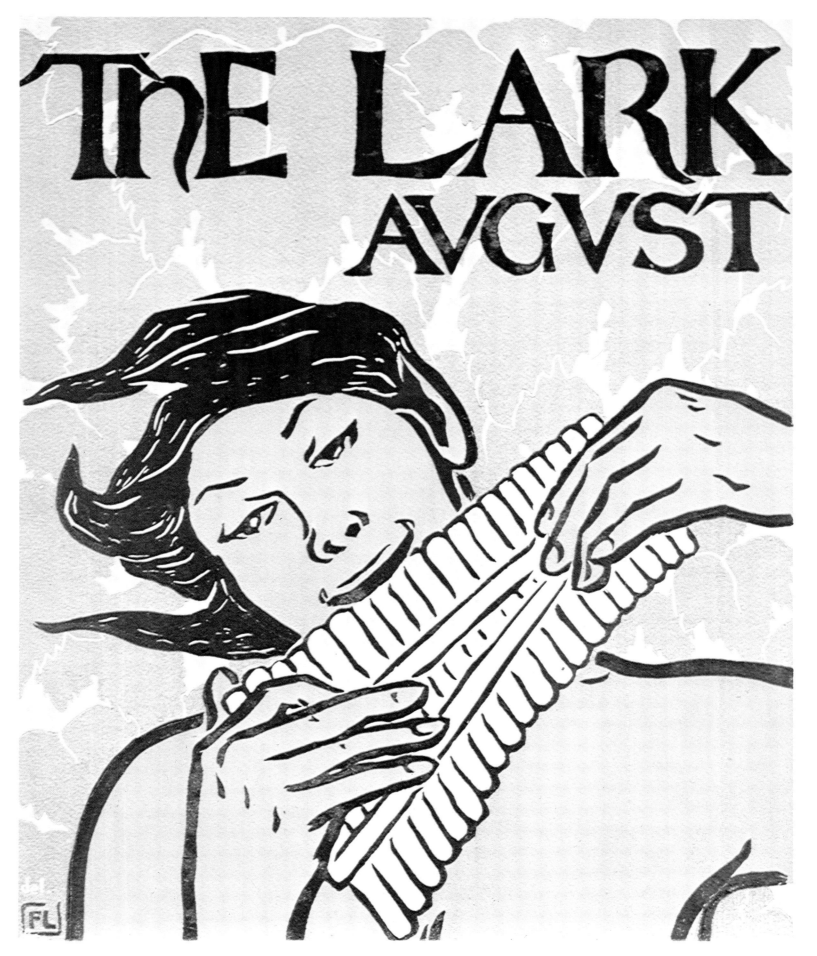

Florence Lundborg, *The Lark*, 1896.

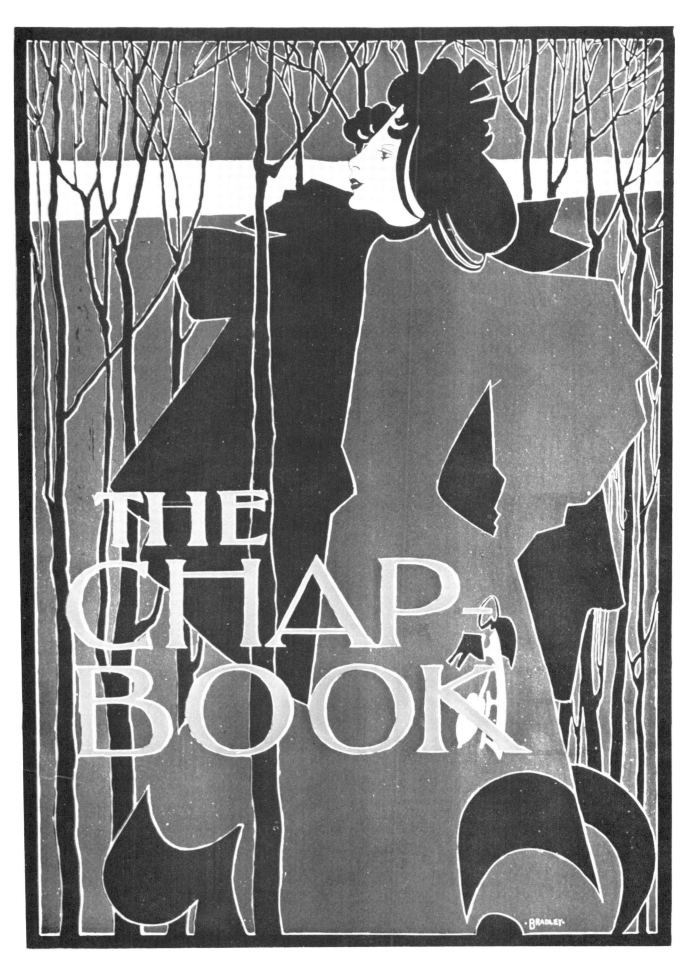

Will Bradley, *The Chap-Book*, ''The Blue Lady'', 1894.

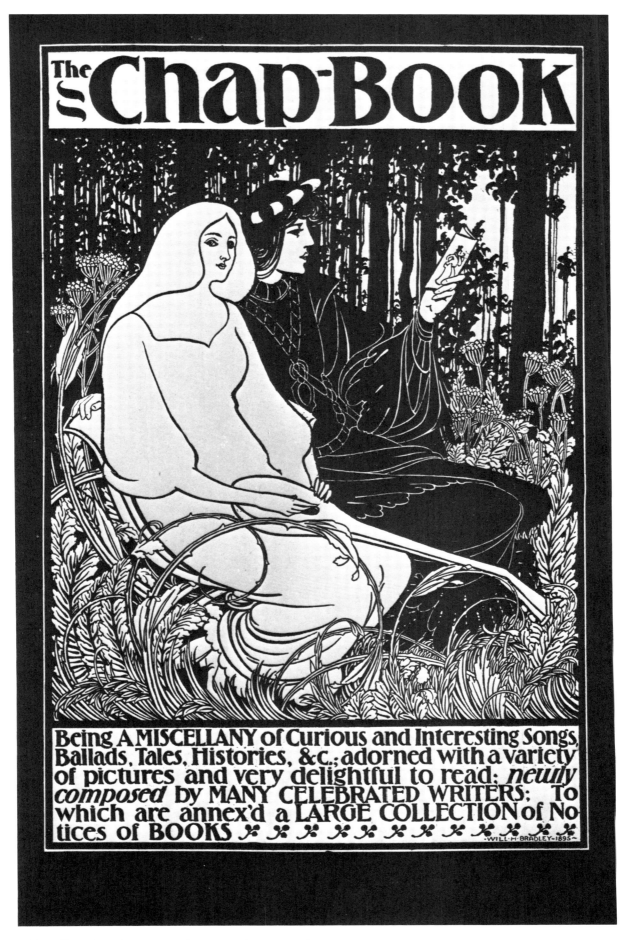

Will Bradley, *The Chap-Book*, "The Poet and His Lady," 1895.
This was Bradley's only *Chap-Book* poster in black and white.

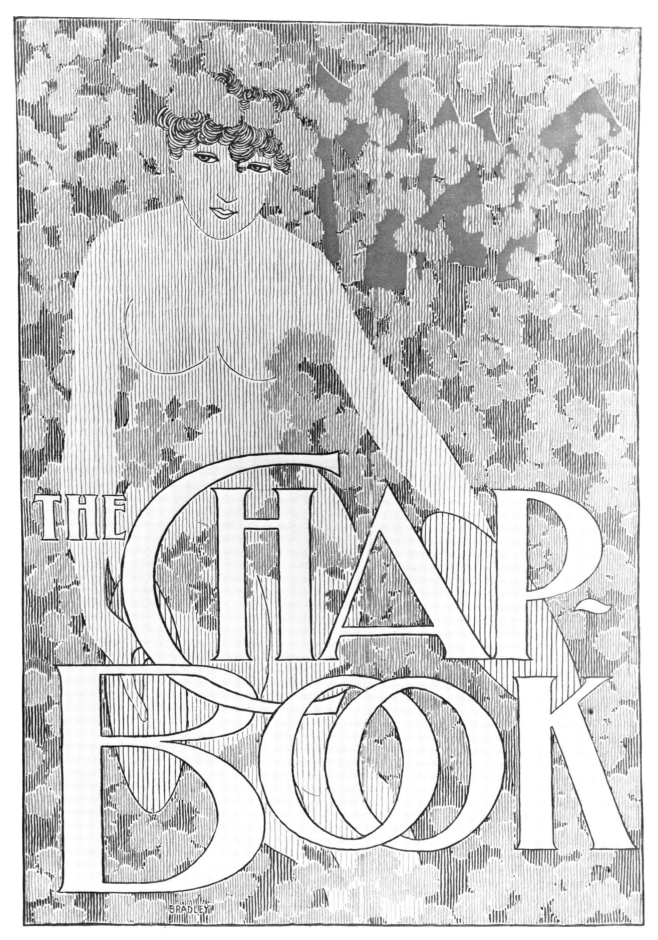

Will Bradley, *The Chap-Book*, "May," 1895. The large letters
spelling "May" are barely distinguishable amidst the flowers.

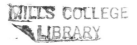

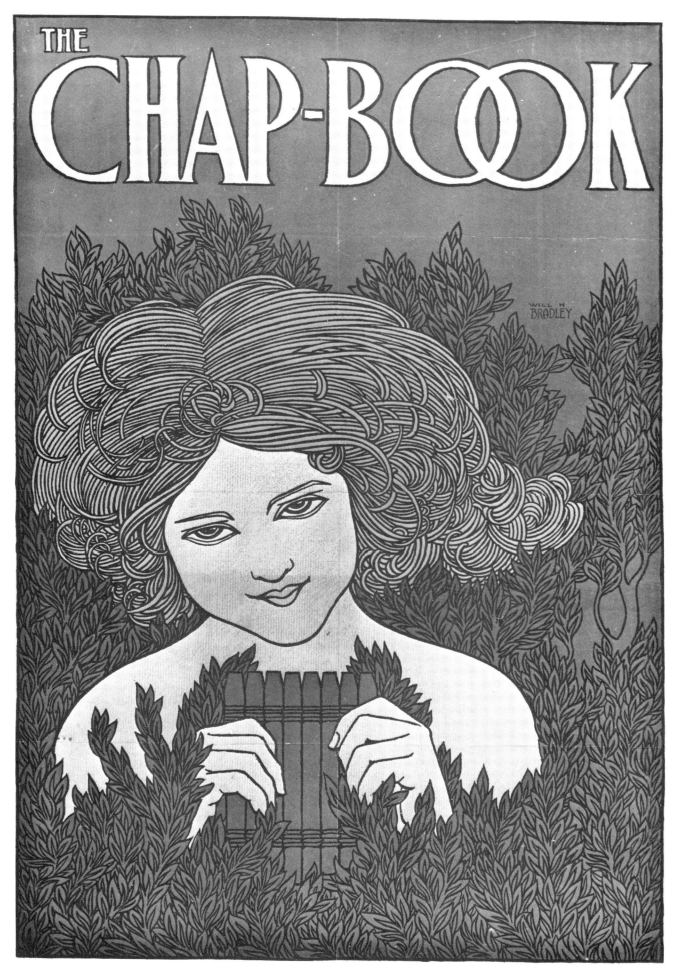

Will Bradley, *The Chap-Book*, "Pan," 1895.

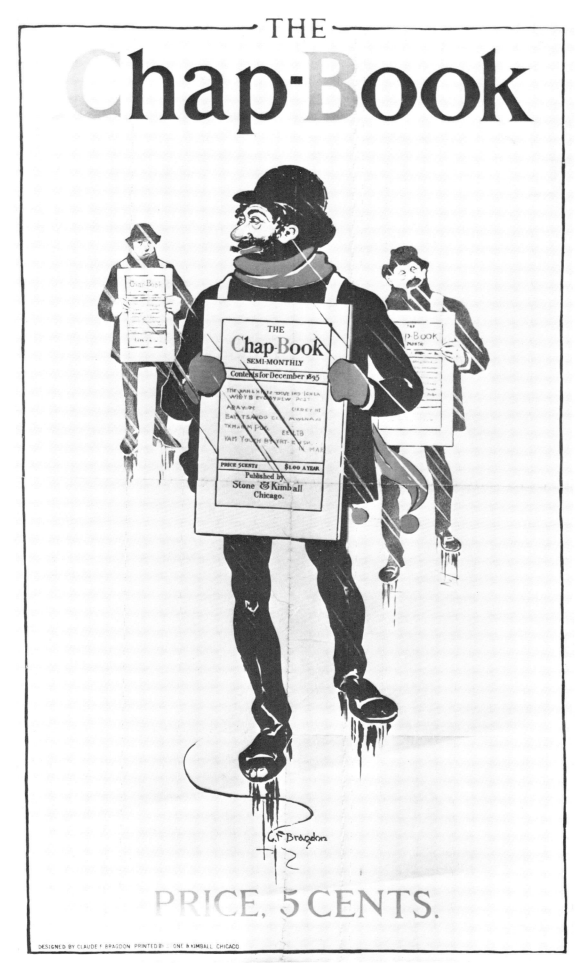

Claude Fayette Bragdon, *The Chap-Book*, 1895.

E.B. Bird, *The Chap-Book*, c. 1895.

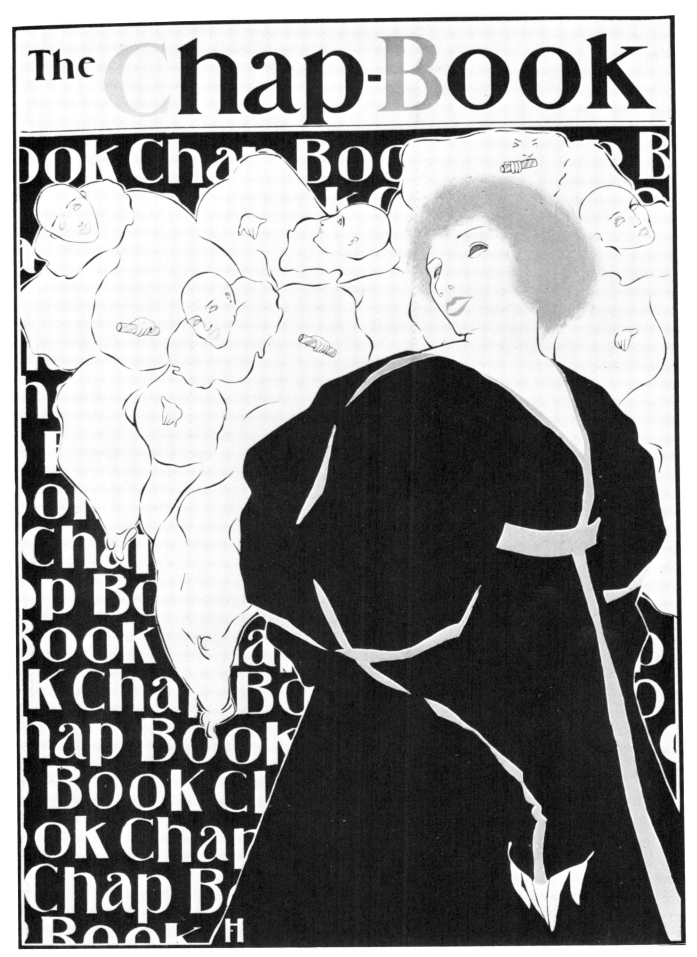

Frank Hazenplug, *The Chap-Book*, "The Black Lady," 1896.

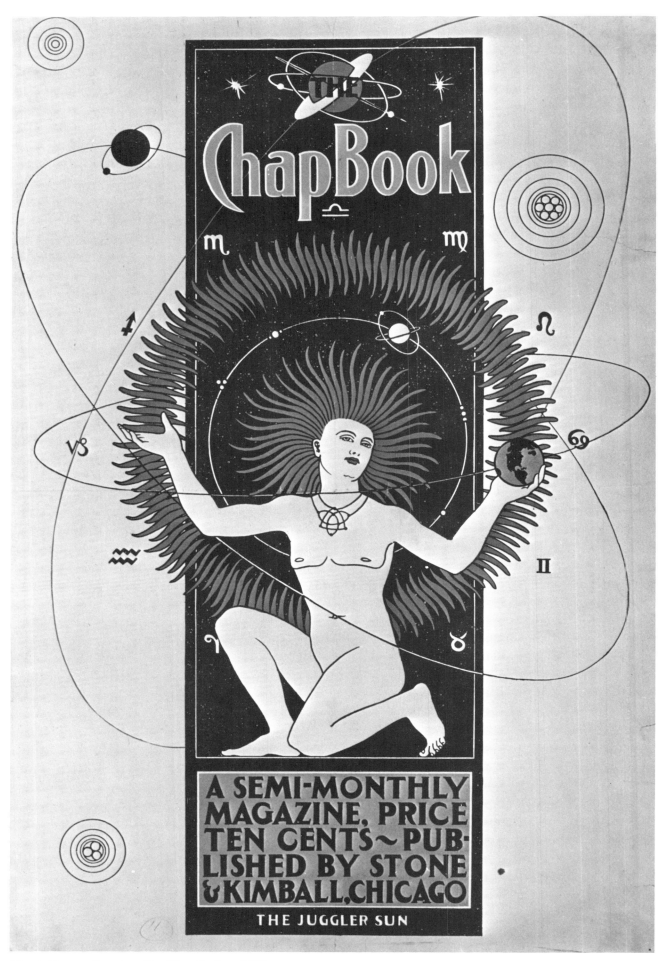

Claude Fayette Bragdon, *The Chap-Book*, c. 1897.

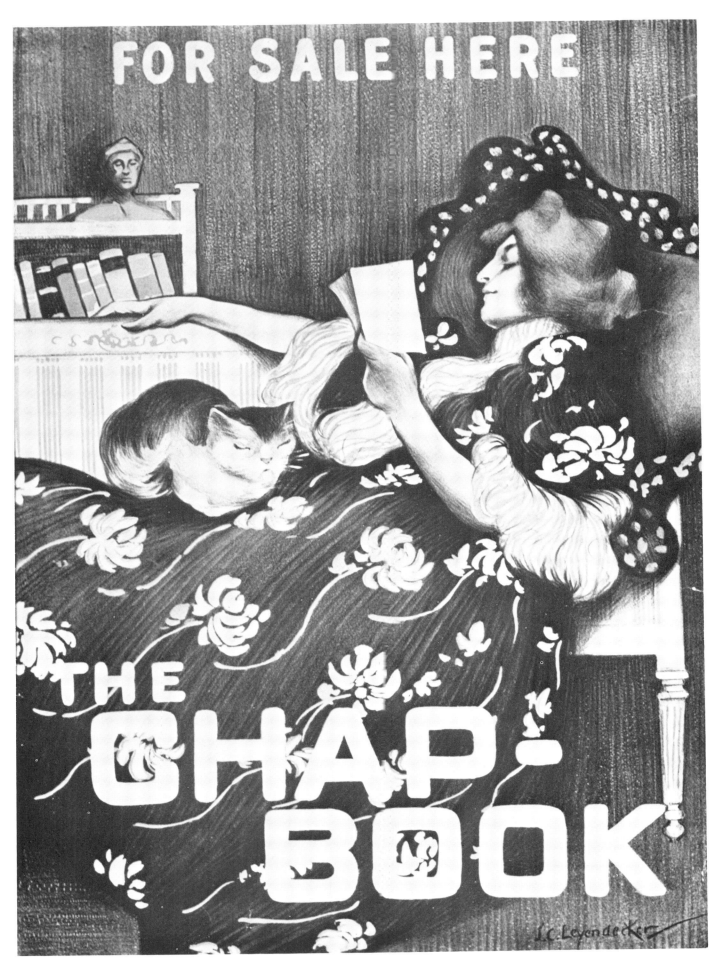

J.C. Leyendecker, *The Chap-Book*, 1897.

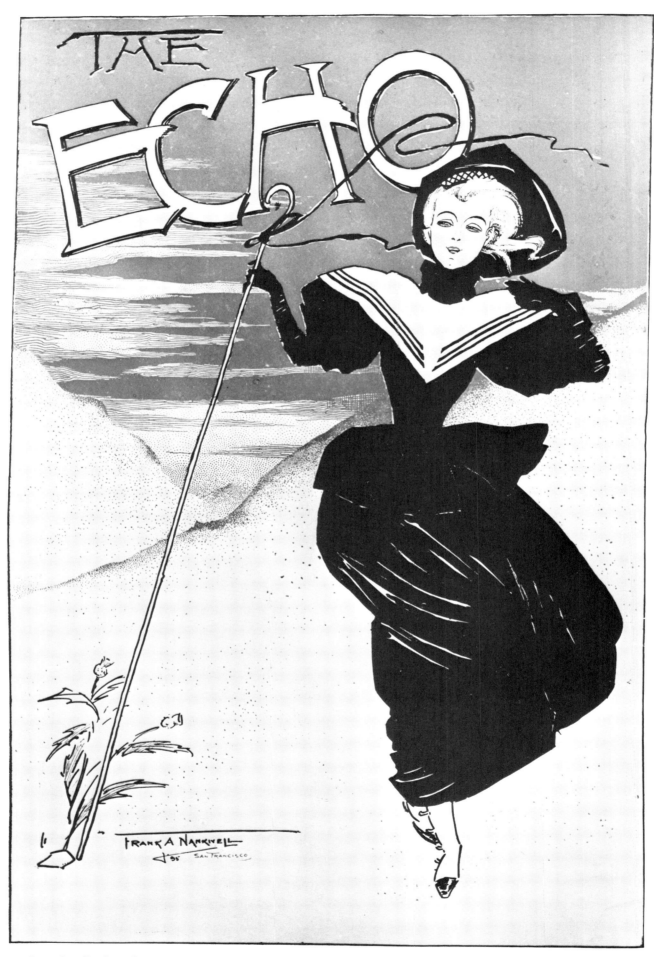

Frank Nankivell, *The Echo*, 1895.

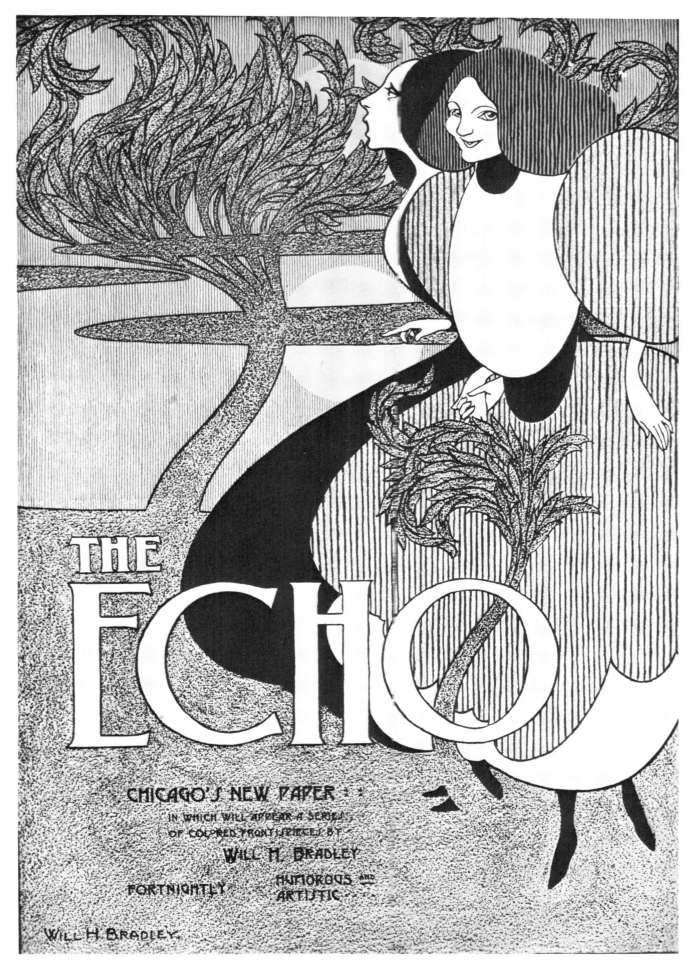

Will Bradley, *The Echo*, 1895. Bradley's poster introduced this new Chicago bi-weekly.

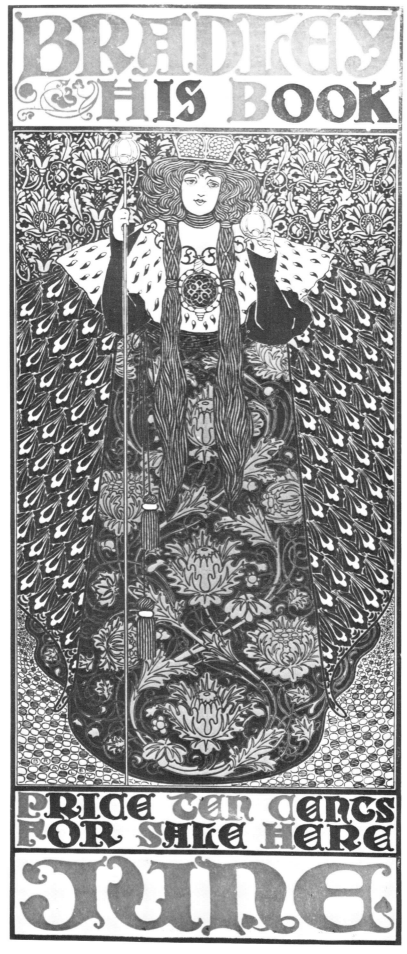

Will Bradley, *Bradley: His Book*, 1896.

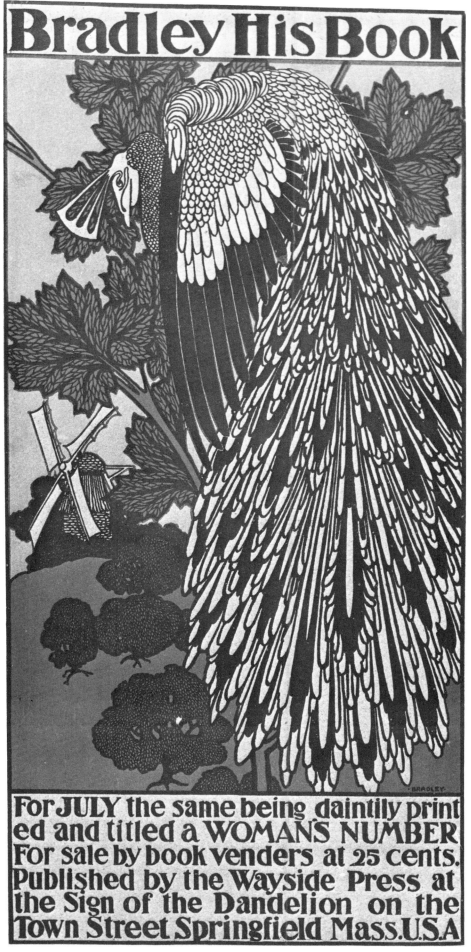

Will Bradley, *Bradley: His Book*, 1896.

APRIL NUMBER

The INTERNATIONAL STVDIO

An Illustrated Monthly Magazine of FINE & APPLIED ART Edited by CHARLES HOLME Published by JOHN LANE The Bodley Head at 140 Fifth Ave New York Price 35 cents Yearly Subscription $3.50 post paid

Supplements in this Number

A STUDY IN GOLD AND COLOURS
By Sir Edward Burne-Jones

AN AUTO-LITHOGRAPH
By R. Anning Bell

AND A TINTED PLATE
AFTER HANS THOMA'S LITHOGRAPH ENTITLED
"REST DURING THE FLIGHT INTO EGYPT"

Will Bradley, *The International Studio*, 1897. This poster is an exquisite example of Bradley's refined taste in the use of typography and ornamentation.

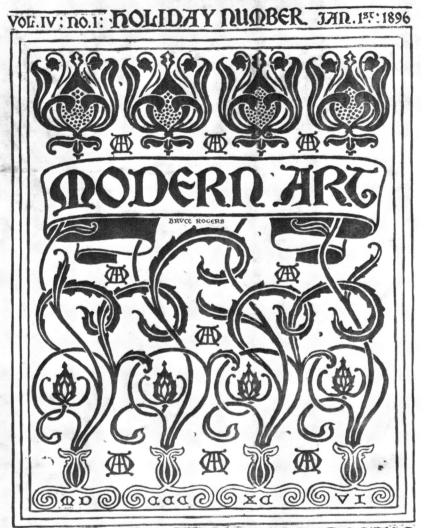

Bruce Rogers, *Modern Art*, 1896. Rogers was a typographer whose few posters employed tasteful arrangements of type and ornaments.

THE·PENNY MAGAZINE

SOLD·HERE·5cts

Ethel Reed, *The Penny Magazine*, c. 1895.

Ah, I see that the Feature of 1896 is to be THE POCKET MAGAZINE!

A.W.B. Lincoln, *Pocket Magazine* posters, c. 1895–1896.

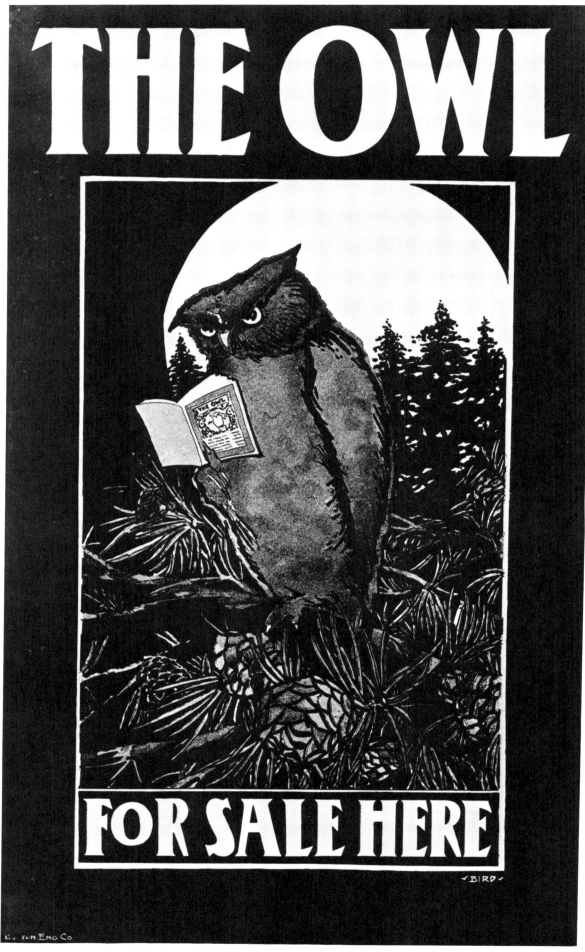

E.B. Bird, *The Owl*, c. 1895.

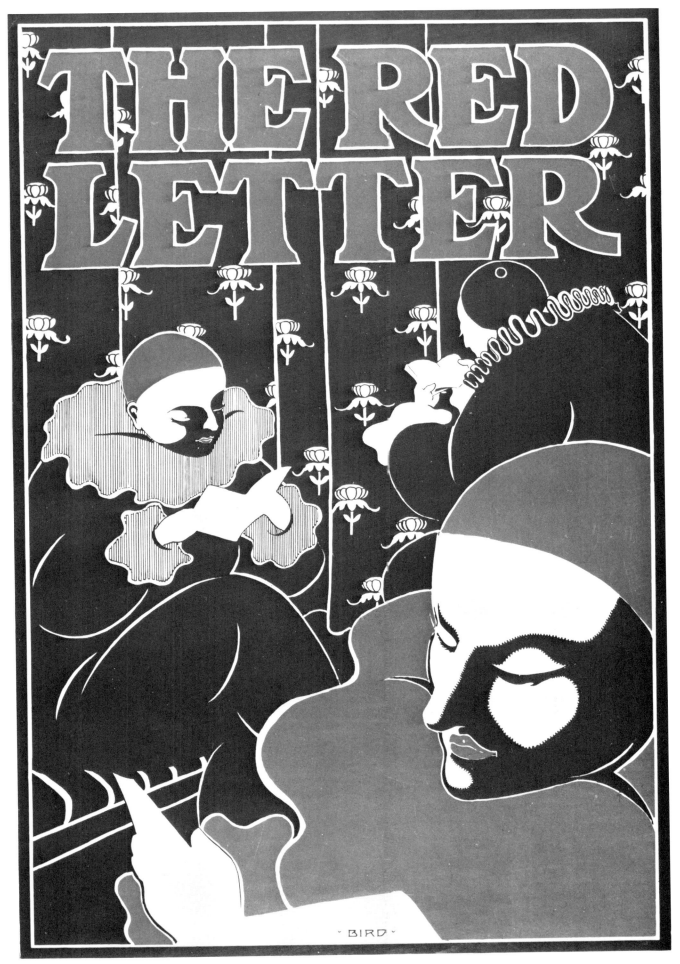

E.B. Bird, *The Red Letter*, 1896.

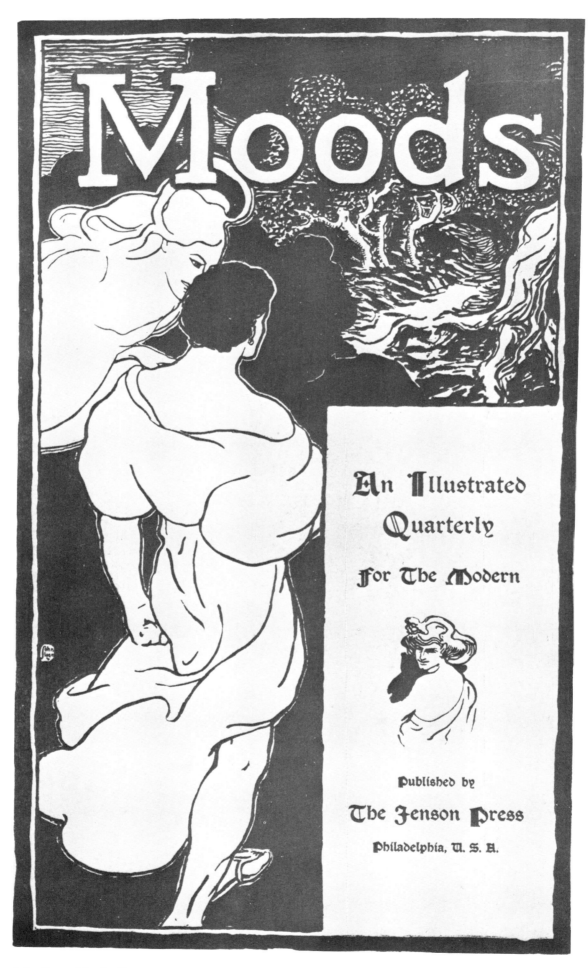

John Sloan, *Moods*, 1895.

Chic Ottman, *Elite*, c. 1895.

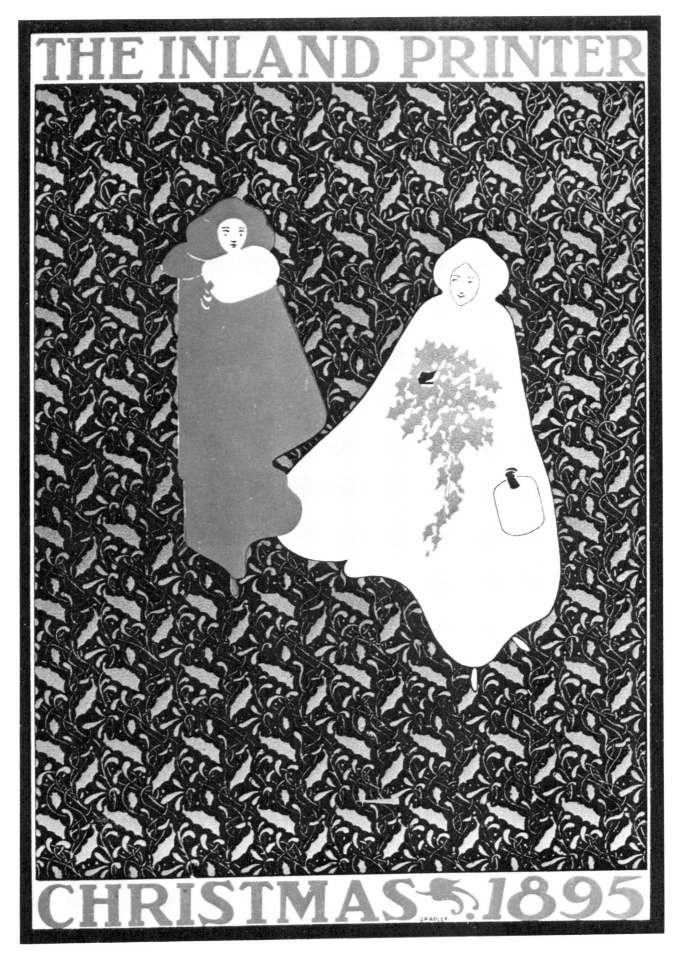

Will Bradley, *The Inland Printer*, 1895.

Inland Printer

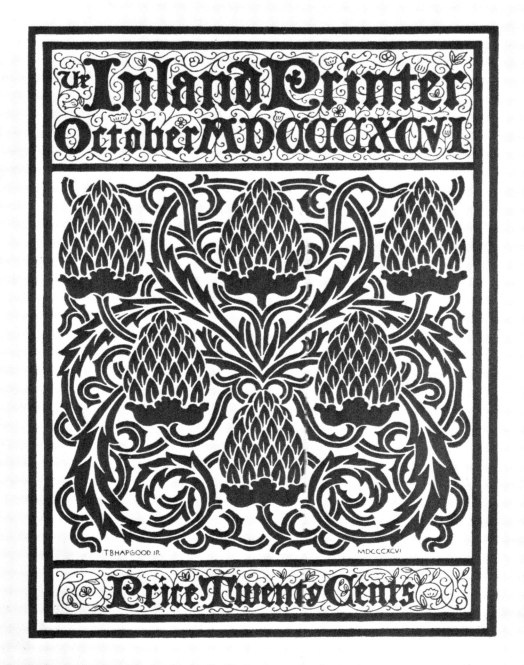

For October

T.B. Hapgood Jr., *The Inland Printer*, 1896. Posters for *The Inland Printer* usually showed the cover of the magazine with large type above and below.

Inland Printer

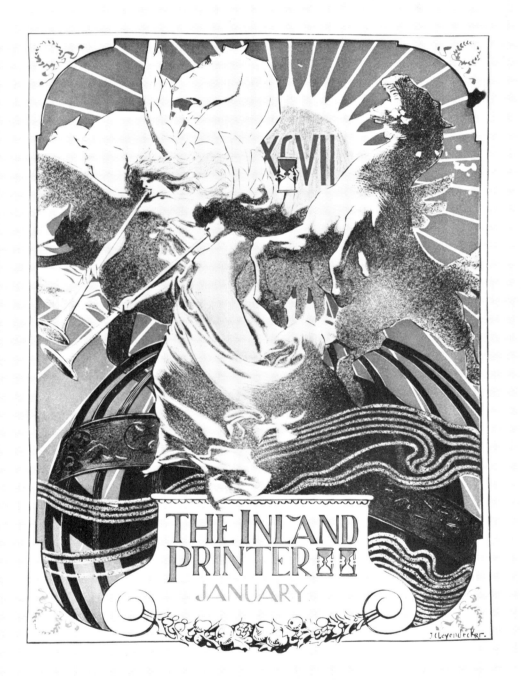

JANUARY

J.C. Leyendecker, *The Inland Printer*, 1897. Leyendecker sent his *Inland Printer* designs
from Paris where he was studying art at the time. This one shows his debt to Tiepolo.

June Now Ready

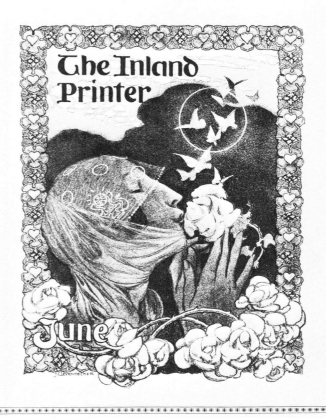

Price Twenty Cents

August Now Ready

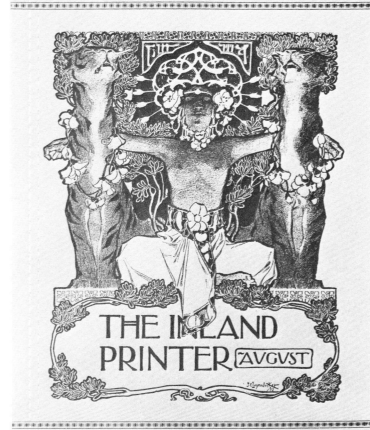

Price Twenty Cents

J.C. Leyendecker, *The Inland Printer* posters from 1897.

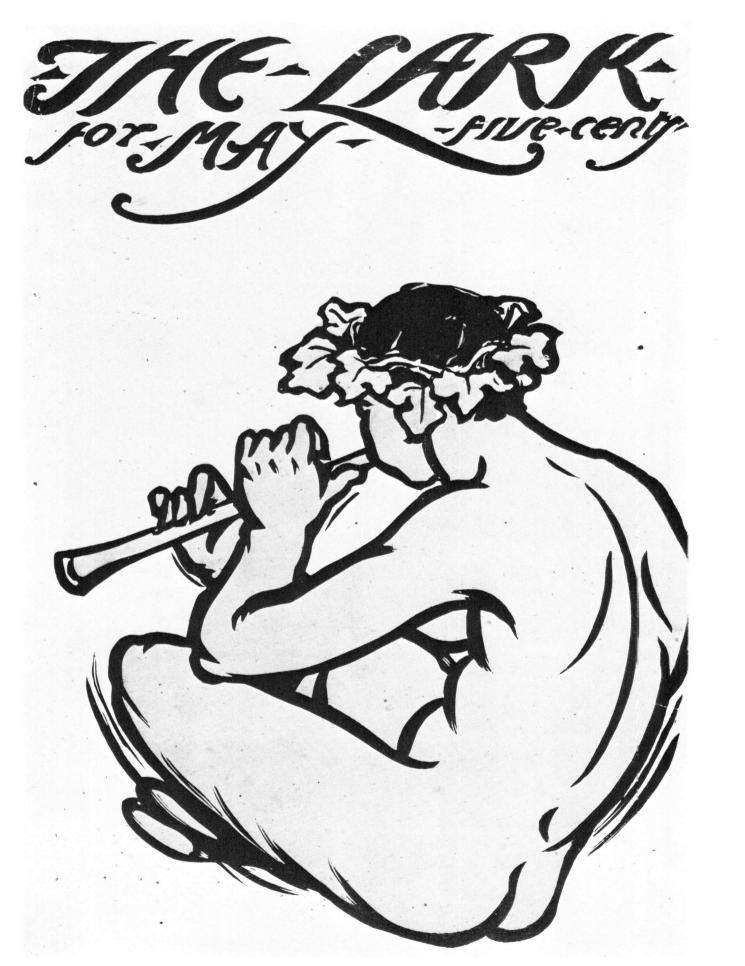

Bruce Porter, *The Lark*, 1895.

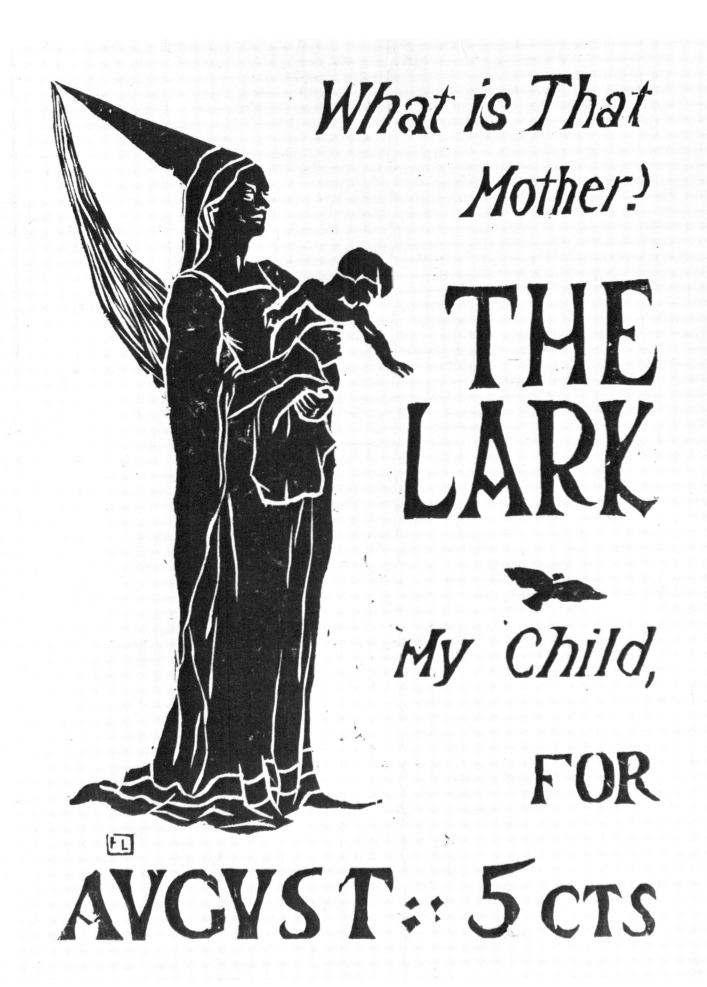

Florence Lundborg, *The Lark*, 1895.

Florence Lundborg, *The Lark*, 1895.

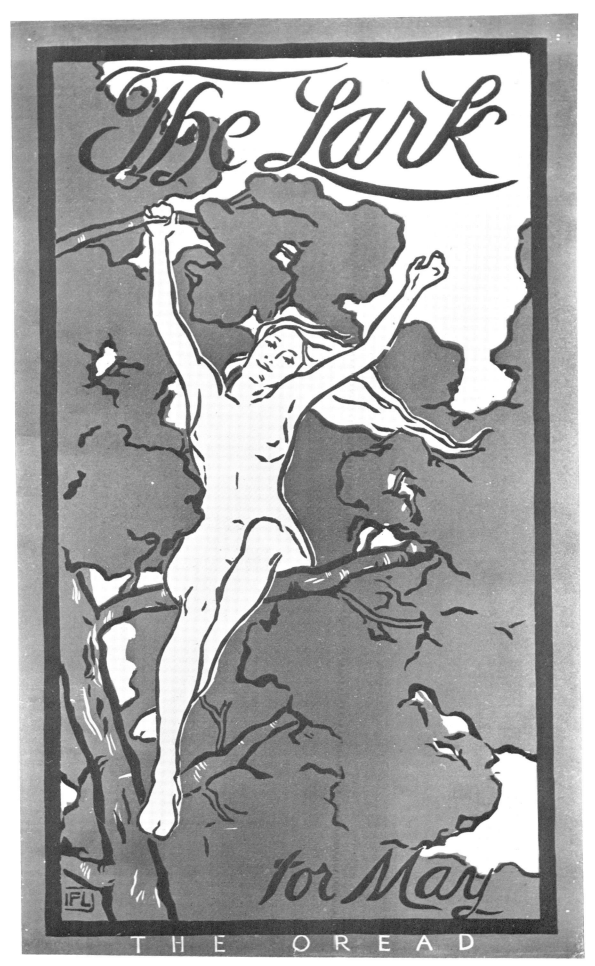

Florence Lundborg, *The Lark*, 1896.

Florence Lundborg, *The Lark*, 1896.

Books

QVO·VADIS·

A·NARRATIVE·OF·THE
TIME·OF·NERO·BY·
HENRYK·SIENKIEWICZ·

·PVBLISHED·BY·LITTLE·
·BROWN·&·C°·BOSTON·

J.A. Schweinfurth, Little, Brown & Co., 1897.

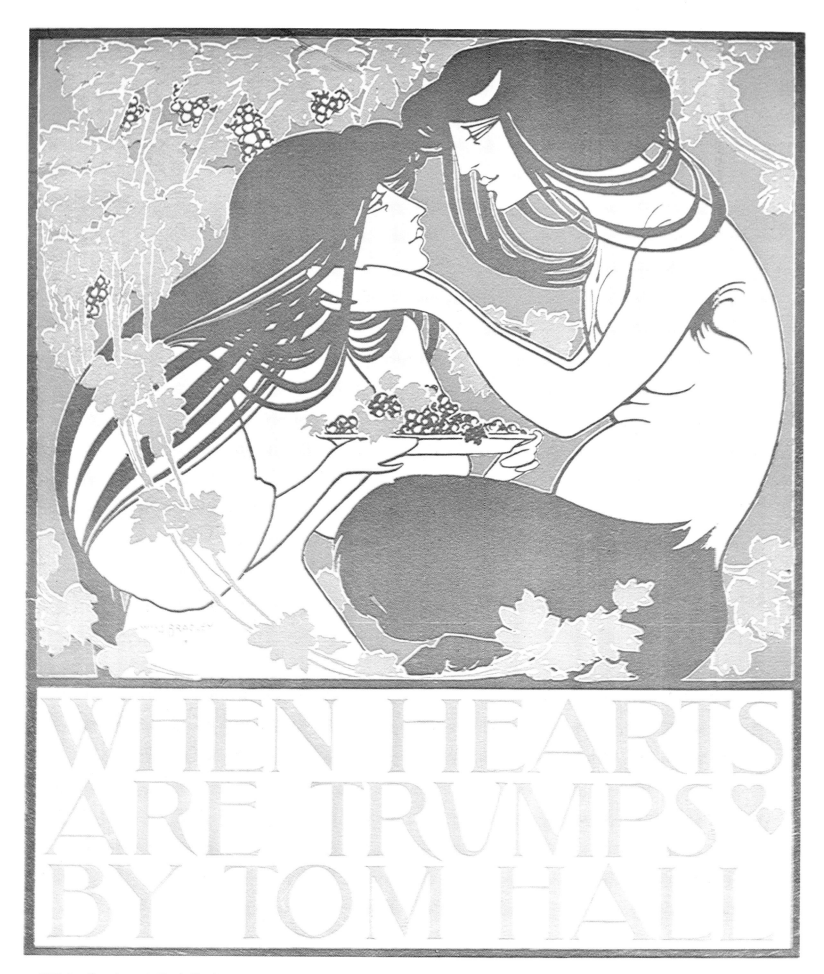

Will Bradley, Stone & Kimball, 1894.

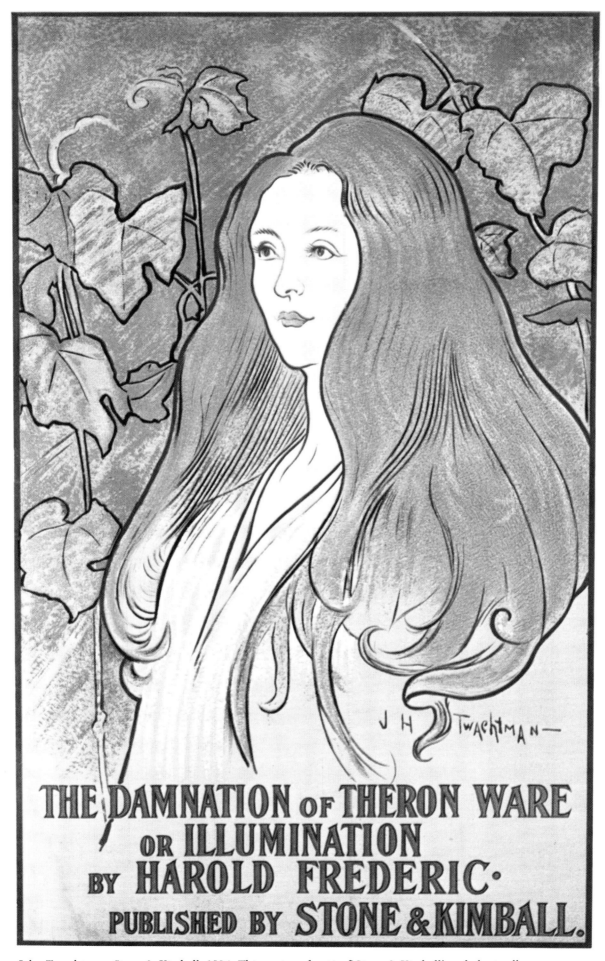

THE DAMNATION OF THERON WARE
OR ILLUMINATION
BY HAROLD FREDERIC·
PUBLISHED BY STONE & KIMBALL.

John Twachtman, Stone & Kimball, 1894. This poster advertised Stone & Kimball's only best-seller.

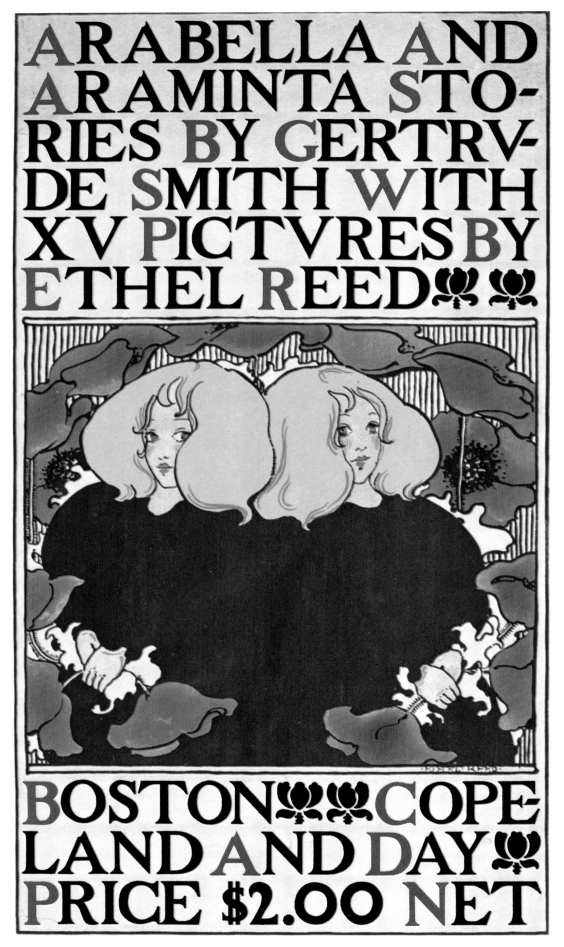

Ethel Reed, Copeland & Day, 1895.

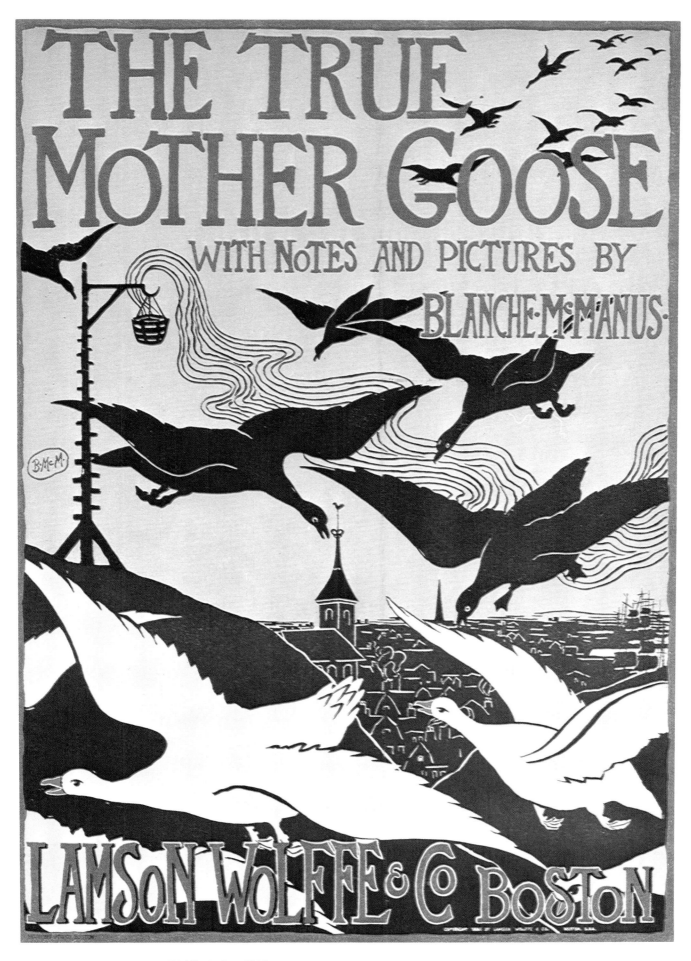

Blanche McManus, Lamson, Wolffe & Co., 1895.

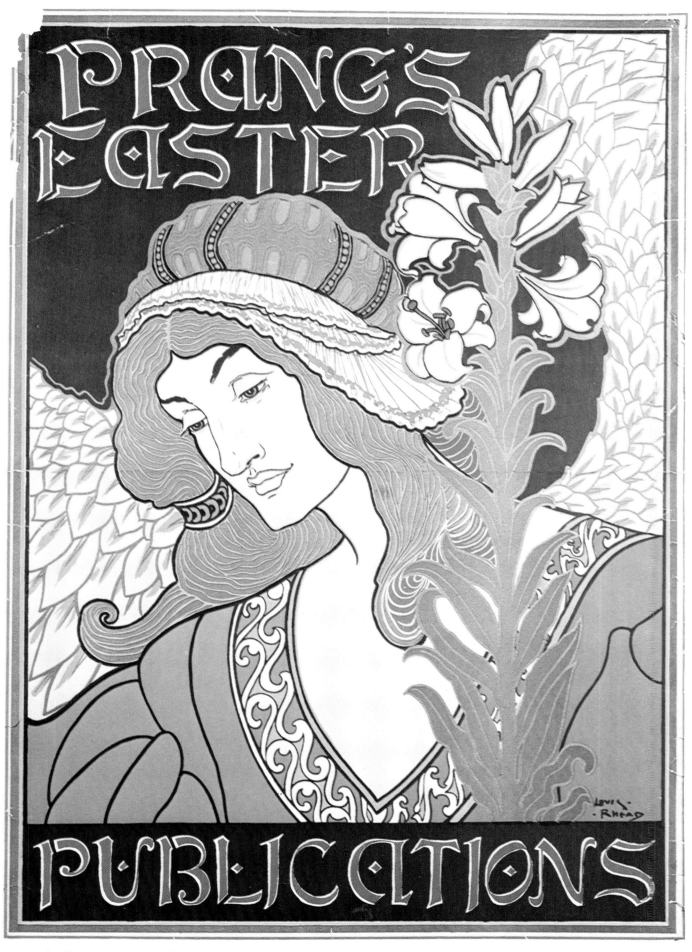

Louis Rhead, L. Prang & Co., 1896.

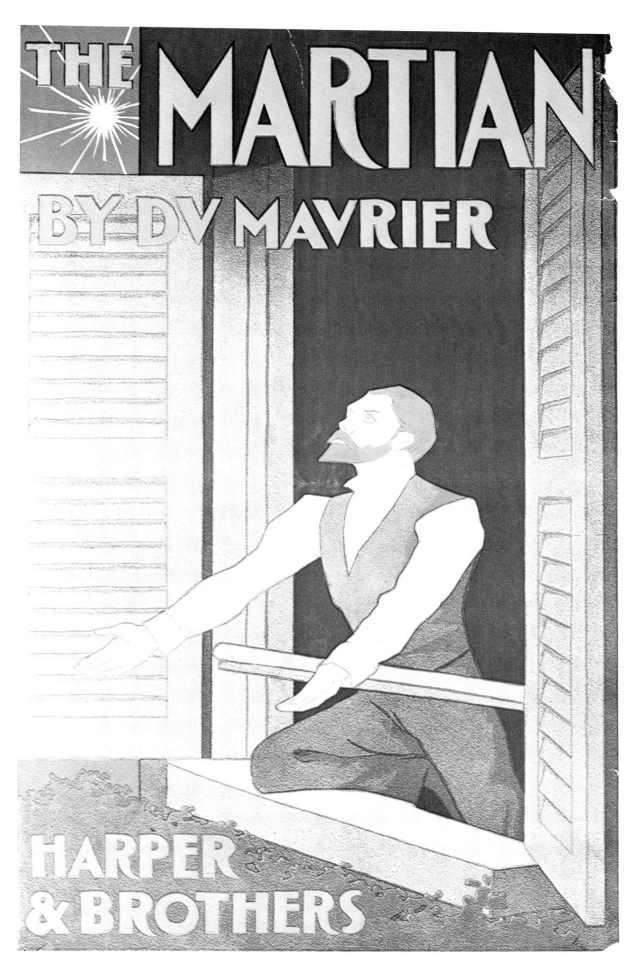

Edward Penfield, Harper & Bros., 1897.

Blanche McManus, Charles Scribner's Sons, 1895.

Peter Newell, J.B. Lippincott Co., 1894.

THE PRINCESS ALINE

By RICHARD HARDING DAVIS

Illustrated by C. D. Gibson

HARPER & BROTHERS, PUBLISHERS

Charles Dana Gibson, Harper & Bros., 1895.

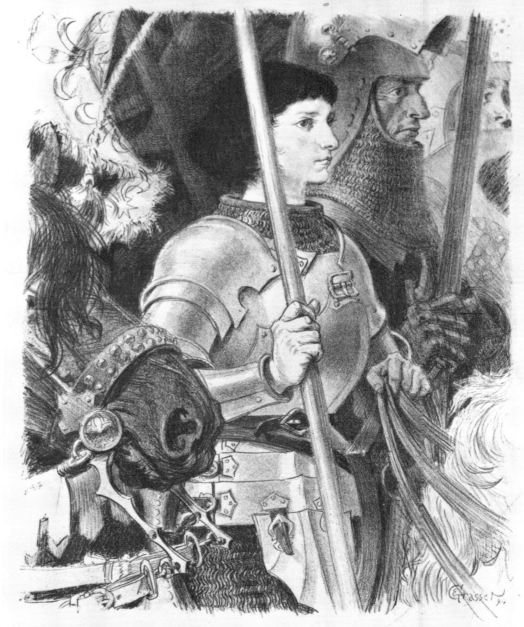

MARK TWAIN'S
JOAN OF ARC

HARPER & BROTHERS
PUBLISHERS

Eugène Grasset, Harper & Bros., c. 1896.

Henry McVickar, Harper & Bros., 1896. Posters advertising three books about women published by Harper & Bros.

July /95

Pony
Tracks

WRITTEN AND
ILLUSTRATED
BY
Frederic Remington

EDWARD PENFIELD

PUBLISHED BY
HARPER & BROTHERS NEW YORK

Edward Penfield, Harper & Bros., 1895.

Edward Penfield, Harper & Bros., 1896.

Lafayette Maynard Dixon, Continental Publishing Co., 1897.

BLACK ROCK and The SKY PILOT

by RALPH CONNOR

ILLUSTRATED BY LOUIS RHEAD

PUBLISHED BY FLEMING H. REVELL COMPANY

Artist unknown, Fleming H. Revell Co., c. 1898.

THE KING IN YELLOW
BY
ROBERT W. CHAMBERS

F. TENNYSON NEELY·· PUBLISHER
CHICAGO ～ NEW YORK

Robert W. Chambers, F. Tennyson Neely, 1895.

A.W.B. Lincoln, Frederick A. Stokes Co., 1895.

Clifton Johnson, Lee & Shepard, 1898.

THE DRAGON OF WANTLEY
HIS TALE: BY OWEN WISTER
ILLUSTRATIONS BY JOHN STEWARDSON

John Stewardson, J.B. Lippincott Co., c. 1893.

The Wonderful Wizard of OZ

BAUM & DENSLOW
B O O K S
FATHER GOOSE
HIS BOOK.
The SONGS of
FATHER GOOSE
(MUSIC BY ALBERTA N. HALL)

L. FRANK BAUM, AUTHOR * W.W. DENSLOW, ILLUSTRATOR * GEORGE M. HILL CO. PUBLISHERS.

Will Denslow, George M. Hill Co., 1900.

Maurice Prendergast, Joseph Knight Co., c. 1895.

VICTORIAN SONGS

COLLECTED·AND··
ILLUSTRATED·BY
EDMUND·H·GARRETT
WITH·AN·INTRO=
DUCTION·BY····
EDMUND·GOSSE

LITTLE·BROWN·&·CO· BOSTON

Edmund Garrett, Little, Brown & Co., 1895.

E.B. Wells, Charles Scribner's Sons, 1896.

Blanche McManus, A.S. Barnes & Co., 1895.

Palmer Cox's brownie drawings (above) appeared in *St. Nicholas* and later in book form (top).

E.B. Bird, R.H. Russell, c. 1895.

Edwin A. Abbey, R.H. Russell, 1895.

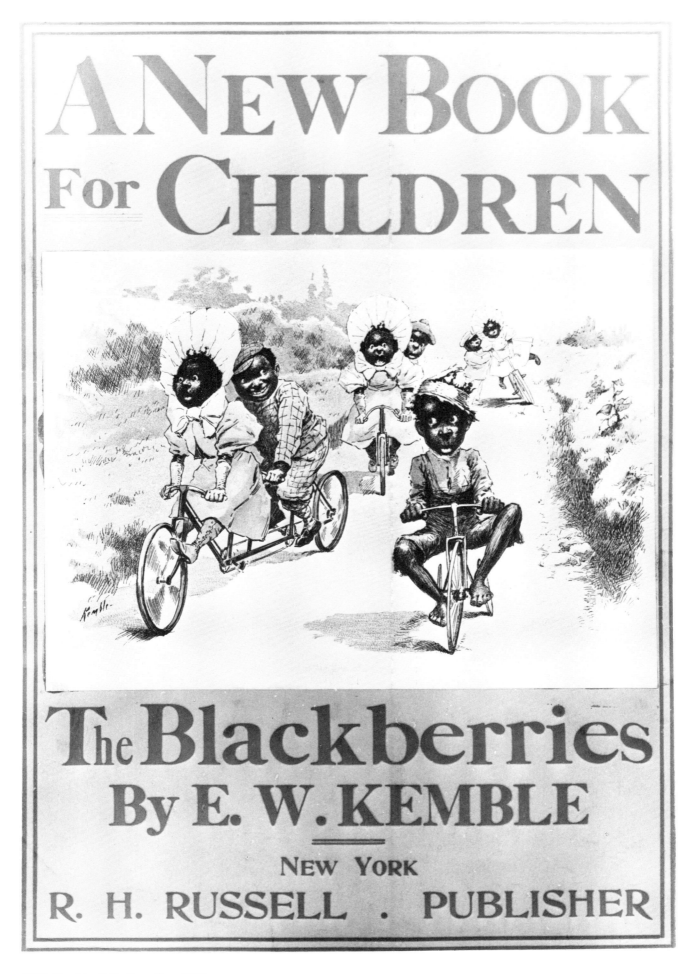

E.W. Kemble, R.H. Russell, c. 1897.

Will Bradley, The Burrows Bros. Co., 1895.

Ethel Reed, John Lane, 1896.

Ethel Reed, L. Prang & Co., 1895.

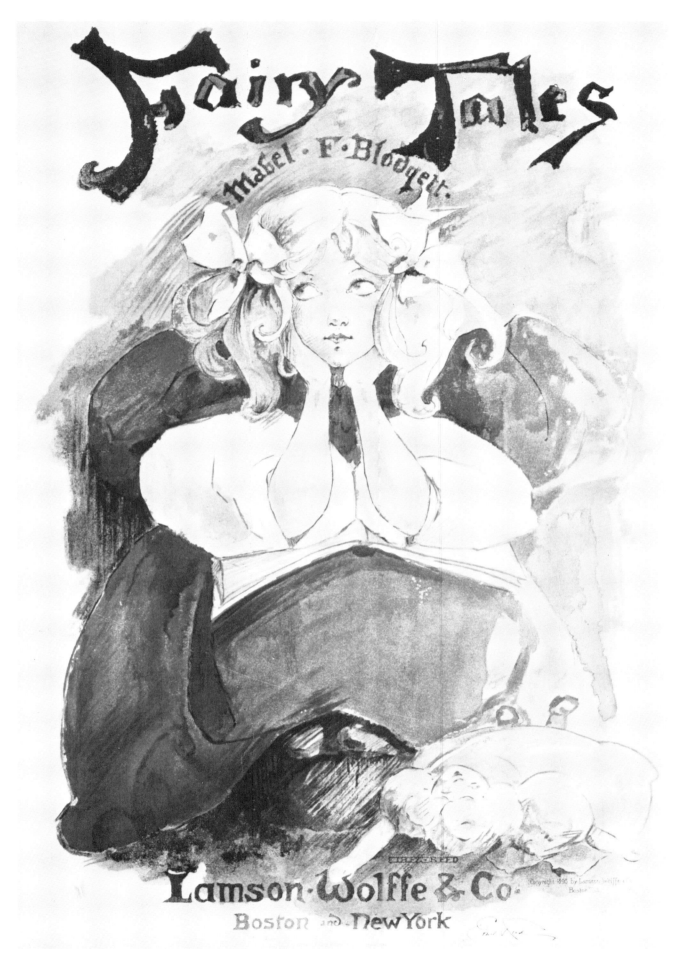

Ethel Reed, Lamson, Wolffe, & Co., 1895.

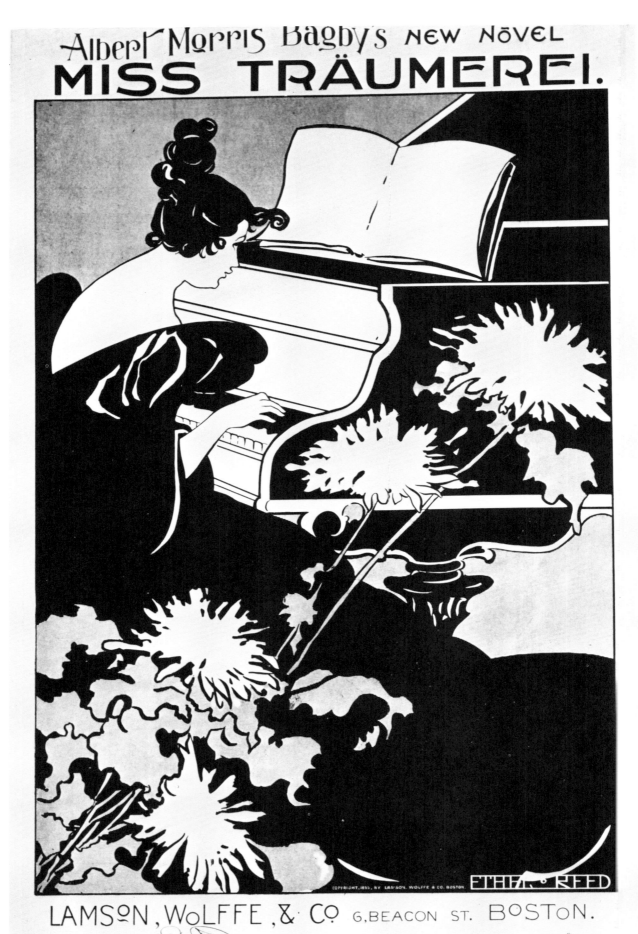

Ethel Reed, Lamson, Wolffe, & Co., 1895.

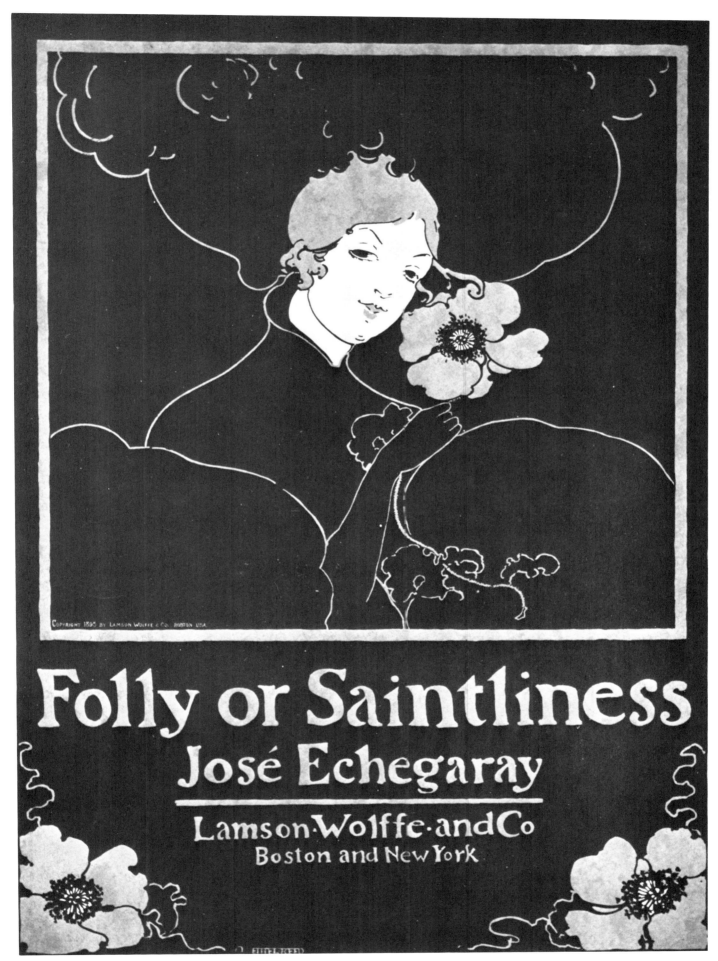

Ethel Reed, Lamson, Wolffe, & Co., 1895.

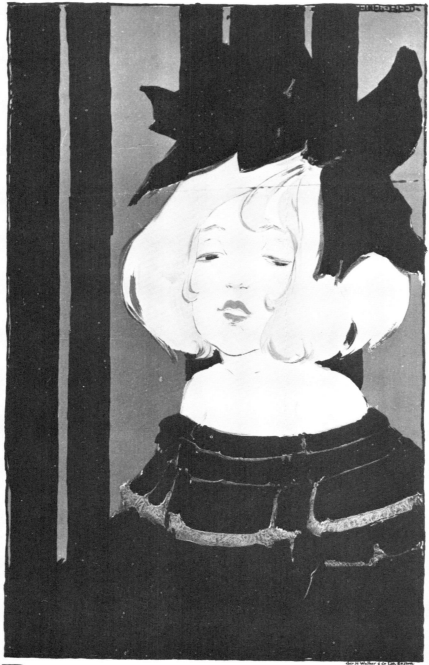

In Childhood's Country ❧ By Louise Chandler Moulton ❧❧❧ Pictured by Ethel Reed ❧❧

Boston: Copeland and Day ❧❧ Price $2.OO

Ethel Reed, Copeland & Day, 1895.

FOR SALE HERE

SONGS FROM
VAGABONDIA

BLISS CARMAN
RICHARD HOVEY

COPELAND AND DAY
BOSTON PRICE $1.00
THIRD
EDITION

Tom Meteyard, Copeland & Day, 1895. A poster for a book
of poems. The faces in the circle are those of Meteyard, the
book's designer, (far left) and the poets Bliss Carman (cen-
ter) and Richard Hovey (right).

MEADOW-GRASS
BY ALICE BROWN $1.50 NET

SICUT LILIUM
CD
INTER SPINAS

BOSTON
COPELAND AND DAY

Louis Rhead, Copeland & Day, 1897.

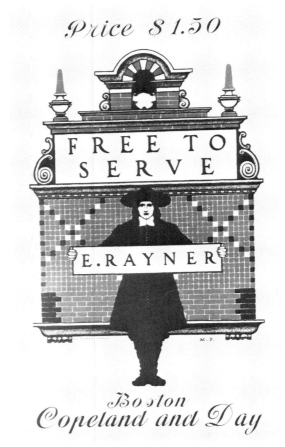

Price $1.50

FREE TO
SERVE

E. RAYNER

Boston
Copeland and Day

Maxfield Parrish, Copeland & Day, 1897.

CINDER-PATH TALES
WILLIAM LINDSEY

BOSTON:COPELAND AND
DAY ❧ ❧ ❧ PRICE $1.00

John Sloan, Copeland & Day, 1896.

E.B. Bird, Copeland & Day, 1896.

THE LITTLE ROOM
AND
OTHER STORIES
BY
MADELENE YALE WYNNE

WAY & WILLIAMS
PUBLISHERS CHICAGO
1895

Artist unknown, Way & Williams, 1895.

Newspapers, Commerce, and Exhibitions

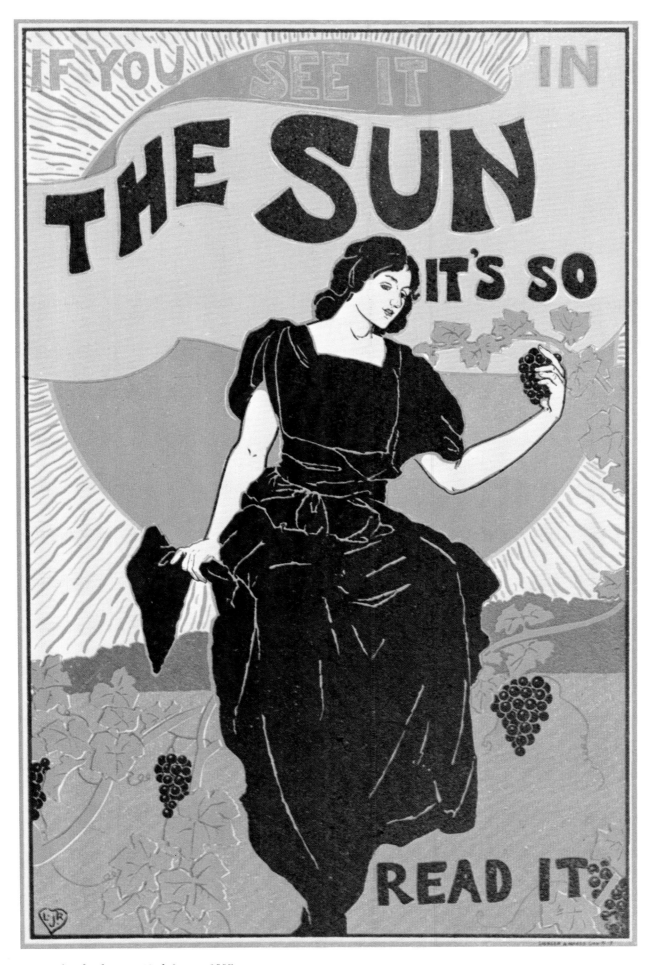

Louis Rhead, *The New York Sun*, c. 1895.

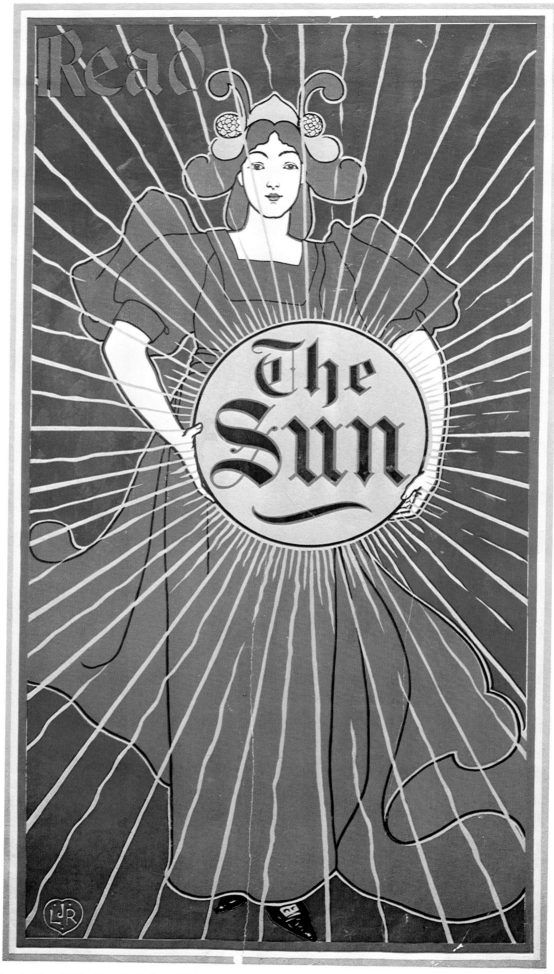

Louis Rhead, *The New York Sun*, 1895.

Frank Nankivell, *The New York Journal*, c. 1896.

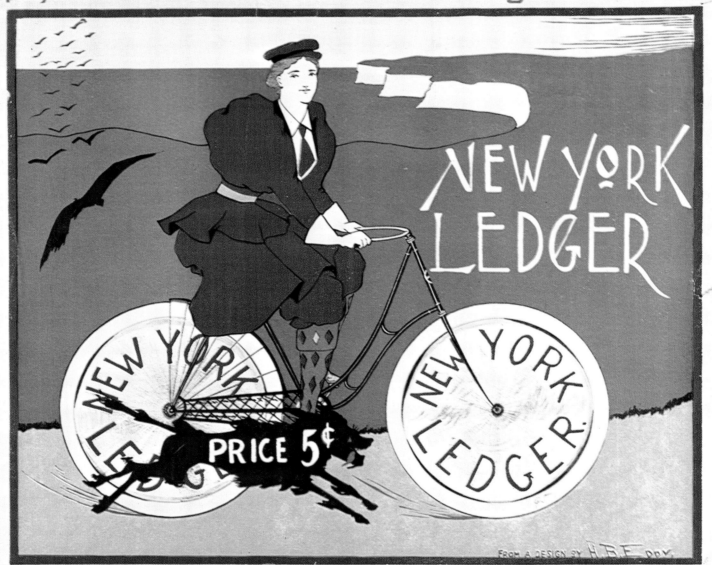

H.B. Eddy, *New York Ledger*, 1895.

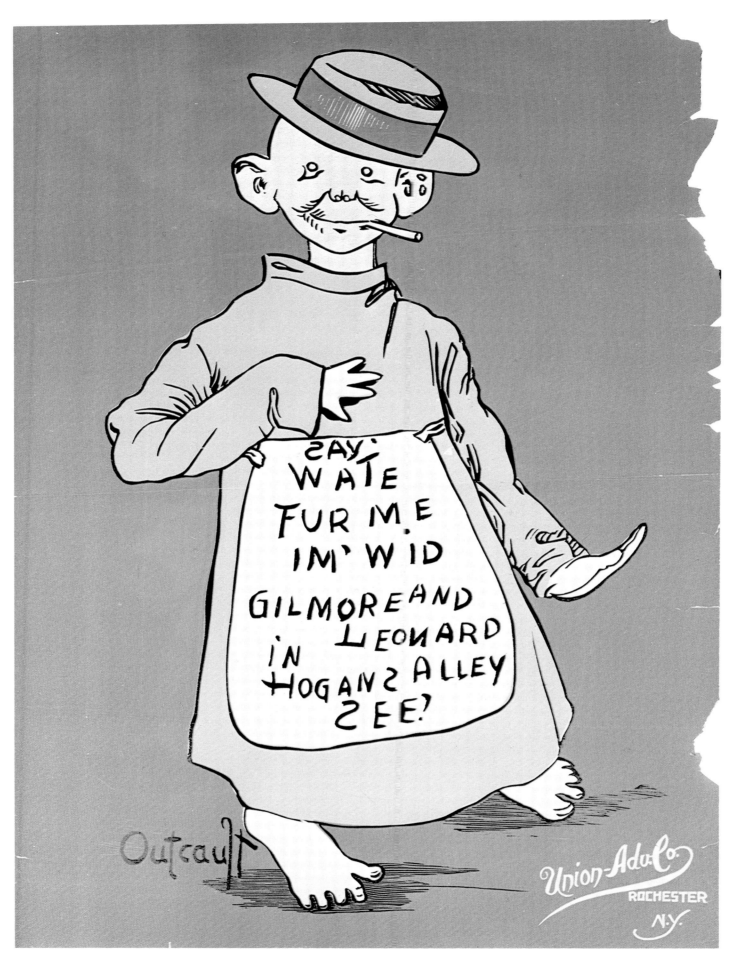

R.F. Outcault, *The New York World* (?), c. 1895.

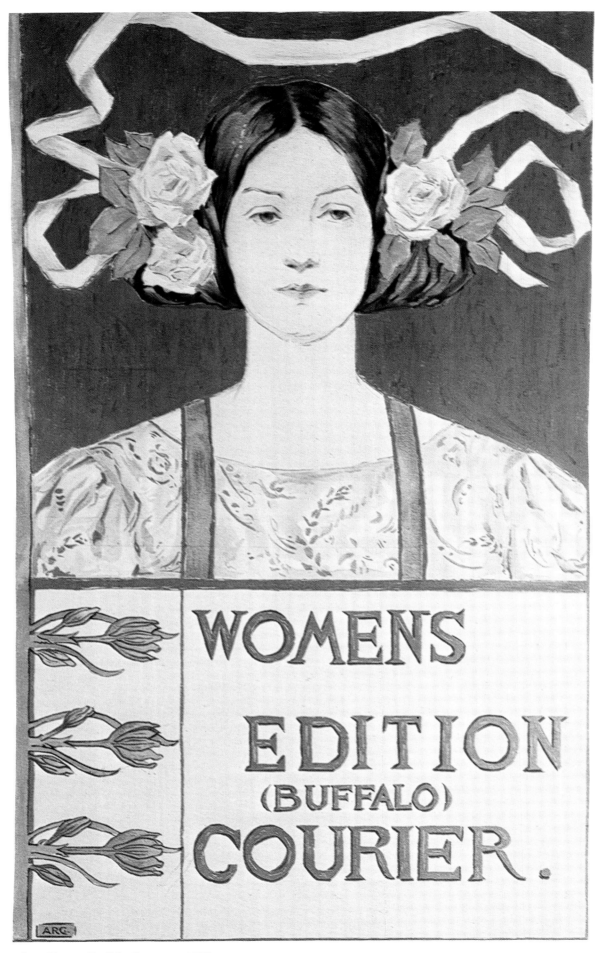

Alice Glenny, *Buffalo Courier*, c. 1895.

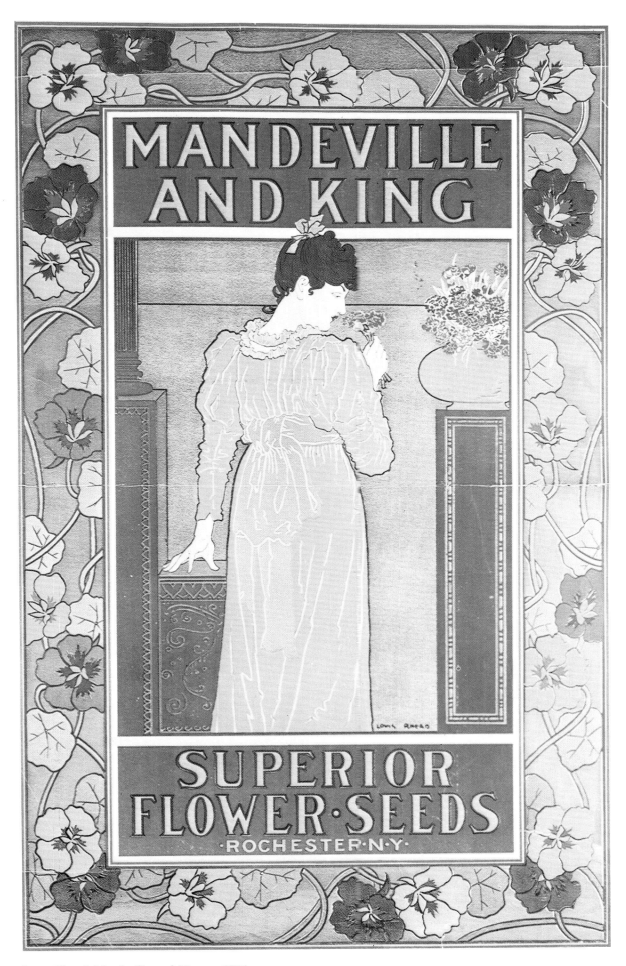

Louis Rhead, Mandeville and King, c. 1895.

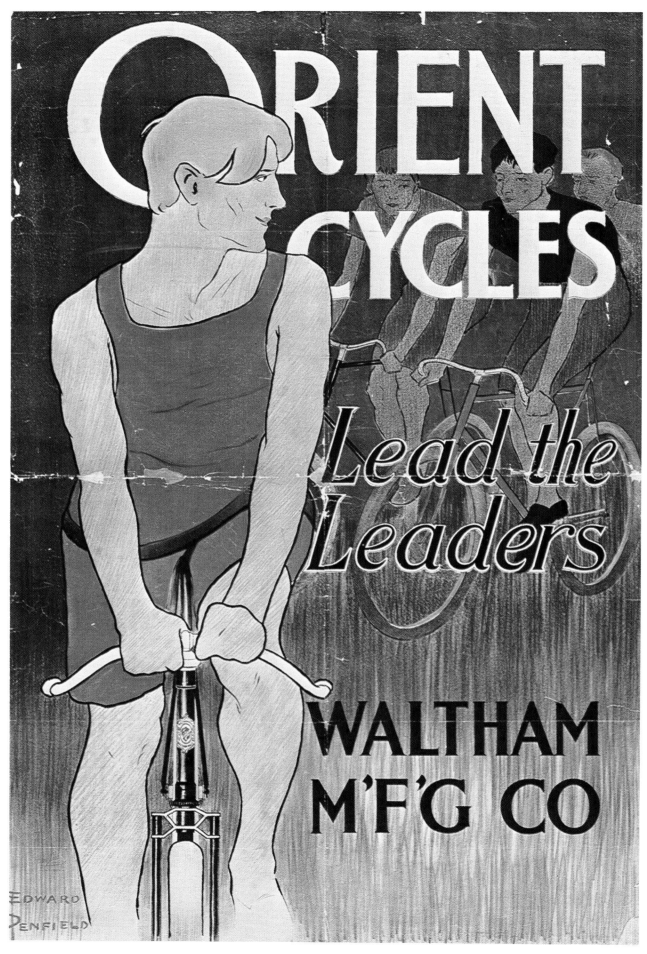

Edward Penfield, Waltham Mfg. Co., c. 1895.

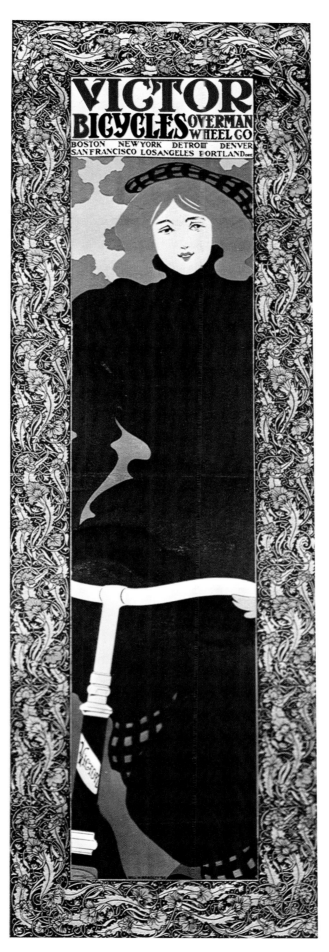

Will Bradley, Overman Wheel Co., 1895.

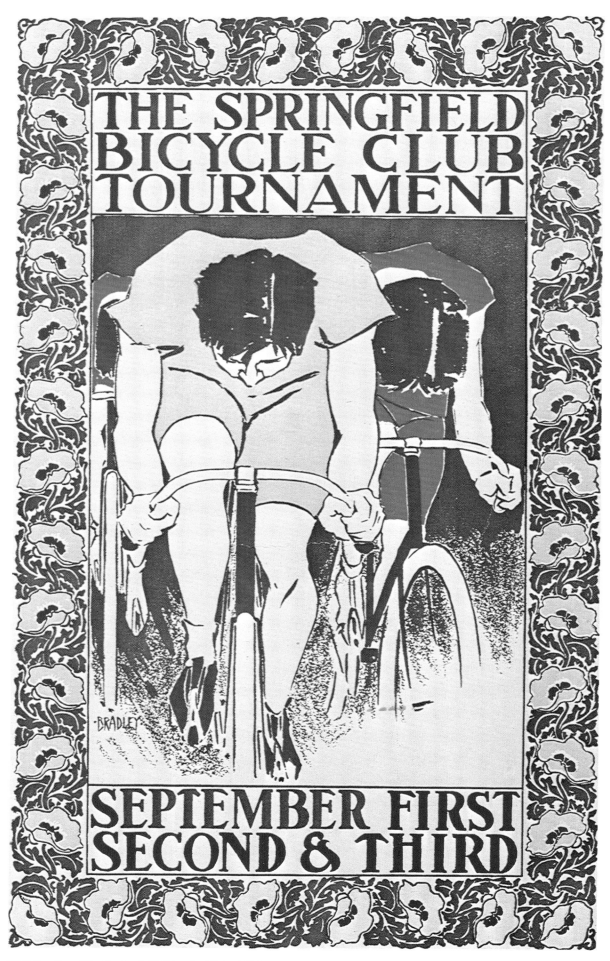

Will Bradley, The Springfield Bicycle Club, 1896.

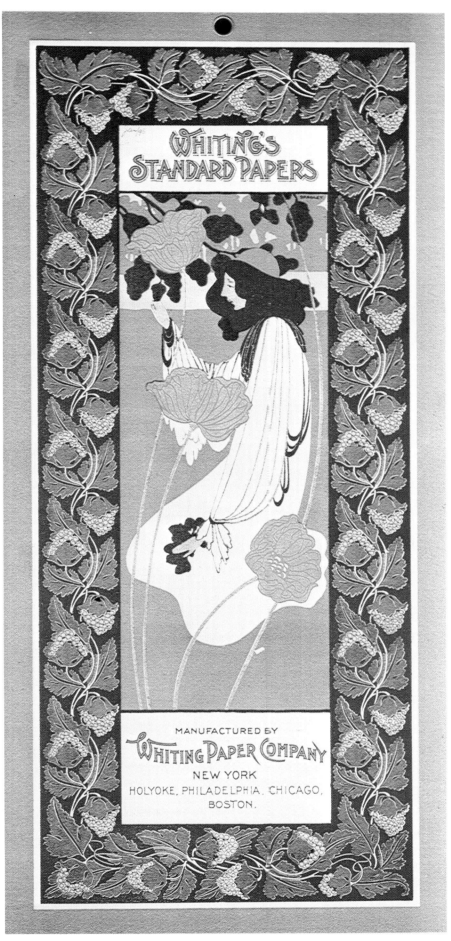

Will Bradley, Whiting Paper Co., 1895.

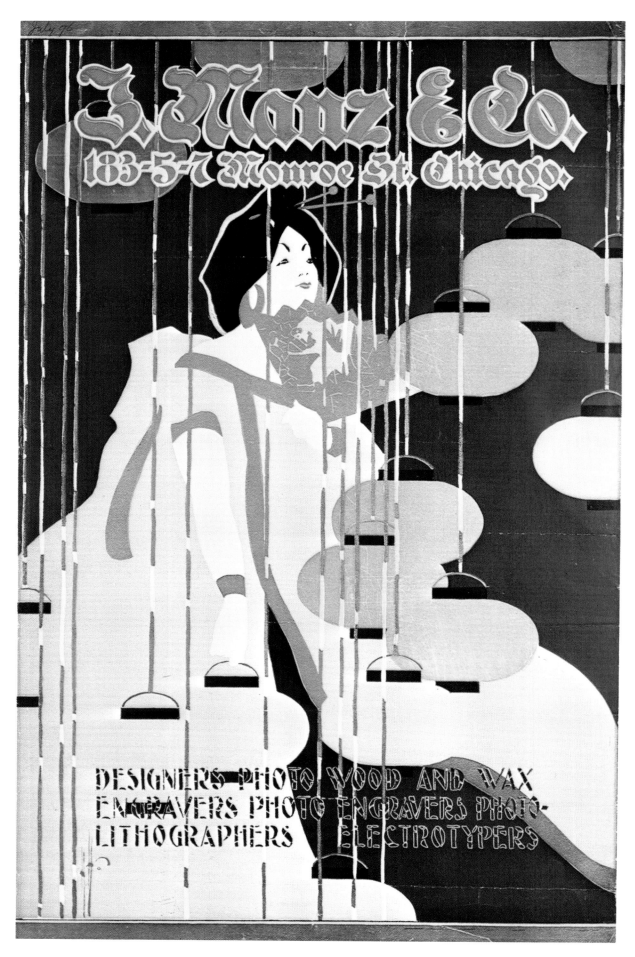

Artist unknown, J. Manz & Co., 1896.

THE ADLAKE CAMERA

4" x 5", with twelve plate holders, $12.

Maxfield Parrish, The Adlake Camera, 1897.

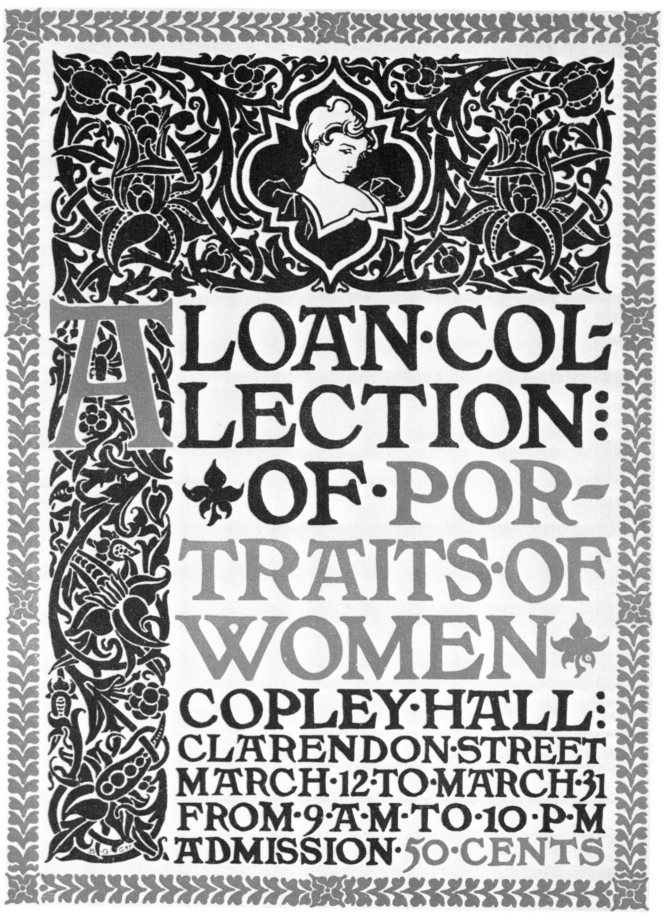

Bertram Grosvenor Goodhue, Portrait Exhibition, 1896.

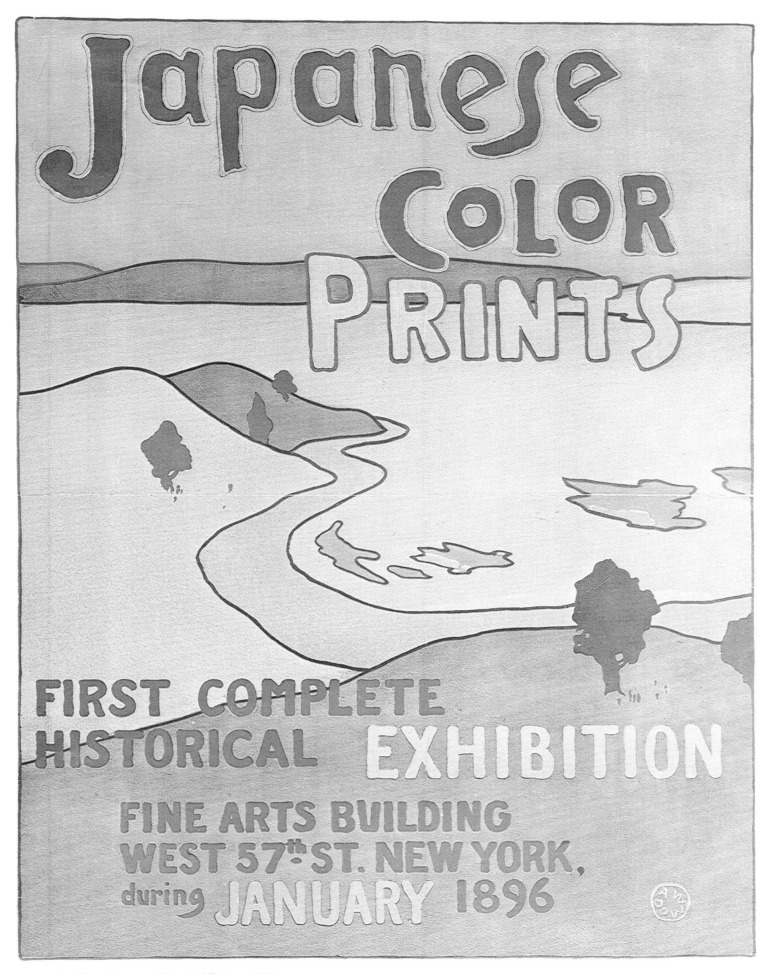

Arthur Dow, Japanese Print Exhibition, 1896.

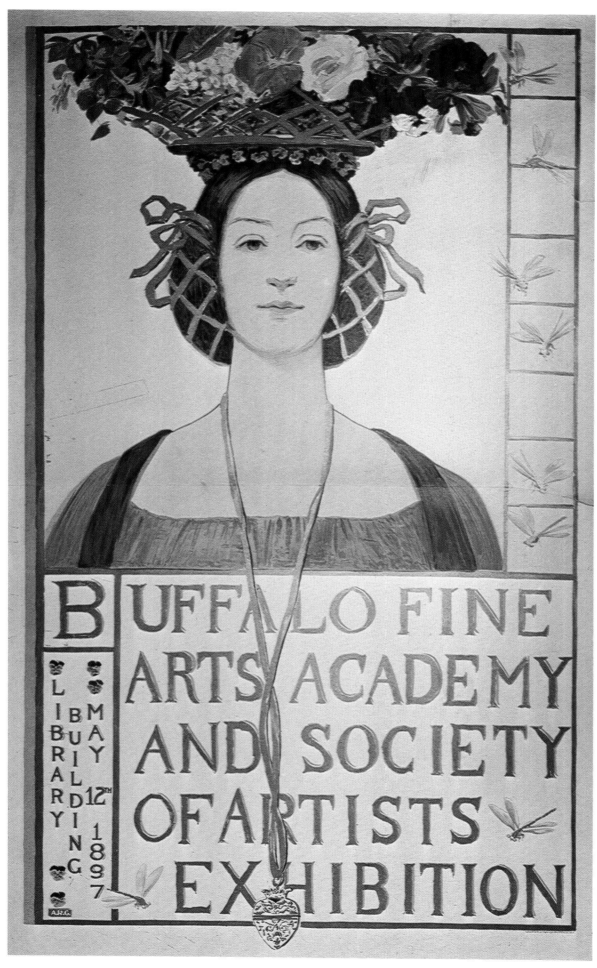

Alice Glenny, Buffalo Fine Arts Academy and Society, 1897.

George Frederick Scotson-Clark, *The New York Recorder*, c. 1895.

Louis Rhead, *The Journal*, c. 1895.

Jules Chéret's sketch was
the source of Ernest Haskell's
poster design on the opposite page.

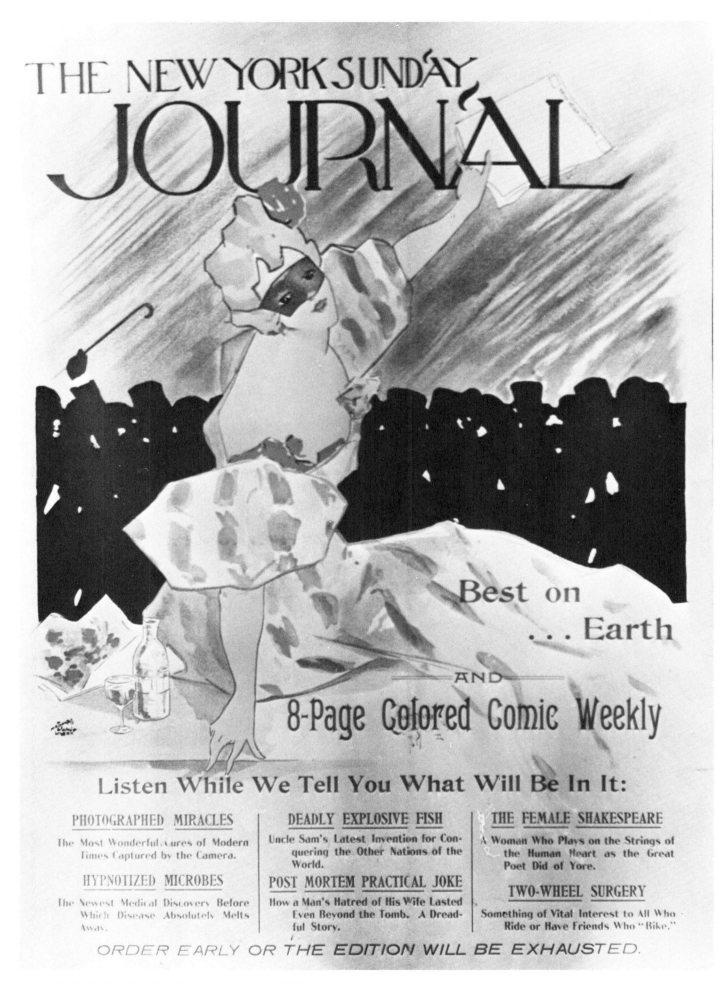

Ernest Haskell, *The New York Sunday Journal*, c. 1895.

Claude Fayette Bragdon, *The Rochester Post Express*, c. 1895.

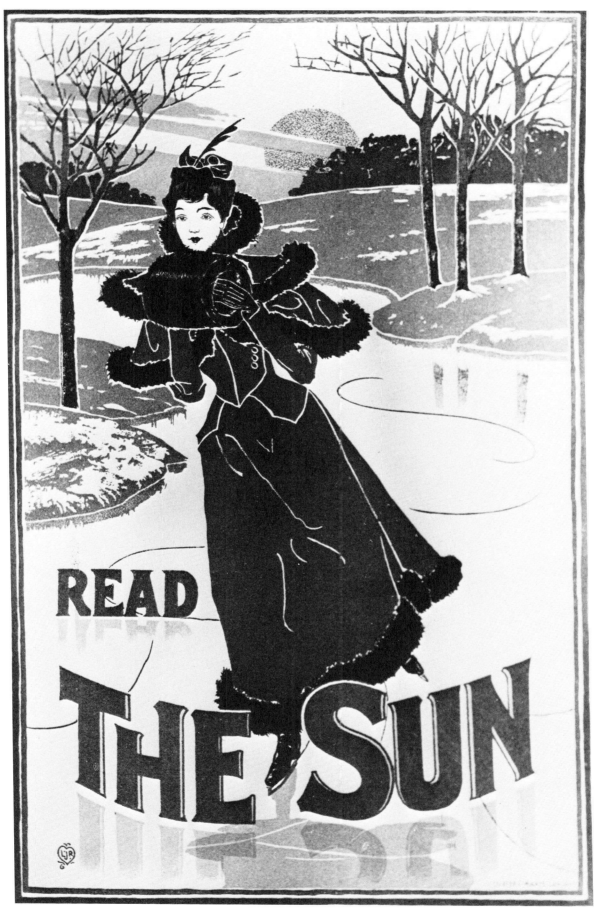

Louis Rhead, *The New York Sun*, c. 1895.

THE BOSTON

EVERY
LADY
WILL
READ

FASHION
SUPPLEMENT
MARCH 24

E·REED

SUNDAY
HERALD

Ethel Reed, *The Boston Herald*, c. 1895.

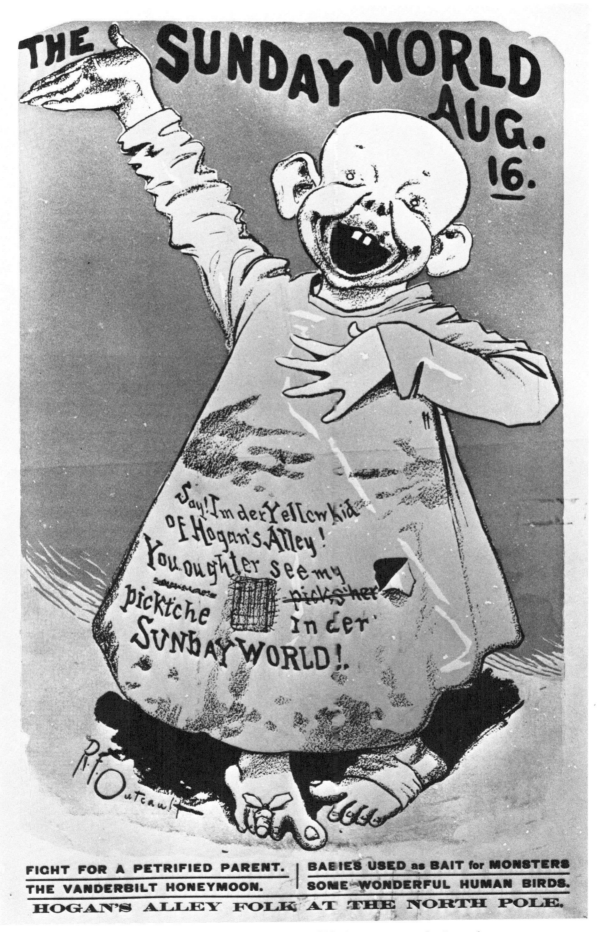

R.F. Outcault's "Yellow Kid" appeared in *The New York World* before moving to the *Journal*.

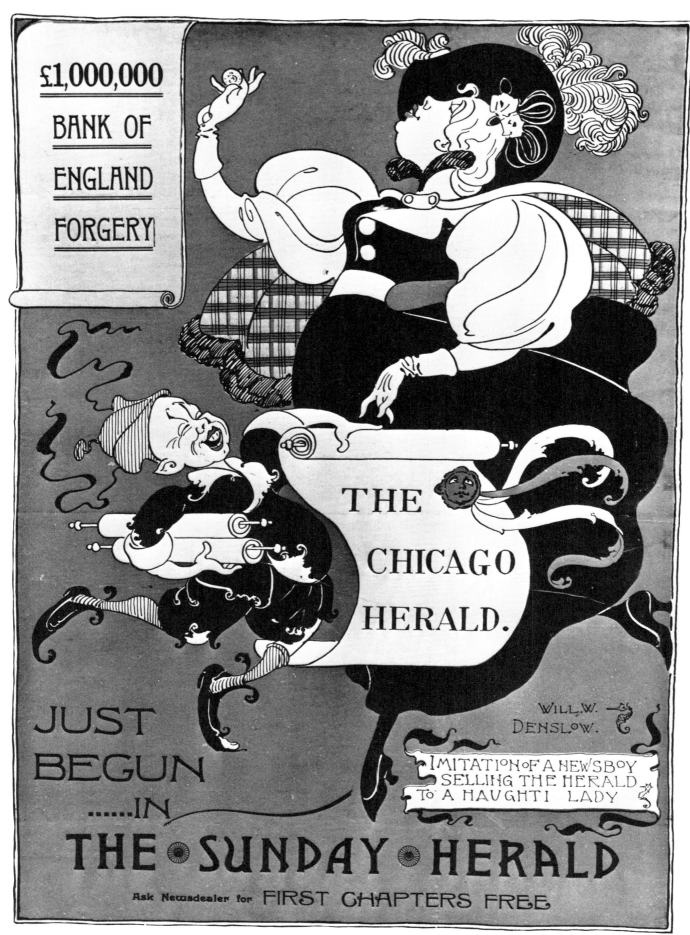

Will Denslow, *The Chicago Herald*, c. 1895. The prancing figure is a
parody of Will Bradley's Art Nouveau *Chap-Book* poster, "The Twins."

J.C. Leyendecker, *The Chicago Evening Post*, 1898.

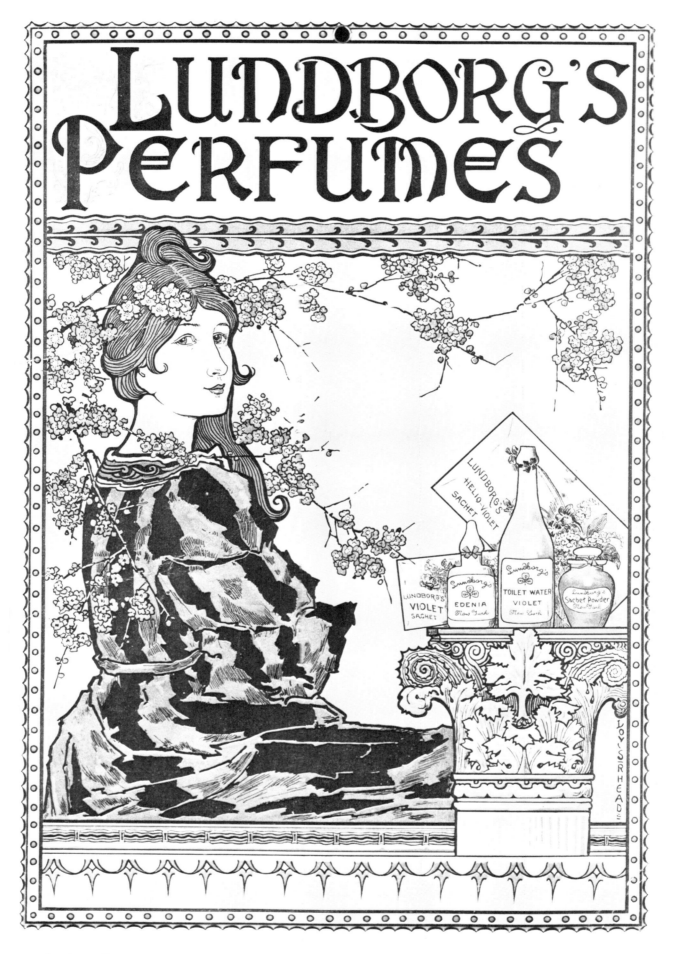

Louis Rhead, Lundborg's Perfumes, 1894.

Frank Hazenplug, The Emerson and Fisher Co., 1896.

Henri de Toulouse-Lautrec, The Ault & Wiborg Co., c. 1896. The couple on the poster are Toulouse-Lautrec's friend Misia Sert and cousin Dr. Tapié de Celeyran.

O. Giannini, The Turner Brass Works, 1895.

Binner Engraving Co., Triumph Furnaces, c. 1895.

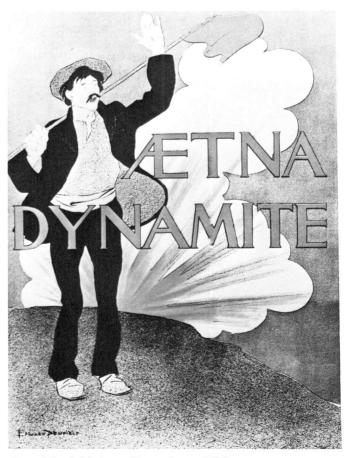

Edward Penfield, Aetna Dynamite, c. 1896.

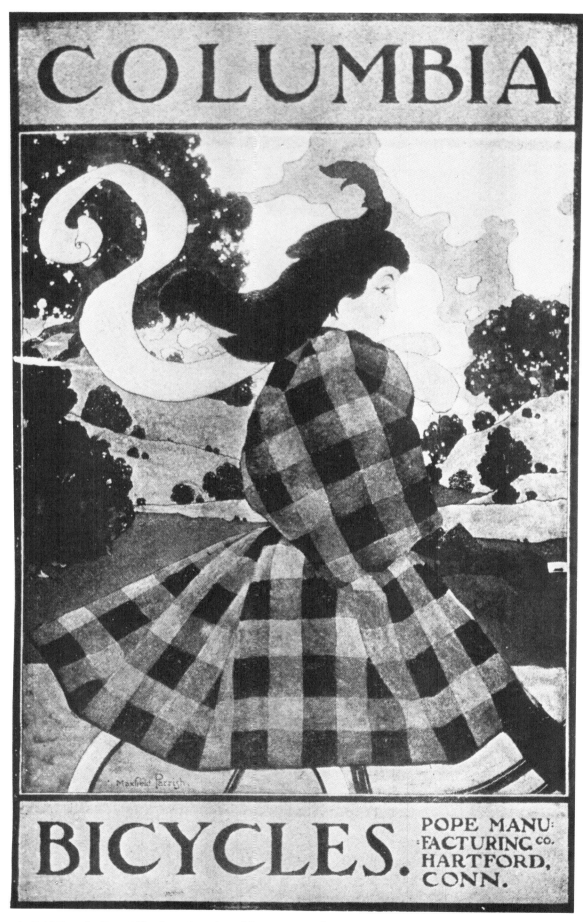

Maxfield Parrish, Pope Mfg. Co., 1896. Parrish's poster won first prize in the 1896 Columbia Bicycle contest.

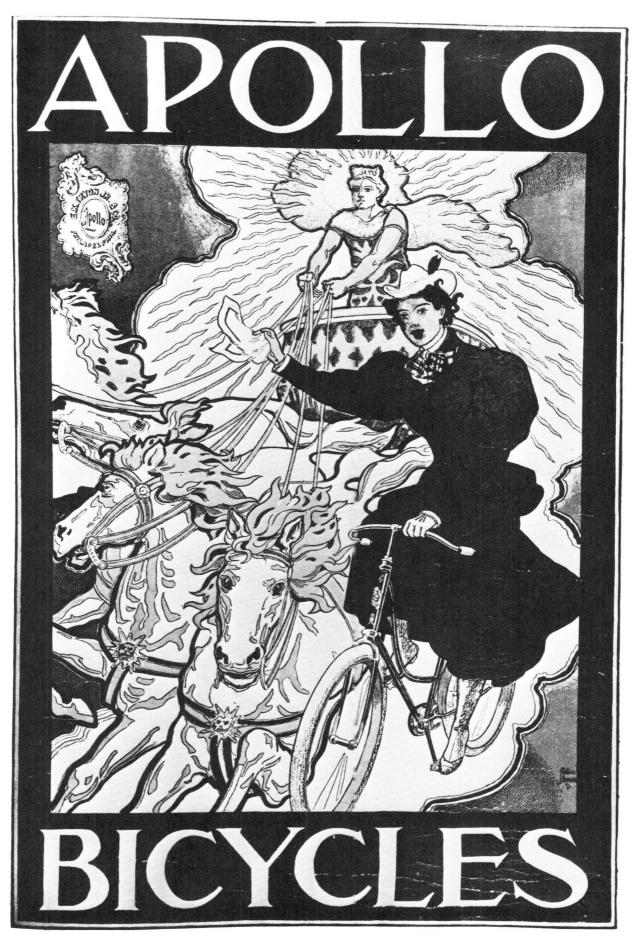

John Sloan, E.K. Tryon Jr. & Co., c. 1898.

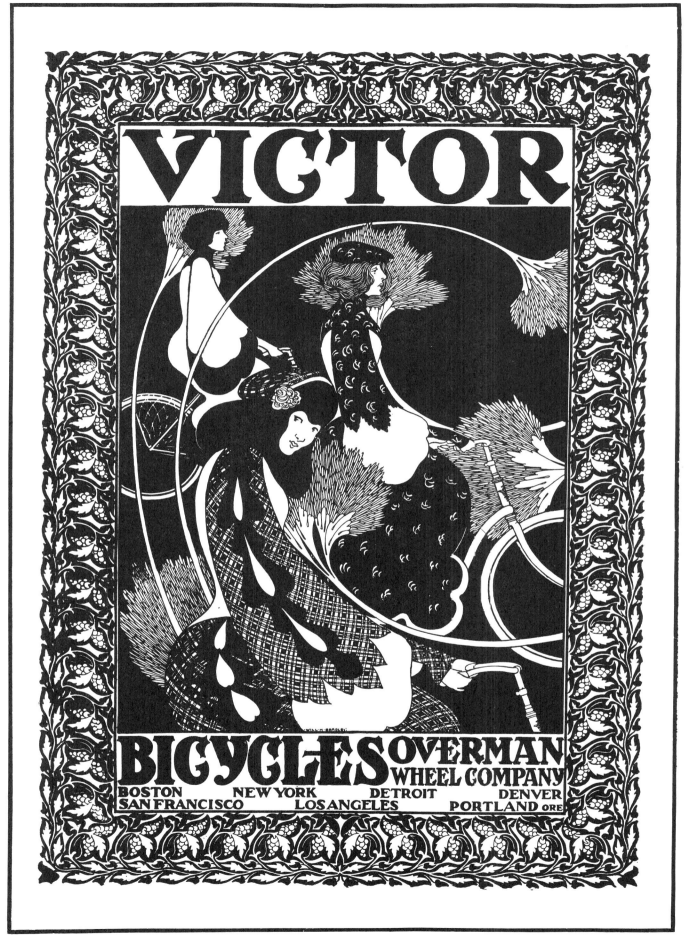

Will Bradley, Overman Wheel Co., 1896.

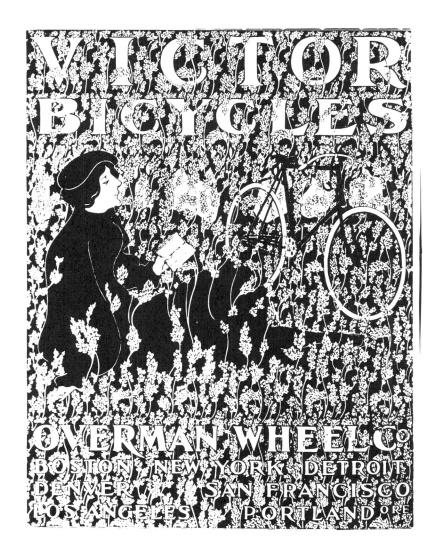

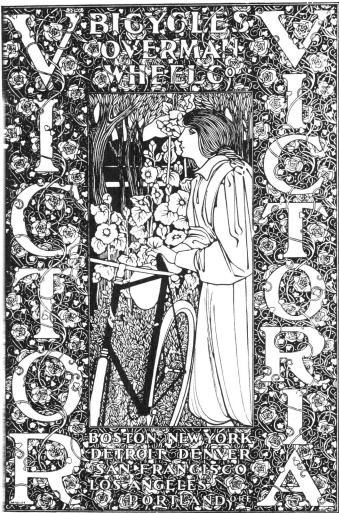

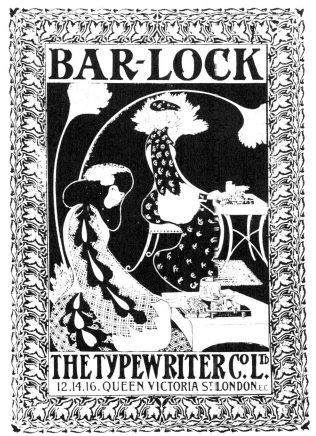

Two posters by Will Bradley for the Overman Wheel Co., c. 1895 (above), and an adaptation of the Victoria Bicycle poster (left) for a London typewriter manufacturer.

Frank Hazenplug, "Living Posters," 1897. A placard for a Chicago poster exhibition.

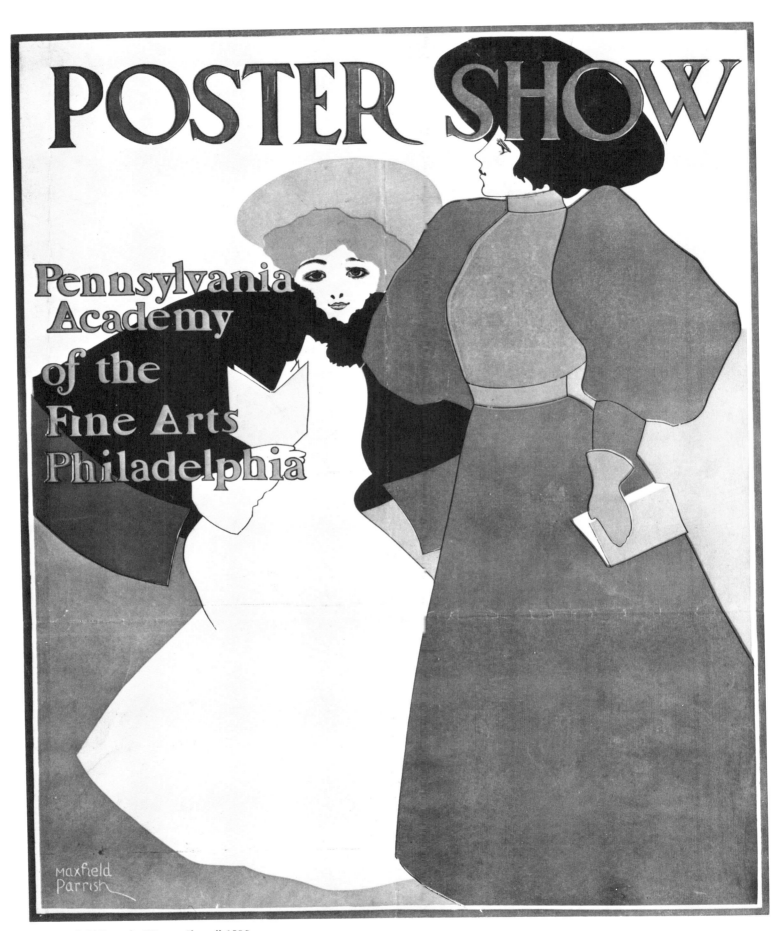

Maxfield Parrish, "Poster Show," 1896.

Charles Woodbury, "Society of Painters in Watercolor of Holland," 1895.

Aprylle Fayre and Easter Carollynge

Atte ẏ Hotel Brunswick
Boylston St., Tuesday & Wednesday Aprylle 16-17, from
ẏ houre of *Noone* to *Ten* of ẏ
Evenynge....Tyckette 50 cents

T B HAPGOOD JR DEL 1895

T.B. Hapgood Jr., "Aprylle Fayre," 1895.

Biographies

Edwin Austin Abbey (1852–1911), who studied at the Pennsylvania Academy of Fine Arts, spent most of his life in England. He gained fame as a pen and ink book illustrator, particularly of works by Herrick and Shakespeare. Later Abbey began to devote increasing time to painting and received an important mural commission from the Boston Public Library for *The Quest of the Holy Grail*.

W. S. Vanderbilt Allen. Biographical information unavailable.

E.B. Bird

Elisha Brown Bird (1867–1943) studied architecture at M.I.T He did illustrations and posters for *The Inland Printer*, *The Chap-Book*, *The Red Letter*, *The Black Cat*, *Copeland & Day*, and other magazines and book publishers. He was promotion designer and cartoonist for several newspapers including *The Boston Herald*, *The New York World*, and *The New York Times*.

G. Willard Bonte designed a number of posters for *Outing* and did occasional book placards.

Caricature by Will True

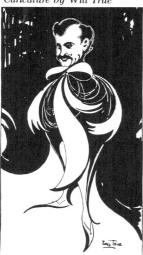

Will Bradley (1868–1962) was a self-taught artist who began as a printer's apprentice and worked in printing shops for some time before starting his career as an illustrator in Chicago. After a series of magazine covers for *The Inland Printer*, Bradley received important book and magazine poster commissions from Stone & Kimball. In 1895 he established the Wayside Press in Springfield, Massachusetts and published his own magazine, *Bradley: His Book*. Numerous requests for posters and brochures came from various manufacturers. Bradley was also a typographer and book designer. After 1900 he was active as an art director for numerous magazines including *Good Housekeeping*, *Collier's*, and *Metropolitan*; he wrote and illustrated a novel which was serialized in *Collier's*. He was also involved in the production of films for William Randolph Hearst.

CLAUDE FAYETTE BRAGDON

Bookplate

Claude Fayette Bragdon (1866–1946) did illustrations and posters for *The Chap-Book* and *The Rochester Post Express*. He also wrote articles on the poster movement. After the turn of the century, Bragdon practiced architecture and designed theater sets and costumes. Late in life he wrote several books on philosophy and architecture.

Jean Carré. Biographical information unavailable.

Will Carqueville (1871–1946) was trained as a lithographer in his father's firm, Shober & Carqueville. He drew a series of posters for *Lippincott's* and *International* before going to Paris to study art. Upon his return he established a lithography workshop in Chicago and did work for the *Chicago Tribune*, among other clients.

Robert William Chambers (1865–1933) studied at the Julian Academy in Paris. He worked as an illustrator for *Life*, *Truth*, and *Vogue* and did occasional book posters.

Howard Chandler Christy (1873–1952) studied at the Art Students League in New York City, and drew illustrations for many books and magazines. His first posters were for *The Bookman*. The young woman in a sailor suit on Christy's famous World War I poster was almost as well known as James Montgomery Flagg's Uncle Sam. Christy received many commissions for portraits after 1920.

Charles H. Cox created a series of posters for *Bearings*, a journal for cyclists.

Francis Day designed posters for *Scribner's* and other publications.

William Wallace Denslow (1856–1915) began his career as a poster designer in Chicago. Among the book publishers, magazines, and newspapers for whom he created placards were *Rand McNally*, *The Echo*, *The Inland Printer*, *The Chicago Times-Herald*, *The Chicago Chronicle*, and *Uncle Sam*. In 1896 he joined Elbert Hubbard's Roycroft Shops and designed books, along with posters for Hubbard's magazine *The Philistine*. Denslow is best remembered for his illustrations for L. Frank Baum's *The Wizard of Oz*.

Lafayette Maynard Dixon (1875–1946), a self-taught artist, designed posters for the San Francisco magazine, the *Overland Monthly*. He was also a book illustrator and did occasional posters for book publishers. After 1900 he designed a memorable series of posters for *Sunset Magazine*. Dixon portrayed the Western scene in many prints and paintings.

Arthur Wesley Dow (1857–1922) studied art in Paris and Boston, where he was introduced to Japanese art by Ernest Fenellosa at the Boston Museum of Fine Arts. He taught at Pratt Institute, the Art Student's League, and Columbia Teacher's College. While director of the Ipswich, Massachusetts Summer Art School he did several series of woodcuts—"Ipswich Prints" (1895) and "Along Ipswich River" (1902).

Henry B. Eddy (1872–1935) created posters for *Clips, The Criterion, The Impressionist, The New York Journal*, and *New York Ledger*, as well as for the theater.

George Wharton Edwards (1869–1950), who studied in Antwerp and Paris, painted portraits, murals, and watercolors. He contributed illustrations to many periodicals and designed posters for *The Century, Collier's, The Pocket Magazine, The Bookman*, and *The American Watercolor Society*. Edwards voyaged extensively and wrote and illustrated twenty travel books including *Alsace-Lorraine, Holland of Today*, and *Vanished Towers and Clime's of Flanders*.

Harvey Ellis (1852–1904) was a painter, sculptor, and architect who studied at the National Academy of Design. He did poster work for *Harper's* and was president of The Rochester Society of Arts and Crafts.

R. L. Emerson designed several illustrative posters for *Atlantic Monthly*.

James Montgomery Flagg (1870–1960) studied art in England and Paris. He contributed illustrations to *Liberty, Cosmopolitan, College Humor*, and other magazines. He is best remembered for his famous World War I recruiting poster showing Uncle Sam, who also appeared on Flagg's posters during World War II.

Edmund Henry Garrett (1853–1929) received his fine arts training in Paris. In addition to illustrations, paintings, woodcuts, and etchings, he designed posters for book publishers and *The Boston Sunday Herald*. He was the author of several books including *Elizabethan Songs* (1891), *Three Heroines of New England* (1894), and *Victorian Songs* (1895).

O. Giannini designed posters for the Turner Brass Works and *The Inland Printer*.

Charles Dana Gibson (1867–1944) studied at the Art Students League and with the sculptor August St. Gaudens. He worked as a staff artist for *Life* and contributed illustrations to *Scribner's, Harper's, The Century*, and London's *Pall Mall Magazine*. He also illustrated books. Albums of his drawings were extremely popular, particularly *The Education of Mr. Pipp of New York*. Gibson subsequently became the editor of *Life* and later devoted more time to oil paintings.

Charles Allen Gilbert (1873–1929) studied at the Art Students League and in Paris. He illustrated books and contributed drawings to *Life* and other magazines. His poster work was for *Scribner's, Life*, and The Century Co.

William J. Glackens (1870–1938) studied at the Pennsylvania Academy of Fine Arts and in Paris. He belonged to the group of painters known as "The Eight." In addition to magazine illustrations, he did occasional posters for *Lippincott's* and for books and magazines published by Charles Scribner's Sons.

Alice Russell Glenny (1858–death unknown) was a painter and sculptor who studied in New York and Paris. She designed posters for *The Buffalo Courrier* and The Buffalo Academy and Fine Arts Society.

Bertram Grosvenor Goodhue (1869–1924) worked extensively as an architect but was also a noted book designer and decorator in the 1890s. He was a co-founder of *Knight Errant*, a magazine dedicated to aesthetic philosophy. The influence of the Arts and Crafts Movement is evident in Goodhue's ornate page designs and borders, particularly for Daniel Berkeley Updike's *Altar Book*.

J. J. Gould was a Philadelphia artist who designed a series of posters for *Lippincott's* after Will Carqueville left the magazine. He later did some cover illustrations for *The Saturday Evening Post*

Eugène Grasset (1841–1917) was a French decorative artist who painted, did book illustrations, and designed tapestries, stained glass, posters, and mosaics. Grasset's first American poster was for *Harper's* magazine. Subsequent commissions for magazine and book posters came from *The Century* and Harper & Bros.

Theo Hampe. Biographical information unavailable.

Theodore Brown Hapgood Jr. (1871–death unknown) studied in Boston at the Museum of Fine Arts. Known for his bronze sculpture, he also designed posters for *The Inland Printer*, The Century Co., Little, Brown, and for the "Aprylle Fayre," held in Boston.

Self-portrait

Ernest Haskell (1876–1925) designed posters for *Truth, The New York World, The Critic, The New York Journal*, and for books. In 1897–98 he studied in Paris and exhibited at the Salon of the Société Nationale. Though he was known for his landscapes and watercolors, he continued to do magazine illustrations, particularly for *Harper's*. After the turn of the century, he gained a reputation for his etchings.

Frank Hazenplug (1873–death unknown) was staff artist for Stone & Kimball. He designed *Chap-Book* posters and several book and exhibition placards. He also illustrated stories and books for the firm and did at least one poster for another company, Emerson and Fisher, the Cincinnati carriage builders.

Higby did several posters for the magazine *Outing*.

Will Hooper studied at the Art Student's League. He was a painter and illustrator.

Clifton H. Johnson (1865–1940), a book illustrator, designed several magazine placards as well as a series of book posters for Lee & Shepard of Boston.

Martin Justice. Biographical information unavailable.

Edward Windsor Kemble (1861–1933) was an illustrator and caricaturist who contributed frequently to many publications in the 1890s; particularly New York's *Daily Graphic, Harper's Weekly, Collier's*, and *Life*. Books he illustrated included *Uncle Tom's Cabin, Huckleberry Finn*, and *Pudd'nhead Wilson*. Kemble was famous for his "darkie" drawings which were collected in books such as *Kemble's Coons* and *The Blackberries*.

H. M. Lawrence created posters to advertise books published by The Century Co. and others; notably *The Swordmaker's Son, The Second Jungle Book*, and *The Prize Cup*. He also did several magazine placards for *The Century*.

Joseph Christian Leyendecker (1874–1971) was an illustrator and advertising artist who came to America from Germany as a

young boy. After studying at the Chicago Art Institute and learning engraving with a commercial firm, he spent several years studying art in Paris. Leyendecker won the *Century* poster competition in 1896 and contributed posters and magazine covers to *Scribner's*, *The Inland Printer*, *Interior Design*, and *The Saturday Evening Post*. His best-known advertisements were for *Chap-Book*. After 1900 he worked extensively for *Collier's* and Arrow collars and Chesterfield cigarettes.

Abraham W.B. Lincoln was a New York artist known primarily for his book posters. He also designed magazine placards for *Godey's* and *The Pocket Magazine*.

Will Low (1853–1932) was a figure and genre painter who studied in Paris with Gérôme and Carolus Duran. He was also active as a book illustrator and designed posters for *Scribner's*, The National Academy of Design, and The Society of American Artists.

Florence Lundborg (1871–1949) is best known for her colorful woodcut posters advertising *The Lark* of San Francisco. Primarily a painter, she studied in San Francisco, Italy, and France. An important commission was the group of wall paintings she did for the California Building at the Panama-Pacific Exhibition. Among the books she illustrated were *The Rubaiyat*, *Yosemite Legends*, and *Honey Bee*.

Henry McCarter (1866–1942) studied with Thomas Eakins in Philadelphia and Puvis de Chavannes and Toulouse-Lautrec in Paris. He worked as an illustrator for *Scribner's*, *The Century*, *Collier's*, and particularly *Harper's*. McCarter designed a widely-used poster for *McClure's* and another for Stone & Kimball's "Green Tree Library." Other placards were done for *Good Housekeeping*, *The Century*, and *Scribner's*. In 1915 the artist won a Gold Medal for Illustration at the Panama-Pacific Exhibition. Books he illustrated included an edition of Verlaine's poems.

Blanche McManus (1870–death unknown), after a sojourn in Paris, returned to America in 1893 and set up a studio in Chicago. She did book and magazine illustrations as well as posters for several book publishers. After the turn of the century, she moved to Paris where she continued to draw for books and magazines. She was the author of *The American Woman Abroad* and *Our French Cousins*.

Harry Whitney McVickar (1860–death unknown) was a writer and illustrator. He designed posters for *Harper's Bazar* and for his book *The Evolution of Woman*. Among his book illustrations were those for Henry James' *Daisy Miller*. His caricatures appeared in *Life*.

O.C. Malcom designed posters for several magazines including *Outing* and *Pearson's*.

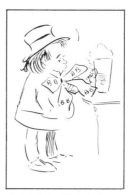

Henry Mayer (1868–1954) was an illustrator and caricaturist who came to America from Germany in 1886. He contributed to many magazines including *Life*, *Truth*, *The Century*, *Collier's*, and *Harper's* and was for a time the editor of *Puck*. Mayer designed posters for *Truth* and *St. Nicholas* and wrote several books including *Autobiography of a Monkey* (1896) and *Alphabet of Little People* (1901).

Thomas Buford Meteyard (1865–1928) studied art in Europe and had painting exhibitions in Paris and Chicago. He worked as a book illustrator and designer and did a poster for Copeland & Day's *Songs of Vagabondia*.

Lucien Métivet (1863–death unknown), a French painter and designer, was one of the outstanding illustrators of the 19th cen-

tury. He contributed to many illustrated journals of his day. His Napoleon poster won first prize in the contest sponsored by The Century Co.

Moores designed posters for books and magazines, including *St. Nicholas*.

Sketch by L.M. Glackens

Frank Arthur Nankivell (1865–1959), an Australian, spent several years in Asia before reaching San Francisco in 1894. His drawings appeared in the San Francisco paper, *The Call*, and in *The Echo*, founded by his friend Percival Pollard in Chicago. Nankivell moved to New York in 1896 and contributed illustrations to *The New York Journal* and *Puck*. Posters were designed for the *Journal*, *The Clack Book*, *The Echo*, and several book publishers. The artist later studied portrait painting and worked for *The Ladies' Home Journal*.

Peter Sheaf Hersey Newell (1862–1924), who studied at the Art Students League, was a painter, illustrator, writer, and lecturer. Most of his illustrations were done for Harper & Bros., particularly the drawings for a special edition of *Alice in Wonderland*. He did occasional book posters and was the author of several volumes of whimsy including *Peter Newell's Pictures and Rhymes*, *Topsys and Turveys*, *The Rocket Book*, and *The Hole Book*.

M.E. Norton was known for the posters she created for *The Bookman*.

Chic Ottman designed posters for the magazine *Elite* and for Schick Bicycles.

Richard Felton Outcault (1863–1928) was the creator of "The Yellow Kid," the first comic panel to appear regularly in an American newspaper, *The New York Journal*. His "Yellow Kid" posters were known all over New York. Another famous Outcault comic series was "Buster Brown."

Maxfield Parrish (1870–1966) studied at the Pennsylvania Academy of Fine Arts and briefly with Howard Pyle. He was awarded prizes in several major poster competitions in the 1890s. Commissions for magazine covers and posters came from *Harper's Bazar*, *Harper's Weekly*, *Harper's Round Table*, *Scribner's*, *St. Nicholas*, and others. Book posters were done for Way & Williams and Copeland & Day. Parrish did extensive commercial work including advertisement for Fiske Tires and Edison Mazda. After 1900 he created many covers for *Collier's*, *Life*, and *The Ladies' Home Journal*. Parrish was one of the most popular illustrators of the early 20th century and his prints adorned walls in homes throughout America.

> M.P. Maxfield Parrish
>
> *Samples of early (left) and late (right) signatures*

Ernest Peixotto (1869–1940), one of the founders of *The Lark* along with Gelett Burgess, Bruce Porter, and Willis Polk, was a painter, writer, and illustrator. He did mural paintings, wrote travel articles, and authored several books including *By Italian Seas*, *Romantic California*, and *Our Hispanic Southwest*.

Caricature by Hy Mayer

Edward Penfield (1866–1925) studied at the Art Students League before serving as Art Director for various Harper periodicals from 1881 to 1901. He designed monthly posters for *Harper's* from 1893 to 1898 and also did some book posters for Harper & Bros. during this period. After 1900 he continued as a book and magazine illustrator. Two books of his drawings were published: *Holland Sketches* (1907) and *Spanish Sketches* (1911).

Bruce Porter (1865–death unknown), who studied art in America and Europe, was a member of the San Francisco literary group that founded *The Lark*. He later painted murals in California churches and public buildings.

Edward Henry Potthast (1857–1927) studied painting in America and Europe. He designed a famous poster for the Barnum & Bailey circus featuring a bareback rider. Another of his placards won honorable mention in *The Century's* poster contest in 1896. As an artist, he was recognized for his seascapes.

Maurice Prendergast (1861–1929), an important American Impressionist painter, was a member of the New York artists' group, "The Eight." He did occasional posters and book illustrations.

Ethel Reed (1876–death unknown) studied art in the Boston area and was already established as an illustrator by the age of 18. Though she did occasional newspaper and magazine placards, she was best known for the book posters designed for the Boston literary publishers, Copeland & Day and Lamson, Wolffe & Co. Several of the books for which she did posters featured her own illustrations. The artist was not heard from after 1898.

Louis John Rhead (1857–1926) was born in England and educated at the South Kensington Art School and in Paris. In 1883 he came to New York to work for the D. Appleton Co. as an illustrator. He received early poster commissions in 1889 and 1890 from *The Century, Harper's,* and *St. Nicholas*. From 1891 to 1894 he studied in London and Paris where he was strongly influenced by the work of Eugène Grasset. The Wunderlich Gallery in New York gave Rhead a one-man exhibition in 1895 and another show followed in 1897 in Paris at the Salon des Cent. Rhead created numerous posters for the *New York Sun* and the *Journal*. Magazine and book posters were designed for *Scribner's*, Copeland & Day, and Prang's Publications; additional posters were done for various manufacturers. After 1900 Rhead was mainly active as a book illustrator and wrote several books on fishing.

Frederick Richardson (1862–1937) was a painter and illustrator who studied in St. Louis and Paris where his paintings were shown at the Salon of 1889. He contributed regular drawings to *The Chicago Daily News* and various magazines. Posters were created for the magazine *International* and *St. Nicholas*.

Bruce Rogers (1870–1957) was one of America's most distinguished typographers and printers. He moved to Boston to become Art Director for *Modern Art* and later designed many books for the Riverside Press. He was subsequently associated with the University Press in Cambridge, England, and with the Harvard University Press. Elegant typographic posters were done for *Modern Art* and *Atlantic Monthly*.

Henry M. Rosenberg (1858–death unknown) was an artist who won an honorable mention in the 1896 *Century* mid-summer poster contest. He later became the Director of the Victoria School of Art and Design.

J. A. Schweinfurth. Biographical information unavailable.

George Frederick Scotson-Clark was an English poster artist who came to America in 1891. He worked as a stage and costume designer and created numerous theatrical posters. He is credited with designing the first American newspaper poster, for *The New York Recorder*. Other posters were done for *The Bookman, The New York World, The New York Ledger,* and *Outing*. Scotson-Clark returned to England in 1897.

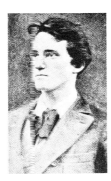
John Sloan (1871–1952) studied at the Pennsylvania Academy of Fine Arts and worked as an illustrator for *The Philadelphia Inquirer* before he was able to pursue a career as a painter and printmaker. He belonged to the group of New York painters, "The Eight." As an illustrator, he had drawings published in *Everybody's Magazine, Harper's Weekly, Collier's,* and *The Chap-Book*. Posters were designed for *Moods, The Echo,* and Copeland & Day, as well as for commercial concerns.

John Stewardson. Biographical information unavailable.

Henri de Toulouse-Lautrec (1864–1901) depicted the night life of Montmartre in the late 19th century in his paintings, drawings, and lithographs. Among his posters were two for American firms: one commissioned by the Ault & Wiborg Co. to advertise printing inks and another ordered by Stone & Kimball to promote *The Chap-Book*. He also entered the poster contest sponsored by The Century Co. to promote a book on Napoleon but failed to win a prize.

John Twachtman (1853–1902), one of the first American Impressionists, studied painting in Cincinnati and Europe and was known for his landscapes. He did a poster for a novel published by Stone & Kimball, *The Damnation of Theron Ware*.

Robert Leicester Wagner (1872–death unknown) was a painter and illustrator who studied at the Julian Academy in Paris. He designed posters for several tobacco companies as well as for the weekly magazine, *Criterion*, and *The Clack Book*. Wagner won medals for painting at the Alaska-Yukon-Pacific Exhibition in Seattle (1909) and the Panama-Pacific Exhibition in San Francisco (1915).

Henry Sumner Watson (1868–1933) publicized such magazines as *Truth, Outing, Recreation,* and *Bachelor of Arts* with his posters.

E. B. Wells. Biographical information unavailable.

Charles Herbert Woodbury (1864–1940) was an M.I.T. graduate who studied painting in Paris and was particularly known for his New England seascapes. He won gold medals for his paintings at the Atlanta Exhibition (1895) and the Panama-Pacific Exhibition (1915). Posters were designed for *The Century*, several book publishers, and an exhibition of watercolors. Woodbury wrote several books including *Painting and the Personal Equation* (1922) and *The Art of Seeing* (1925).

Acknowledgments

An historian must be something of a detective, with a taste for following up clues and tracking down odd bits of information. During the course of writing this book, I was fortunate to encounter a group of people who kindly shared their knowledge with me, directed me to poster sources, and, in several cases, loaned me material from their own collections.

Robert Brown loaned me his copy of *Das Frühe Plakat*, an invaluable German catalog of 1890s posters. I am indebted to essays on the 19th century poster by Dr. Edgar Breitenbach in the book *The American Poster*, and by Roberta Wong in her catalog for the exhibition "American Posters of the Nineties." Susan Thompson of the Columbia University School of Library Science told me about the Engel Collection of the Columbia University Libraries, probably the most complete collection of late 19th century American posters in the United States. Robert Nikirk, Librarian of the Grolier Club, shared the resources of the Grolier Club library with me. Roberta Wong of the Print Division at the New York Public Library, who is an authority on Will Bradley, gave me much help in checking facts and details about posters and artists.

Kenneth Lohf, Head of Special Collections of the Columbia University Libraries, made the Columbia poster collection available to me. During the long hours of selecting and photographing the posters, I was helped immensely by members of his staff: Bernard Crystal, Mimi Bowling, and Henry Rowan.

At the Library of Congress, I thank Alan Fern, Chief of the Prints and Photographs Division and his staff members: Milt Kaplan, Elena Millie (Curator of the Poster Collection), Jerry Kearns, and Leroy Bellamy. Other museums and archives which furnished advice or photographs include the Chicago Historical Society, the Metropolitan Museum of Art, the New York Public Library, the Currier Gallery of Art in Manchester, New Hampshire, and the Hopkins Center Art Galleries at Dartmouth College.

Ray Wapner and Justin Schiller of Justin G. Schiller Ltd., dealers in posters and children's books, loaned me a hard-to-find Victoria Bicycle poster by Will Bradley, and Leslie and Alice Schreyer made available several items from their collection. Donald Manza photographed all the posters at Columbia University and from the private collections.

Lastly, I think the editorial staff at Watson-Guptill for their help and suggestions; Don Holden, Editorial Director, Diane Casella Hines, Associate Editorial Director, and my editor, Sarah Bodine.

Illustration Credits

Chicago Historical Society	10
Columbia University Libraries, Engel Collection	8, 9, 14, 19, 20 (top), 22 (upper left), 26 (top), 30, 33–35, 36 (top), 37 (top), 39, 40 (top), 41, 43 (bottom), 45 (middle), 46, 49–56, 58–60, 63 65, 67, 69, 70, 73–82, 83 (top right and bottom left), 84, 85, 87, 89–93, 97 99, 102–111, 114, 116–118, 120–122, 124, 125, 128, 129, 131–134, 137–139, 141, 142, 144–146, 148–154, 155 (top), 156–159, 161–174, 179–183, 187, 190–192, 195–197, 199–203, 205 (bottom), 210, 212, 213
Currier Gallery of Art	155 (bottom)
Hopkins Center Art Galleries, Dartmouth College, Courtesy of the Trustees of Dartmouth College	61, 123, 177
Library of Congress	13 (top), 16, 17, 37 (middle), 38, 57, 62, 64, 66, 68, 71, 72, 88 (top), 94, 98, 100, 101, 113, 115, 119, 127, 130, 140, 147, 184, 186, 198, 206, 208, 211
Metropolitan Museum of Art, Gift of Mrs. Fern Bradley Dufner, 1952	18
Justin G. Schiller Ltd.	185
Leslie and Alice Schreyer Collection	81 (top left), 143, 188
Yale University Press, reprinted from *John Sloan's Prints* by Peter Morse © 1969 by Helen Farr Sloan	207

Bibliography

Posters

Abdy, Jane. *The French Poster*. New York: Clarkson N. Potter, 1969.

"L'Affiche internationale illustrée," *La Plume* (October 1, 1895).

Alexandre, Arsene, et al. *The Modern Poster*. New York: Scribner's, 1895.

Allner, Walter. "Booksellers Posters in the Romantic Era." *Graphis IV*, no. 22 (1948): 123–127.

Alloway, Lawrence. "The Return of Maxfield Parrish," *Show IV*, no. 5 (May 1964): 62–67.

The American Federation of Arts. *The American Poster*. New York: October House, 1967.
Catalog of an exhibition circulated between June 1967 and June 1969. Text by Edgar Breitenbach and Margaret Cogswell.

American Posters of the Nineties. Manchester, N.H.: Currier Gallery of Art, 1974.
Exhibition catalog. Introductory essay by Roberta Wong.

Ault & Wiborg Co. *Poster Album*. Cincinnati: Ault & Wiborg Co., 1902.

Bauwens, M., et al. *Les Affiches étrangères illustrées*. Paris: Boudet, 1897.

Bolton, Charles Knowles. *A Descriptive Catalogue of Posters, Chiefly American, in the Collection of Charles Knowles Bolton*. Boston: W.B. Jones, 1895. Biographical notes and a bibliography.

————. *The Reign of the Poster*. Boston: Winthrop B. Jones, 1895.

Bradley, Will. *Will Bradley: His Chap Book*, New York: The Typophiles, 1955.

A Collection of Seventeen Photographs of Posters Designed by Louis J. Rhead, with a Portrait of the Artist. New York: B. Bogart, 1896.

Ettinger, Paul. "Will H. Bradley." *Das Plakat*, v. 4 (July 1913): 149–164.

Flood, Ned Arden. *A Catalogue of an Exhibition of American, Dutch, English, French and Japanese Posters from the Collection of Mr. Ned Arden Flood*. Meadville, Pa.: Flood and Vincent, 1897.

Freeman, Dr. Larry, ed. *Victorian Posters*. Watkins Glen, N.Y.: American Life Foundation, 1969.

Das Frühe Plakat in Europa und den USA, Band 1. Berlin Gebr. Mann Verlag, 1972.

Goldwater, Robert J. "L'affiche moderne," *Gazette des Beaux-Arts*, XX (December 1942): 173–182.

Hiatt, Charles. *Picture Posters*. London: George Bell, 1895.

Hillier, Bevis. *Posters*. New York: Stein & Day, 1969.

Koch, Robert. "Artistic Books, Periodicals, and Posters of the 'Gay Nineties,' "
Art Quarterly, 25, no. 4 (winter 1962): 370–383.

————. "The Poster Movement and Art Nouveau," *Gazette des Beaux-Arts* (November 1957): 285–296.
Based on an unpublished thesis "The Poster in the Development of the Modern Movement, 1880–1890," New York University, Institute of Fine Arts, 1953.

————. "Will Bradley," *Art in America*, 50, no. 3 (fall 1962: 78–83.

Ludwig, Coy. *Maxfield Parrish*. New York: Watson-Guptill, 1973.

Matthews, Brander. "The Pictorial Poster," *The Century*, v. 44 (September 1892): 748–756.

Morse, Peter. *John Sloan's Prints: A Catalogue Raisonée of the Etchings, Lithographs, and Posters*.
With a foreword by Jacob Kainen. New Haven: Yale University Press, 1969.

Pica, Vittorio. "A travers les affiches illustrées, I. Les Etats-Unis,"
L'Estampe et l'Affiche, no. 7 (September 1897): 163–169.

Pollard, Percival. *Posters in Miniature*. New York: R.H. Russell, 1896.

Price, Charles Matlack. *Poster Design*. New York: G.W. Bricka, 1922.

Rodgers, W.S. *A Book of the Poster*. London: Greening & Co., 1901.

Sloan, Helen Farr. *The Poster Period of John Sloan*. Lock Haven, Pa.: Hammermill Paper Co., 1967.

Sponsel, Jean Louis. *Das Moderne Plakat*. Dresden: Gerhard Kühtmann, 1897.

Walsh, Ruth. "L'Affiche: The New Art of Expression of the Late Nineteenth Century." M.A. Thesis, Columbia University, 1952.

Wember, Paul. *Die Jugend der Plakate, 1887–1917*. Krefeld: Scherpe Verlag, 1961.
A catalog of the poster collection in the Kaiser Wilhelm Museum, Krefeld, Germany.

Wong, Roberta. *Bradley: American Artist and Craftsman*. New York: Metropolitan Museum of Art, 1972.
Exhibition catalog, June 16–July 31, 1972.

_____."Will Bradley and the Poster," *Metropolitan Museum of Art Bulletin*, v. 30 (June/July 1972): 294–299.

_____. and Clarence P. Hornung, eds. *Will Bradley: His Graphic Art*. New York: Dover, 1974.

Wunderlich, H. & Co. *Original Designs by Louis J. Rhead*. Exhibit on catalog. New York: Wunderlich & Co., 1895.

Magazines with articles and information about the poster movement:

Bradley: His Book. Springfield, Mass., 1896–1897.

The Chap-Book. Chicago, 1894–1897.

L'Estampe et L'Affiche. Paris, 1897–1899.

The Inland Printer. Chicago, 1883–1958.

La Plume. Paris, 1889–1913.

The Poster. New York, 1896.

The Poster and Art Collector. London, 1898–1901.

Poster Lore. Kansas City, 1896.

General

Beers, Thomas. *The Mauve Decade: American Life at the End of the Nineteenth Century*. New York: Vintage Books, 1960, © 1926.

Bleyer, Willard. *Main Currents in the History of American Journalism*. Boston: Houghton Mifflin, 1927.

Brown, Henry Collins. *In the Golden Nineties*. Hastings-on-Hudson Valentine's Manual Inc., 1928.

Fleming, Herbert. *Magazines of a Market Metropolis*. Chicago: The University Press, 1906.

Hart, James D. *The Popular Book: A History of American Literary Taste*. New York: Oxford University Press, 1950.

Holme, Charles, ed. *The Art of the Book*. London: The Studio, 1914.

Jackson, Holbrook. *The Eighteen Nineties*. London: Pelican Books, 1939, © 1913.

Kramer, Sidney. *A History of Stone & Kimball and Herbert S. Stone & Co*. Chicago: The University of Chicago Press, 1940.

Lehmann-Haupt, Hellmut, in collaboration with Lawrence C. Wroth and Rollo G. Silver. *The Book in America: A History of the Making and Selling of Books in the United States*, 2d ed. New York: R.R. Bowker & Co., 1952.

Madison, Charles. *Book Publishing in America*. New York: McGraw-Hill, 1966.

Mott, Frank L. *American Journalism: A History; 1690–1940*, 3d ed New York: Macmillan, 1947.

_____. *Golden Multitudes: The Story of Best Sellers in the United States*. New York: Macmillan, 1947.

_____. *A History of American Magazines*, v. 4. Cambridge, Mass.: Belknap Press, 1957. 4 v.

_____. "The Magazine Revolution and Popular Ideas in The Nineties," *Proceedings of the American Antiquarian Society*, v. 64 (1955): 195–214.

Murrell, William. *A History of American Graphic Humor*. New York: Macmillan, 1938.

Pevsner, Nikolaus. *Pioneers of Modern Design: From William Morris to Walter Gropius*. London: Penguin Books, 1960.

Schlesinger, Arthur. *The Rise of the City, 1878–1898*. A History of American Life, v. 10. New York: Macmillan, 1933.

Thompson, Susan Otis. *The Arts and Crafts Book*. The Arts and Crafts Movement in America, 1876–1916, edited by Robert Judson Clark. Princeton, N.J.: Princeton University Press, 1972.

Weitenkampf, F. *American Graphic Art*. New York: Macmillan, 1924.

Index